W9-BFQ-678

JAPANESE DECORATIVE STYLE

Japanese

SHERMAN E. LEE

Decorative Style

Icon Editions
Harper & Row, Publishers
New York, Hagerstown, San Francisco, London

Board of Trustees

Trustees of The Cleveland Museum of Art

George P. Bickford
Willis B. Boyer
James H. Dempsey, Jr.
Robert I. Gale, Jr.
Mrs. David S. Ingalls
James D. Ireland
Severance A. Millikin
Mrs. R. Henry Norweb, *President*
A. Dean Perry
Mrs. Alfred M. Rankin
Ralph S. Schmitt
James N. Sherwin
Daniel Jeremy Silver
Paul J. Vignos, Jr.
John S. Wilbur
Lewis C. Williams
Charles B. Bolton, *Emeritus*

Printed by arrangement with the Press of Case Western Reserve University.

First ICON edition published 1972.

JAPANESE DECORATIVE STYLE. All rights reserved by the Cleveland Museum of Art, University Circle, Cleveland, Ohio 44106. Printed in the United States of America. No part of this book may be used or reproduced in any manner whatsoever without written permission except in the case of brief quotations embodied in critical articles and reviews. For information address Harper & Row, Publishers, Inc., 49 East 33rd Street, New York, N.Y. 10016. Published simultaneously in Canada by Fitzhenry & Whiteside Limited, Toronto.

STANDARD BOOK NUMBER: 06-430017-X

79 80 81 10 9 8 7 6 5 4 3

Preface

The earliest Western interest in Japanese art was shown by the patrons of the Rococo style in Europe. Modern Western interest began with the French discovery of the Japanese woodblock print and the minor arts of lacquer, sword-furniture, and the like. The Rococo was, above all else, a decorative style; and much of the impact of late nineteenth and early twentieth-century French painting can be described as decorative. Rather than perpetuate the still common Occidental opinion that Japanese art is but a secondary rendering of Chinese style, we should learn from the eighteenth and nineteenth centuries and seek for at least one of Japan's original artistic contributions in the area of decorative art and style.

This small introduction to Japanese decorative style is a by-product of the exhibition of that name organized by The Cleveland Museum of Art and co-sponsored by the Art Institute of Chicago. The phenomenal growth of the public and private collections of Japanese art in the United States since the second World War is reflected in the catalogue of objects shown in the exhibition. A small measure of the still greater wealth of material conserved and registered in Japan can be had from the quality of the fourteen largely unpublished and unknown objects lent by the various generous lenders through the courtesy of the National Commission for Protection of Cultural Properties, Tokyo.

We are particularly indebted to Prof. Yukio Yashiro, Acting Chairman of that Commission, for his aid in assembling the loans from Japan; to Junkichi Mayuyama for his painstaking and unselfish assistance with the myriad details of arranging the loans; to Marquis Moritatsu Hosokawa, Rikichiro Fukui, Fujio Koyama, Takaaki Matsushita, Yuzuru Okada, Inosuke Setsu, Osamu Takata, and to Jiro Umezu for their kind assistance in arranging for the loans from Japan. The generous cooperation of the American and Japanese lenders to the exhibition has been most gratifying. Particular mention should be made of Margaret Gentles, Associate Curator of Oriental Art, The Art Institute of Chicago, for the preparation of the catalogue entries for the Japanese prints under her jurisdiction. Margaret F. Marcus,

Research Assistant of The Cleveland Museum of Art was a faithful collaborator in preparing the catalogue listings while Wai-kam Ho, Assistant Curator of Oriental Art, contributed many neat items of research and translation. Thanks are also due to Louise G. Schroeder, Margarita Delvigs, and Charlotte Finley for their typing of the manuscript; Merald E. Wrolstad, Editor of Museum Publications, is responsible for the excellent design of the book and its editing; Edward B. Henning and Rémy Saisselin were invaluable critics of the draft text; and William E. Ward, Museum Designer, was in charge of the splendid installation of the exhibition. Without the cooperation and help of all these and many others, neither the exhibition nor its catalogue could ever have materialized. The publication of this book was made possible through The Cleveland Museum of Art Publication Fund established in 1959.

Sherman E. Lee

May 1961

Contents

Chronology of Japanese Art

PERIOD	YEARS	COMPARATIVE PERIOD IN CHINESE CHRONOLOGY
Archaeological Age	up to 552 A.D.	
Jomon, up to 200 B.C.		
Yayoi, 200 B.C.–200 A.D.		*Han Dynasty, 206 B.C.–220 A.D.*
Kofun (Haniwa), 200–552		
		"Six Dynasties," 220–589
Asuka (Suiko)	552–645	*Sui Dynasty, 589–618*
Nara	645–794	
Hakuhō, 645–710		*T'ang Dynasty, 618–907*
Tempyō, 710–794		
Heian	794–1185	
Early, Jōgan, 794–897		*Five Dynasties, 907–960*
Late, Fujiwara, 897–1185		
		Sung Dynasty, 960–1279
Kamakura	1185–1333	
		Yüan Dynasty, 1260–1368
Nambokuchō (North-South Schism)	1336–1392	
Muromachi (Ashikaga)	1392–1573	*Ming Dynasty, 1368–1644*
Momoyama	1573–1615	
Edo (Tokugawa)	1615–1868	
Early, 1615–1716		*Ch'ing Dynasty, 1644–1912*
Late, 1716–1868		
Modern Japan	1868–	

JAPANESE DECORATIVE STYLE

CHAPTER ONE: Style, decorative style,

Style is both a means and an end. From the invention of the concept in Roman analyses of rhetoric, or what is now chillingly called "arts of communication," it has been recognized as both the manner in which matter is expressed and as a good-in-itself. Style is the significant contribution of the individual artist, whether his tools be the power of the word, the brush, or the sculptor's knife. We recognize the personal touch in athlete and artist alike. It is what gives him his color, his particular conformation, usually a contribution built on preceding styles and itself capable of imitation, variation, or further development. It is the means by which the artist achieves an end; perhaps a competitive victory, or one calculated by scoring, or simply a position of excellence. This latter end is the one most amenable to the aims of the visual artist for his art can only be an imprecise definer of already vague concepts —stress, force, sadness, reverie, calm, joy, and a host of other pleasant or unpleasant tones. Since these ends are vague and cannot be measured by victories, or points, and since they can be evoked in varying degrees of explicitness by such various arts as literature, music, dance, painting, and sculpture, the means furnish the substance of what we call style in the visual arts.

The artist thinks, sees, and acts in what Focillon called "the World of Forms."[1] If he did not he would be something else, and we must enter his world when we deal with his works. This world includes far more than merely presented shapes, colors, textures, tones, etc. These are an alphabet only. Their relationships and implications of visual tension, relaxation, movement, weight, and numerous other subtle suggestions make up the vocabulary and grammar of the artist's style; but what he does with these makes his style. It may be a superficial and imitative one, or it may soar with a seeming godlike power. Evaluate it we must, and as best we can, knowing that our judgments must be relative and continually subject to error and revision. As Focillon points out,[2] the work of art exists both in and out of time, for it is a historical fact as well as a present

2

and Japanese decorative style

commodity. We poor mortals, however, are only too thoroughly enmeshed in time.

One can also speak of the style of a given geographic area. We casually speak of Venetian style or Florentine style, but what we probably mean is school. That is, the style is that which is associated with an individual artist whose power is so great that clustered about him are many who imitate him or are influenced by him. Attempts to find a *mystique* of geographic influence on style are usually built on flimsily constructed rationalizations. Many parts of Japan are very much like those of the Pacific Northwest, but any connection between the primitive or modern art styles of the two areas is either nonexistent or the result of direct exposure to works of art from the other environment. As every competent art critic or historian knows, art proceeds from art, not from observation of nature and even less from environment.

Since the individual and, after him, the school may have a style, we can expect the larger social bodies, particularly those more coherent groups we call societies or cultures, to present us with works of art which may have common properties of style. These in turn influence others produced by the social order and form an Egyptian style, a Far Eastern (Chinese, Korean, and Japanese) style, a modern Western style. Within the society, variations or even aberrations may appear, but general, shared characteristics can be found. In some tightly knit, conservative societies, a general style may continue with minor variations or developments through long periods of time. Thus we can speak of the successive Egyptian styles of the Old, Middle, and New Kingdoms. Within the framework "Ancient Egypt," the relatively subtle variations assume a significance which may well disappear when one compares Ancient Egyptian style with Chinese Bronze Age style.

The largest divisions of style are associated with giant cultures which comprise numerous lesser groupings. It is possible to discuss meaningfully a Western and a Far Eastern style, but it must be done in the most

3

general terms. Their generality need not impair their significance. If we follow the course of Western art with particular attention to such accepted divisions as Classical, Late Medieval, Renaissance, Baroque, and Modern (pre-1900), it is quite clear that there are certain basic assumptions affecting our concept of an Occidental style. Experimentation and innovation lead to more rapid changes in Western styles than in those of the more traditional Far East, hence the greater variety in appearance of Western art.

The Renaissance artists of the West, like the humanists and early scientists with whom they were often closely related, were much concerned with the conquest of the appearances of nature, including man. Realism at various levels of accomplishment has been characteristic of Western style, particularly with regard to the representation of naturally articulated objects and figures in suggested space. While this has been accomplished by ever more sophisticated conventions or acceptable visual substitutes for reality,[3] the substitutes of the Far East appear more conventional than Western ones since they are derived from contemplation—rather than observation—of nature, and from the identity of the tool of painting with that of calligraphy, the brush. This leads to a kind of double conventionality which emphasizes calligraphic signs for objects in nature, type forms that stand for foliage, water, trees, rocks, or mountains. The lack of interest in objectively perceived space on the part of the Far Eastern painter produced works which ignore the continuity of space from foreground to distant horizon, so that even the composition or framework of a landscape is more conventional than that in most Western art. This statement does not imply that, within each cultural context, some Western works are not more conventional than others and hence more "Oriental"; or that there are not some Chinese or Japanese paintings, particularly of later date, which show some continuous reality in space related to that achieved in the West.

The Western tendency to model figures in light and shade to imply roundness and mass represents a degree of realism; in the East painters usually suggest these properties by line and its implied movement. Color tends to be flatter, more uniform, and arbitrary in Far Eastern art than in that of the European tradition, qualities that are sometimes described as decorative rather than functional. To achieve its ends the West developed a most complex technique of painting, culminating in the use of oils and varnishes which could be superimposed to symbolize the subtle variations of tone and hue observed in nature. The Far Eastern painter worked as much in monochrome ink as in color, a technique principally used in Europe for preliminary drawings or studies of specialized aspects of a projected work.

Enough has been suggested to make the reader aware of style and of contrasts in Eastern and Western styles. We must now consider another style type, one that cuts across time and space, for it is based on certain social and aesthetic assumptions common to widely separated periods and cultures—decorative style. So, to the described usages of the word style we can add another—the description of a manner within the specialized world of art divorced from a social context. Thus the Realistic style of Caravaggio or Courbet, the Idealistic style of Poussin or Seurat—or Decorative style.

All works of art have decorative elements. Embellishment or decoration is added to the bare bones of a concept to make it more attractive, to add those aesthetic elements that make a painting, in Delacroix' well-

4

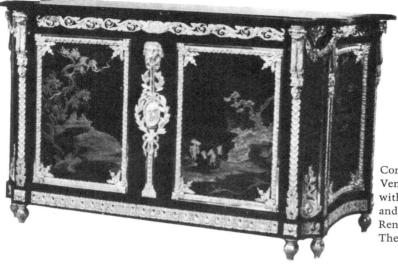

Commode, ca. 1770.
Veneered ebony
with Japanese lacquer panels
and ormolu mounts.
René Dubois, French (Paris)
The Cleveland Museum of Art

chosen phrase, "a feast for the eye." Perhaps the greatest examples of such decorative styles are those of International Gothicism; of the Rococo, particularly derived from France in the eighteenth century; of Islamic culture, particularly in Spain and the Near East; and of Japan in the Heian, Momoyama, and Edo periods. For a Puritan, decorative might well be a derogatory adjective. Pleasure has often been suspect among us, but great decorative art exists on just such a plane, to please, to charm, to give pleasure and delight. Since these are luxuries beyond the scrabbling-ground of creature comfort, decorative style has usually been produced for a leisured group in a developed society which could afford it. By affinity, and not coincidence, a French cabinet maker such as Dubois (1737–1799) combined gold and silver lacquered panels from a then exotic Japanese chest with the decorative materials of his own tradition—ebony and gilt bronze (ormolu). The formal balance of the composition reflects the West, as do the re-alistically modeled mask, and the leaf and petal motifs derived from classical antiquity. The dark brown-black lacquer panels fit the over-all conception because of their gold and silver. But their asymmetrical composition, non-realistic foliage, and foregrounds irregularly sprinkled with small gold and silver squares represent another decorative style, an original Japanese contribution.

Perhaps we can best understand this style by seeing its place in the general context of Far Eastern painting, particularly in a comparison of Japanese and Chinese paintings of the same subject. Here the similarities are dominant and our most significant clues are to be found in those nuances of the Japanese painting which, like the significant slips of a Freudian analysis, reveal the innermost workings of the artist's native style while, at the same time, he is trying to impress us with his mastery of a Chinese manner. In this analysis the subjects—tiger and dragon —are so characteristically Far Eastern as to disarm us if we are not on guard.

The Chinese abbot-painter Mu Ch'i (active until about 1279) makes a serious, even rational proposition within the misty ambience we Westerners mistakenly assume to be romantic. His brushwork is assimilated into the very structure of the tiger whose furry exterior is as baggy and relaxed as that of the real animal. His tiger possesses a reality, a power, and a presence that dominate the suggested windy and rainswept environment of the hanging scroll. Means and ends are merged in an image of the highest seriousness. Sesson's tiger, perhaps directly based on this particular painting attributed to Mu Ch'i, inhabits a world of aesthetic awareness. Sesson's brushwork has become an end in itself, producing a playfulness that amuses and delights us. His swelling rhythms, staccato brush notes, and sheets of rain seem more carefully, even cunningly, disposed. Comparison of the dragons by the two artists further confirms the impression made by the tigers. Mu Ch'i's dragon rests quietly, with an inner, almost throbbing, power—full of capability. The waves below him are subsidiary and natural—water and foam above all else. Sesson's beast strides and twists his way through carefully controlled patterns of water and vapor. The waves in the Japanese painting are particularly significant for they are arranged in graceful and rhythmically repetitive reflex curves, primarily decorative shapes, and only secondarily water and foam.

In short, despite their fundamental similarities when compared with Western art, these particular paintings by Mu Ch'i and

Details from *Tiger* and *Dragon*
a pair of six-fold screens by Sesson.
See also Figure 47, pages 50–51.

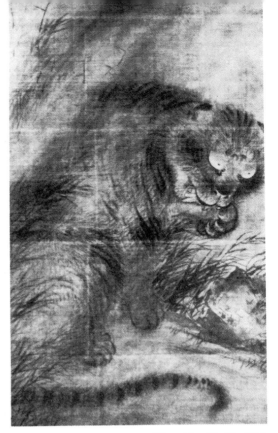

Tiger (detail), Mu Ch'i,
The Cleveland Museum of Art

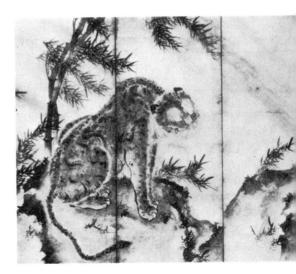

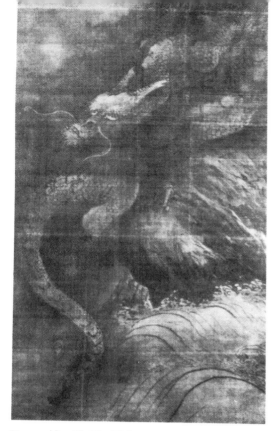

Dragon (detail), Mu Ch'i,
The Cleveland Museum of Art

Sesson reveal striking differences which place the Japanese works as more consciously aesthetic and decorative, products of a confident and conscious exercise of taste. What might the Japanese artist produce when he was not absorbed by both Chinese imagery and Chinese style?

The popular image of Japanese art as mimicry of its more ancient and advanced neighbor's art was never a valid generalization. That China often provided impetus and inspiration not even the most ardent Japanophile would deny. The traditional theory of alternating waves of Chinese influence and troughs of Japanese assimilation is certainly nearer a truth, but we must recognize additional waves of intense creativity when the Japanese made contributions as original and significant, if of a different order, as those made by the Chinese. Nationalistic critical efforts have attempted to isolate the uniquely "Japanese" qualities of the islands' art: loyalty and patriotism, purity and cleanliness, gracefulness and quietness, valor and activity, fatalism, intuition, sensitivity, love of nature, dexterity, simplicity, reticence, *shibumi* (subdued and unpretentious) as embodied in *sabi* (aged, lacking the aggressiveness of the new), and *wabi* (the same concept applied to architecture).[4] An objective study of the range of any art might well find such qualities, but certainly Japanese art reveals numerous works and schools which display none of these qualities, all encompassing as they seem to be. Many of these aberrations are the result of too much tea; and the tea ceremony is not the only historical expression of Japanese culture.

One very general characteristic of Japanese culture and art—a tendency to rather wild extremes of behaviour and appearance —has been remarked by many.[5] Movie buffs

have on occasion been puzzled by such masterpieces of the cinema art as *Rashomon, The Magnificent Seven,* and *Gate of Hell.* Where was legendary restraint and innate grace? Whence this melodramatic gnashing-of-teeth and violence? These extremes of wave and trough seem to be especially marked in Japanese art, particularly in its most creative aspects when it is most itself. The most marked periods of Chinese dominance, Buddhist art of the seventh through the tenth century, the monochrome painting and tea arts of the fourteenth through the sixteenth century, and the literary painting schools of the eigtheenth and nineteenth centuries, are periods of greatness within Far Eastern international styles formed by Chinese moderation. At other times the Japanese make their original contributions at the two extremes of a realistic, even caricature-like, narrative style[6] or of a consciously refined decorative style.

This original style, quite unique in the Far East, is composed of certain forms and combinations repeated with subtle and seemingly infinite variation. Like other decorative styles, it relies heavily on the use of precious materials, particularly gold and silver, in juxtaposition with pure color. Its basic compositional devices are markedly asymmetrical, unlike so much of the decorative art of China, and very much like the modes of European *art nouveau.* Indeed, some of the assumptions of this particular early twentieth-century Western style owe much to Japanese influence. Within the asymmetry characteristic of Japanese decorative style we find a thorough use of patterning, both in the arbitrary use of cut or sprinkled gold and in the exploitation of textile patterns in represented costumes, as in the paintings of Vuillard. Motifs, or more prosaically, decorative units, were used al-

most as if they were interchangeable parts from a pattern book. Aesthetic importance rested in their tasteful arrangement in carefully adjusted relationships. Space is minimized in the style, emphasis being placed on flat, plain or patterned, shapes that reinforce the flat surface of the painting or object. The motifs are relatively limited in number and are repeated again and again in different media, in varying sub-styles, and over a long period of time. Significantly, they have strong literary connotations of a particularly aristocratic and esoteric type, derived from such traditionally hallowed masterpieces as the *Genji Monogatari* by Lady Murasaki (d. 1031?),[7] or the loosely organized combinations of narrative and poetry in the *Isé Monogatari.*[8] Like some of the decorative art of the *dix-huitième siècle,* one had to be cleverly literate to extract the full pleasure of nostalgic literary remembrance from the equally sweet but more evident visual pleasures of the decorative style. Finally, this style was applied to the whole range of Japanese art materials and techniques: painting, some sculptures, ceramics, lacquer, textiles, sword fittings, and many others. It is not a technical manner but a style. Perhaps its most important product is among the most conspicuously decorative works ever produced—the folding screen, a movable and flexible wall of dubious utilitarian value, but perhaps the most significant creation of this Japanese decorative style.

To see and understand this aspect of Japanese art, and its variations and development, we must follow the style from its appearance in the predominantly Buddhist art of the Heian period to the nineteenth century when stresses from the western world put an effective period to the traditional arts of Japan.

CHAPTER TWO

Decorative elements in the Buddhist art of the Heian Period

Despite their use as objects of decoration by contemporary minded Japanese and Westerners, the "primitive" products of pre-Buddhist Japan (before 552) do not reveal either a primarily decorative aim or a demonstrable relationship to later sophisticated Japanese art. The essence of early art, culminating in the Haniwa culture (200–552), was ancestor to a continuing tradition of folk art, just as the native Shinto faith continued as a common leaven[9] of craft and low culture even though it was formally displaced in the high intellectual tradition by Buddhism imported from China.

With the new religion came a new urban and ultra-sophisticated culture, that of China in the late Six Dynasties period, and the Sui and T'ang Dynasties. It would be difficult to exaggerate the extent of Chinese influence in Japan during the seventh and eighth centuries. Chinese and Korean artists immigrated to the islands, works of art were imported, city plans copied, court protocol imitated, law and administration remodeled, all in the Chinese image. And the imitation was not mere mimicry, for if one compares the finest Japanese Buddhist images of the Asuka and Nara periods with the few remaining Chinese counterparts, they do not suffer.

Naturally, many of the Japanese works of this time were beautifully decorated with stylized floral, bird | 1 |, animal, and figure designs of an opulence that mirrored the great T'ang international culture. The Shōsoin (dedicated in 756), miraculously still standing with almost all of its Imperial Household gifts of that year intact, is an incredibly rich storehouse of Japanese and Chinese decorative arts—but all in the T'ang style, or more rarely mirroring Near Eastern art. These objects are essential for the study of Chinese art and the art of the Nara period

1 | Ornamental Tile, with phoenix

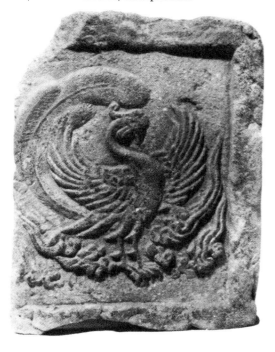

9

摩訶僧祇律卷第三

復次佛住王舍城廣說如上諸沙王先祖時

治罪人法有作賊者以手指頭以為嚴教賊

大慚愧與死无異後更不作至祖王時治罪

人法有作賊者以灰圍之須臾放去賊大慚

愧與死无異後更不作至父王時治罪人法

有作賊者駈令出城賊自慚愧與死无異後

更不作況沙王法有作賊者駈令出國以是

為教時有一賊七反駈出猶故來還却教村

2 | *Canon Law of the Great Order*, hand scroll

in Japan. They are not part of the main stream of Japanese decorative style, although they did provide a beginning vocabulary for the first essays in native development during the Heian period.

The extant works of the first half of this important period of native resurgence are almost completely non-secular, partly through the historical accident of use and normal destruction of domestic artifacts and partly because of the dominantly religious tone of the times. The esoteric and theologically complex Buddhism of the Shingon and Tendai sects absorbed the efforts of wealth and artistry in architecture, sculpture, painting, and the "minor arts." The decoration, or better still, the ornamentation, of religious objects was enormously rich and costly but served to glorify deity, please the discerning eye, and impress the crude on-looker. The sutras of the Kegon sect of Shingon Buddhism contained detailed descriptions of the various Paradises—the faithful were heir to their heavily jeweled trees, many-hued flowers, heavenly scents, and other forms of sensuous imagery. These literary

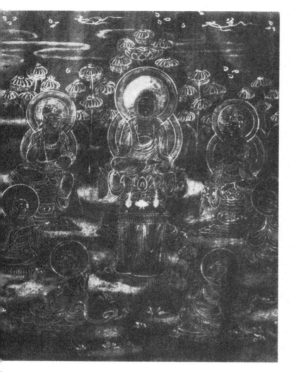

Further Discourses on the Supreme Truth (detail), hand scroll

3 a | *Further Discourses on the Supreme Truth* (detail)

descriptions were translated into decoration of precious metals, gold, silver, and mother-of-pearl in all products of religious art. The sacred texts were often written in gold and silver on deep blue paper with decorated end papers |2, 3|, the inside picture representing a holy scene in iconic form. The exterior end paper, with the sutra title, displayed floral decoration in curling arabesques which still recalled T'ang Chinese motifs |3 a|. The figural panels reveal abstract abbreviations and decorative stylizations in such significant details as the extremely simplified notations for facial features and the rolling, repetitive rhythms of the rocks and mountains derived from the more rational conventions of Chinese painting. The somewhat rigid symmetry of the compositions is still in thrall to earlier iconic dispositions. Sumptuous color also played its part in the decoration of sutras, as in the classic example of those dedicated by the Taira clan and kept at the Shintō shrine of Itsukushima.[10] The end papers of these beautifully preserved sutras are nominally religious devotional scenes but executed in the

4 | Sutra Cover

new Yamato-e style we shall consider in the next chapter.

The decorated sutra was protected by skillfully woven covers of split bamboo and cloth |4| which were in turn decorated, using techniques and motifs derived from the Chinese-influenced Nara period. In Figure 4 the gilt copper clasp and corner braces are shaped to represent stylized butterflies, suggesting the transitory nature of the material world. This motif, much enlarged

5 | Cover for a Sutra Box

from its usual representation in T'ang and Nara art, is one of a number of specific decorative units which assume particular importance in the aesthetic vocabulary of the Heian period (see also Figure 13, page 19). The covered sutra was further protected and stored in a sutra box, often decorated with gold and silver lacquer | 5, 6 | or with applied ornaments of gilt copper or bronze | 7 |. These, too, use the same conservative decorative techniques though the develop-

ment of gold lacquer (*maki-e*) was probably a specifically Japanese contribution. The Ninna-ji type | 5 | uses various motifs derived from representations of Paradise, lotus, falling petals and flowers, clouds, birds, and Buddhist bird-angels *(Karyōbinga),* in addition to two small seated Buddha images. Evidence of decorative domination is to be found in the balanced aesthetic equation around the central lotus on the cover—bird-angels = Buddha—certainly not a balanced

13

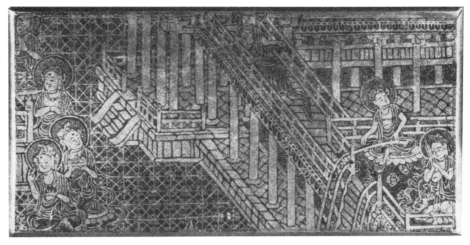

6 | Fragment mounted as a Box Cover

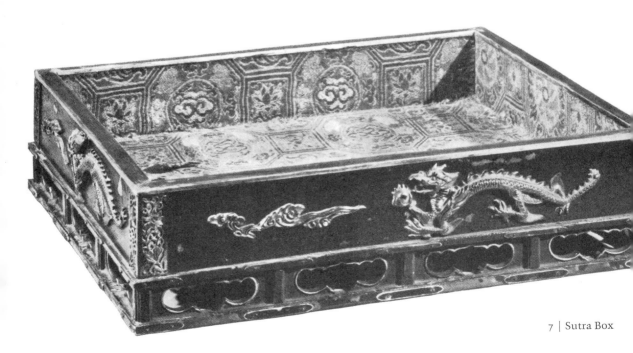

7 | Sutra Box

theological statement. The flower, cloud, and bird motifs will reappear as secular decorative elements in their own right.

The lacquer fragment of a large box | 6 |, presumably with a representation of the Western Paradise of Amida (*Amitābha*), is particularly interesting for complex figural decoration in lacquer is rare. The diapered background reveals the influence of another decorative technique much used in early Japanese Buddhist art—cut-gold decoration *(kirikane)*. While this process is known in Chinese sculpture and painting and was probably derived from them, it was particularly favored by Japanese artisans who cunningly elaborated and applied *kirikane* with almost superhuman craftsmanship. (Figure 8 is a later example.)

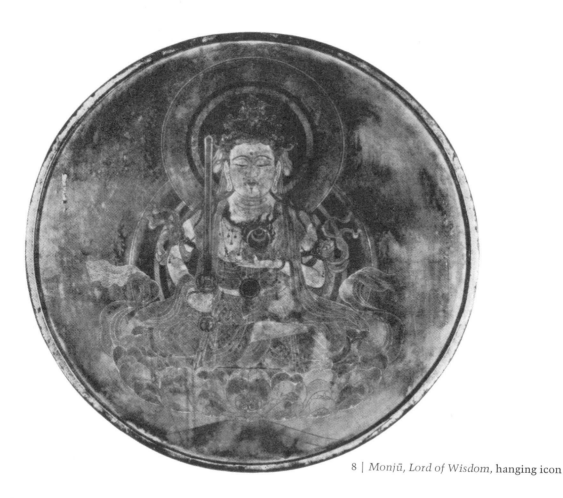

8 | *Monjū, Lord of Wisdom,* hanging icon

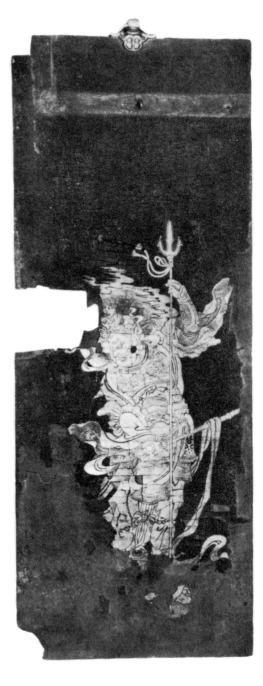

LEFT TO RIGHT
9 | Shrine Panel, with trident-bearing Bishamonten
10 | Shrine Panel, with lotus and calligraphy
11 | Shrine Panel, with lotus and calligraphy

The decorative development of gold-lac-
quered containers for Buddhist objects ex-
tended to tabernacles for images | 9, 10, 11 |.
The panel with a representation of Bisha-
monten, the Guardian King of the North,
is in effect a painted icon in gold; but the
other two panels show elements of the first
purely Japanese decorative style more read-
ily seen in semi-secular and secular objects
of the same time (see Figure 35, page 40). The
inscriptions are religious in content and sen-
timent and the lotus are traditional symbols
of rebirth. While they are not unlike certain
Chinese flower paintings of the late T'ang
and Five Dynasties period, the gold lacquer
technique, the modified symmetry of the
balanced lotus groups, and particularly the
gracefully rhythmical water convention,
seem more peculiarly Japanese. The ripples
are another of the numerous type represen-
tations that were isolated and used as stock
decorative motifs in numerous media for
various uses (see Figure 42, page 45, and
Figure 140, following page 118).

16

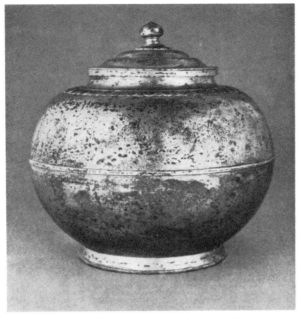

12 | Covered Cinerary Jar

Gilt bronze vessels and implements were also subject to decorative development. One of the rarest and most interesting of these is a covered jar probably used as a cinerary urn for the ashes of an important priest-aristocrat | 12 |. Its richly gilded surface is ornamented with a precisely and delicately incised design representing the Western Paradise in the upper register and a fanciful earthly realm in the lower. One progresses from the still T'ang shape of the jar, through the more or less traditional representation of the cloud-borne palaces and pagodas of the blessed with the adoration of Amida as the main subject, to the more arbitrarily arranged motifs below. The two registers are intended to be seen as one scene, judging from the clouds reaching into the lower register. In the latter, the motifs seem to be

12 a | Detail from Figure 12 showing its incised design

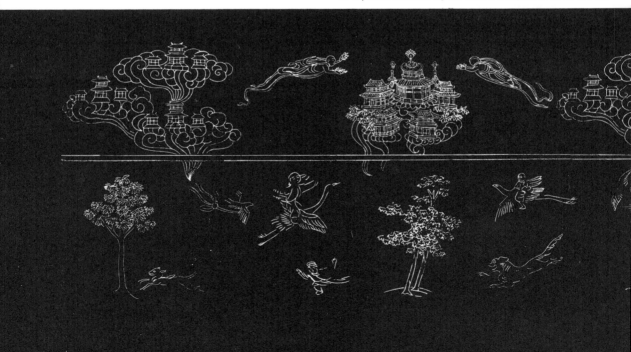

isolated and carefully deployed with a rough symmetry oriented to the paired triple-leaved trees. The apparently playful running tiger, the mounted lions and cranes, and other units go back to T'ang-style decoration on objects preserved in the Shōsōin; but the dominant impression is of the additive disposition of single motifs. Such a decorative schema is intermediate between the either completely pictorial or heraldic symmetry of earlier decoration and the quite arbitrary asymmetrical decoration often used in the fully developed Late Heian style. The alms bowl | 13 | is a further development from the cinerary urn in its lack of specifically figural religious ornament, and its magnification of the ancillary butterfly and floral designs, obviously to offer decorative pleasure.

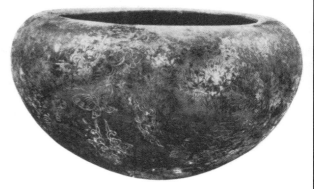

13 | Alms Bowl, with flowers and butterflies

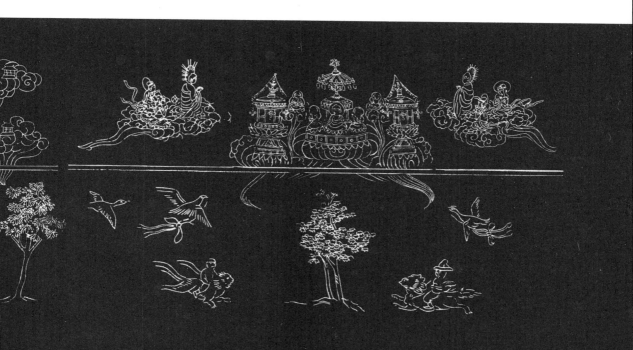

14 | Flower Tray, with floral arabesques

16 | Hanging Ornament, with music-playing *Apsara*

15 | Hanging Ornament,
with two phoenixes

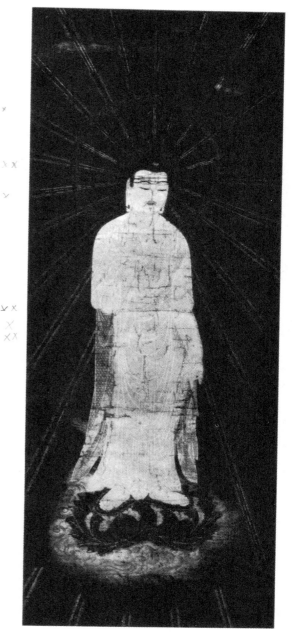

Pierced metal objects | 14, 15 |, used to enrich the environment of the altar, retain the Buddhist decorative designs we have already seen on the end papers of contemporaneous sutras. The *Keman* | 15 |, a kind of fan-shaped hanging, is not only especially beautiful and complex but also possesses an additional subtlety—a metaphor of materials —for the silvered and gilt hanging bow-knot simulates a plaited silken cord. Other *Keman* | 16 |, in less luxurious times, were made of carved and pierced wood, gilded in part to simulate metal, but enriched by color and *kirikane.* This carved wood technique was to be used much later in purely decorative architectural panels.

The principal products of Heian religious art, painted and sculptured icons, are somewhat less revealing in this way than the decorative arts. Still, some of their details and techniques are comparable to these tendencies. The esoteric icons | 17 | are usually severe and rational in their over-all organization and suggested tone. Only in the rich coloring and particularly in the *kirikane* decoration is there a conscious effort to delight the senses. The combination is awesome in its splendor, especially in such early hanging scrolls where the *kirikane* is boldly applied in large and simple patterns. Later examples are increasingly complex and delicate until the time-saving use of painted or stenciled gold became necessary. The resulting ease of application finally leads to unimaginative repetitiveness from the fourteenth century on.

18 | *Benten Playing on a Biwa,* hanging scroll

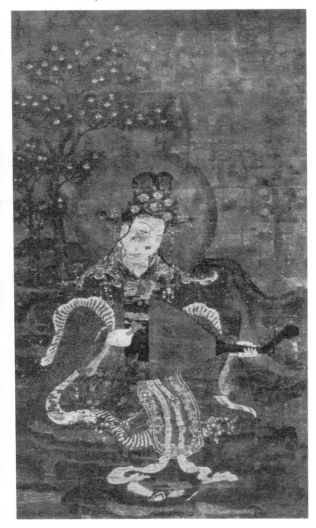

Secondary images, such as the hanging scroll representing Benten, patroness of music | 18 |, may have a more informal composition and character. In this case, the flowery tree and rolling hummocks recall the aesthetic vocabulary of the blue paper sutras (see Figures 2 and 3, pages 10 and 11) or the cinerary urn (see Figure 12, page 18). The physically plump face and figure, like the shape of the urn, is derived from T'ang China.

Painted representations of the Western Paradise, whether of Heian date or tradition (Figure 19 is a thirteenth-century example), afforded natural outlets for decorative intentions. Silver and gold, blue azurite, and green malachite pigments enrich the upper register of Paradise, while below only color and ink are used. But in this lower world of the senses one still delights in the flowery trees and undulating hummocks we have seen before. And the scenes of entertainment, love, and death use conventions of drapery and figure against arbitrary architecture in a full *Yamato-e* (literally, Japanese picture) style whose origins in the late Heian period will be considered in the following chapter. The same mixture of the fash-

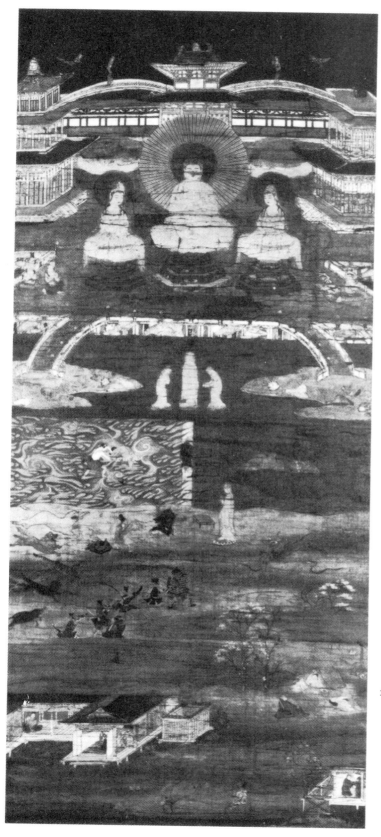

19 | *The White Path to the Western Paradise across Two Rivers,* hanging scroll

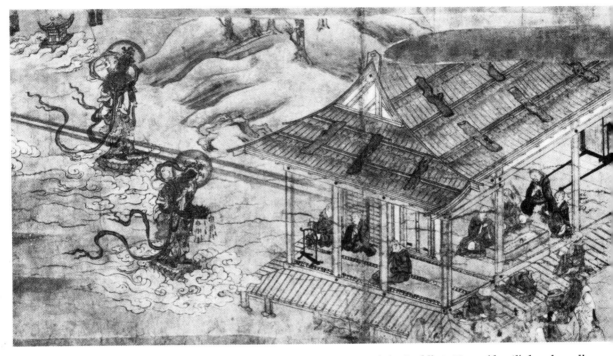

20 | *The History of the Yūzū Invocation of the Buddha's Name* (detail), hand scroll

ionably new secular style with traditional early Heian religious splendor can be found in the earliest (early fourteenth century) of known hand scrolls | 20 | giving the history and merits of one of the important Kamakura Amida sects—Nembutsu—where the constant repetition of the holy name sufficed to guarantee entry to the Western Paradise. The gold decorated Bodhisattvas coming down to receive the soul of the Nembutsu sect's founder, Priest Ryōnin, are among the last still convincing statements of earlier Heian piety and gorgeousness. But

20a | *The History of the Yūzū Invocation of the Buddha's Name* (detail), hand scroll

the narrative scenes, particularly where the court ladies are represented |20a|, reveal delight in sprinkled rectangles of gold and silver, angular and arbitrary drapery, and poignant chords of shaded color. This is the sweet, new style of Yamato-e, by this time already about two hundred years old.[11]

All of these Buddhist works reveal a homogeneous decorative manner ultimately derived from the T'ang international style. A subtle development toward a Japanese flavor can be discerned in the series. Such precious objects were produced by a well patronized professional artisan class for priests and aristocracy. The boundaries between the latter two classes were by no means well marked, for the custom of high-born lords and ladies taking holy orders was increasingly common. Perhaps the rising delight in a still-emerging decorative style can be attributed to the influence of the aristocracy for it is certain that the secular works of art commissioned specifically by them in the later Heian period represent the flowering of a "lovely" and "up-to-date"[12] new decorative style.

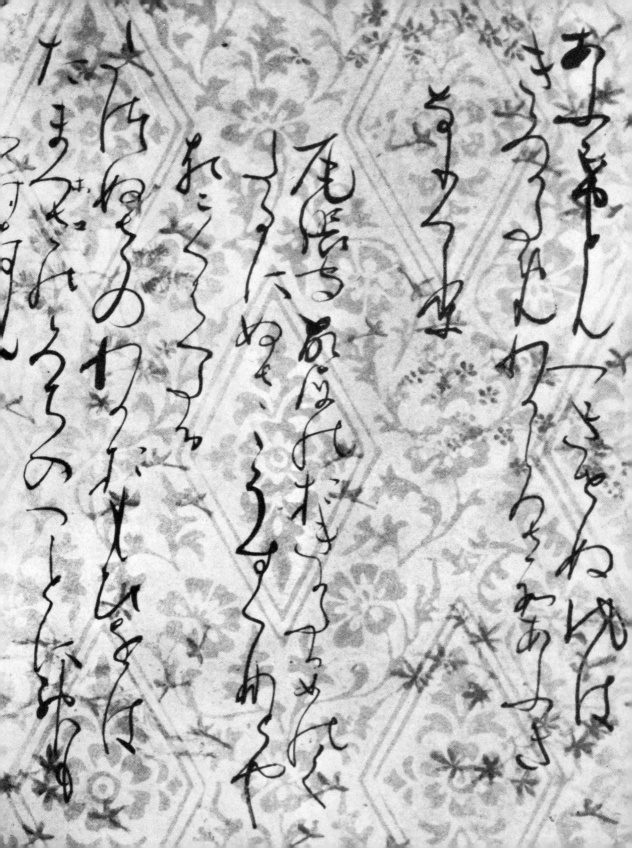

Perhaps the poem written on decorated paper is our best introduction to the new mode of the later Heian period | 21 |. Even one not versed in the language senses a radical change from such calligraphy as that on the Buddhist sutras (see Figures 2 and 3, pages 10 and 11).

The visual impression is one of an elegance and refinement produced consciously, and admired for its pleasing effect against the more rigid lozenge and floral pattern of the decorated ground. This impression is confirmed by cultural analysis. Where the sutras are written in purely Chinese characters, conceptual and architectonic ideographs, the sounds of the poem are conveyed by a mixture of drastically abbreviated Chinese characters with newly invented Japanese phonetic signs called *hiragana*. These *hiragana* became a half-accepted means of writing in the ninth century, half accepted because they were principally used by the ladies of the court (another name for *hiragana* was *onnade* or female hand) rather than by the men who formally continued to use the more difficult logic of the system appropriated from the mainland.[13] Knowing this we can openly express one of the first descriptive words that occurs on viewing the page—feminine. It is no coincidence that three of the most interesting works of Heian literary art are by women, the *Tale of Genji* and the *Diary* of Lady Murasaki, (c. 975–c. 1025) and the *Pillow Book* of Sei Shōnagon (active c. 1002).[14]

The dominantly Chinese and Buddhist culture of the seventh through the ninth century, with its accompanying strong central authority of the Emperor, was succeeded by a Japanese culture purposefully isolated from now troubled China and dominated by a sophisticated aristocracy centered in Kyōto. Control was exercised

CHAPTER THREE

Yamato-e: the first flowering of Japanese decorative style

through almost powerless Emperors by the Fujiwara clan. This complex and well-ordered society continued its Buddhist worship, but with a sadder and less evangelical air. Family and clan connections were all important and the virtuous Chinese-type scholar-administrator all but forgotten. Power was wielded by indirection, ceremony was dominant, and peaceful leisure permitted the indulgence of a highly refined hedonism. All aspects of life conformed to an aesthetic pattern, broken only in some masculine gatherings by common consent, or by boorish individuals. One could almost characterize the ethos with the words of a modern French aristocrat, Antoine de St. Exupéry, "What I value is a certain arrangement of things."[15]

Very close to this attitude is the Japanese ideal of *mono no aware o shiru*, "to understand and indulge in the emotional appeal of objects to the human heart." "*Mono no aware* is the spirit of *aware* (nostalgic emotionalism) discovered in *mono* (things, objects). It is an ideal world discovered in

27

| *Poems* by Ki no Tsurayuki, page of calligraphy (enlarged)

It was a morning when mist lay heavy over the garden. After being many times aroused Genji at last came out of Rokyjo's room, looking very cross and sleepy. One of the maids lifted part of the folding-shutter, seeming to invite her mistress to watch the prince's departure. Rokyjo pulled aside the bed-curtains and tossing her hair back over her shoulders looked out into the garden. So many lovely flowers were growing in the borders that Genji halted for a while to enjoy them. How beautiful he looked standing there, she thought. As he was nearing the portico the maid who had opened the shutters came and walked by his side. She wore a light green skirt exquisitely matched to the season and place; it was so hung as to show to great advantage the grace and suppleness of her stride. Genji looked round at her. 'Let us sit down for a minute on the railing here in the corner,' he said. 'She seems very shy' he thought, 'but how charmingly her hair falls about her shoulders,' and he recited the poem: 'Though I would not be thought to wander heedlessly from flower to flower, yet this morning's pale convolvulus I fain would pluck!' As he said the lines he took her hand and she answered with practiced ease: 'You hasten, I observe, to admire the morning flowers while the mist still lies about them,' thus parrying the compliment by a verse which might be understood either in a personal or general sense. At this moment a very elegant page wearing the most bewitching baggy trousers came among the flowers brushing the dew as he walked, and began to pick a bunch of the convolvuli. Genji longed to paint the scene.[17]

the objects as they are. We might also say that it is the world of sentiments which is discovered in the harmony between the heart (mind) and the form of the objects. Motoori Norinaga (1730–1801) considered *mono no aware* to be the keynote of the *Genji Monogatari* and the essence of the literature of the Heian period. It is not the primitive emotionalism which is to be found in the literature of ancient times, but a stage at which that emotionalism has been refined to the utmost. From an etymological point of view *aware* has not the meaning of sadness, but it is the emotion of saying 'Oh!,' common to occasions of grief as well as occasions of joy..." (Hisamatsu Sen'ichi).[16]

But almost any passage from the *Tale of Genji* conveys the flavor of this Fujiwara way of life with greater effectiveness than chapters of exposition (above). Color, intrigue, sensualism, quickness—all are woven into a fabric as silkily decorative as that of Fujiwara society and the new Japanese art style it created.

Where before the most creative works were produced for purely religious purposes with originality emerging in the minor arts, now the icons perpetuated old ways, and secular painting and objects were vehicles of the most original contributions. The most beautiful and significant work of the period is the scroll, traditionally attributed to Takayoshi, illustrating Lady Murasaki's already classic *Tale of Genji (Genji Monogatari)*.[18] The scroll was laid out as a text alternating with pictures. The sections probably by Takayoshi stand as the greatest accomplishment of the new Yamato-e style | 22 |.[19]

The basic components of the style, presented at a less exalted level, are common to most of the secular and even religious narrative paintings produced by the artists patronized by the Kyoto aristocracy. The compositional devices depend upon use of all the available space from the bottom to the top edges of the scroll. Horizon lines are almost nonexistent for the painters wished to decorate the entire surface, even suggest-

22 | Second illustration to the Azumaya chapter of the *Genji Monogatari*, hand scroll

ing movements beyond the horizontal boundaries of the paper. Arbitrarily placed cloud-bands, originally derived from T'ang painting, are used inside as well as outside of rooms, as boundaries or ties between adjacent areas. Architecture is treated most arbitrarily. The roofs of houses are removed to permit a partial bird's-eye view of the interiors. Diagonals of screens, shutters, walls, mats, or flooring create dominant patterns and directional movements.

Pattern is exploited to the utmost, from the large framework organizations to the most detailed and complex utilization of textile designs. Sudden little vignettes of decoratively arranged nature or of representations on painted screens vary the dominance of more arbitrary patterns. The pure colors, mauve, malachite, azurite, cinnabar, and red lead, are carefully applied with emphasis on their flat decorative quality. The hues are juxtaposed with subtle sweetness occasionally modified by tart combinations. Gold and silver, in powder or cut shapes,

are sprinkled on the calligraphic sections, written in the cursive Japanese manner.

The figures inhabiting this artificial world conform to their environment; they are a part of the decorative life. Heavily draped in patterned silks, brocades, or gauzes made stiff with starch and lacquer, they are like charming puppets whose idealized doll-like faces peep out from the masses of drapery, the long black tresses of the ladies, or the formal, almost grotesque headgear of the gentlemen. They are rarely agitated, never individualized. Such illustrative effects as exist are produced by the over-all tone of the picture, sadly quiet or gay and sprightly. Above all the Yamato-e style beguiles and charms. In the words of Lady Murasaki, "dazzling to the eyes in its modernity and gayety."

The doll-like appearance of the figures may well derive from feminine dominance of the arts of leisure. All ladies painted, some skillfully. Competitions, open to men and women alike, were fashionable and involved

There are painters in Japan, but we do not know their names. Their works portray the natural objects, landscapes, and intimate scenes of their own country. Their pigments are laid on very thick, and they make much use of gold and jade color. Study shows that they are not necessarily truthful; they are meant to make a brilliant display by their bright colors, and to win admiration for their beauty. But though one may commend the pictorial method for its ability to express the purpose—for the way it shows the people and customs of a foreign land in an unfamiliar quarter, a country which is rude and out of the way, uncivilized, lacking ceremonies and propriety—how can one evaluate their skill or awkwardness any more closely, when we think of the cultural splendors of China, which have been attained over so long a period?[20]

comparisons of works painted by professionals or by the participants. Papier-mâché and other kinds of dolls with silken costumes were common and one of the Fujiwara period is still to be seen in the nunnery, Hōkke-ji, at Nara. Such "motifs" were readily available and may well have been a major source for Yamato-e figure types.

This style shows its homogeneity when contrasted with the almost caricature-like realistic and narrative manner which became dominant in the succeeding Kamakura period and which is evident in parts of the *Yūzū nembutsu engi*. This latter style, which we can term *e-maki* (picture-scroll), was non-aristocratic. It was derived from off-hand sketches and caricatures of professional painters, and can be described as a low tradition, popular with the rising provincial warrior classes and the commoners. It stands in opposition to Yamato-e, a part of another extreme of the Japanese artistic genius.

24 | *The Thirty-Six Immortal Poets* (detail), hand scroll

Soper has cited a particularly revealing contemporary Chinese opinion of Yamato-e (left), one whose morality and intellectual rigor provides a significant contrast to the standards of Lady Murasaki.

The importance of a total aesthetic arrangement of life is evident in a particularly Japanese subject—*Sanjuroku Kasen: The Thirty-six Immortal Poets.* This combination of literary content, calligraphy, decorative costume, and painting originated in the Fujiwara court and became a traditional Yamato-e subject. Again we are conscious of a motif, the angular draped figure, isolated from a context like the *Genji Monogatari,* and disposed with calculated sensibility. These are not portraits, but ideal types, even decorative signs. The earliest examples extant date from the early thirteenth century and are usually richly colored | 23, following page 54 | while the later paintings often present the shapes and patterns in ink alone, or with only slight color | 24 |. The album sheet format, which coexisted with the handscroll versions of the thirty-six poets in the twelfth and early thirteenth centuries, became the dominant format for this particular subject. This may be attributed to the growing dominance of the narrative hand scroll with a continuous picture painted in the *e-maki* style. Since the poets with their poems were single units, and since the book-album format was a particular favorite with the court ladies, the abandonment of the hand scroll in this instance is understandable.

One detail | 24 |, showing the poetess Isé (died 939), provides a specialized and exaggerated instance of the Yamato-e love for gay and clever pattern. Other examples go further and the head of the lady is sometimes completely hidden by the draperies. The three poems from the leaf | 25 | "showing" Mibu-no-Tadaminé (died 965) are perfect examples of the sweet sadness that pervades much of Yamato-e.

25 | *Ideal Portrait of Mibu no Tadaminé,* album leaf

As if to herald
The arrival of spring
The mountain of Miyoshino
In the mist enveloped
This morning appears.

More than a dream
The thing that fleets
Is the hour of parting
When the dawn
Ends the summer night.

Since we parted —
My lover cold and unfeeling
Like the morning moon then shining —
Nothing gives me more pain
Than the daybreak.
 Tr. Kojiro Tomita

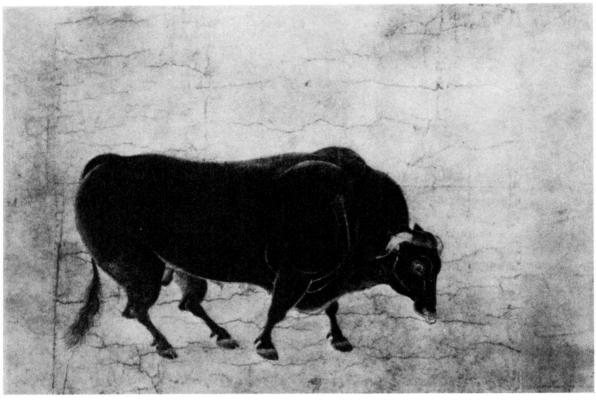

26 | *One of the Ten Fast Bulls,* section of a hand scroll

One might think that animal portraits would hardly be susceptible to decorative treatment. The very idea of portraying the most famous and fastest bulls and oxen from the various provinces is more a part of the Kamakura interest in realism and portraiture; nevertheless, taste and sensibility triumph in the finished scroll painting |26, 27|, known to us through scattered fragments. A bow to realism is made with

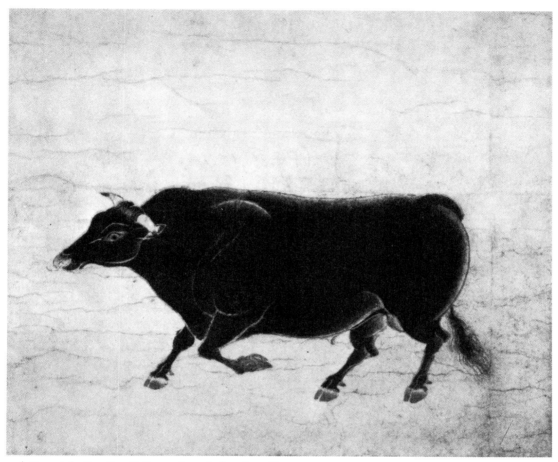

27 | *One of the Ten Fast Bulls,* section of a hand scroll

the faintly shaded edges of the silhouetted shapes, but the impression of power and strength is conveyed by the silhouette a-gainst bare paper. One small detail, the gold wash around the pupils of the eyes, confirms the decorative training of the artist. And when we know further that this scroll in-spired the greatest master of decorative style in the seventeenth century, Sōtatsu, our im-pressions are confirmed by eyes with greater affinities to decorative form than our own.

Numerous details of this kind could be singled out from the narrative scrolls of the Kamakura period. A leisurely study of the *Yūzū nembutsu engi* (see Figure 20, page 24), already mentioned, would show such characteristic decorative motifs, but largely submerged in the realistic and narrative requirements dominant in the thirteenth century.

28 | *Legends of the Kitano Shrine,* fragment of a hand scroll

29 | *Legends of the Kitano Shrine,* fragment of a hand scroll

The Yamato-e style continued under the patronage of the Kyoto aristocracy—and the ladies. A few rare scrolls of favorite Kyoto subjects, *The Pillow Book (Makura-no-Sōshi)*; the *Story of Kitano Shrine (Kitano Tenjin engi)* | 28, 29 |, were executed during the fourteenth century in the now old manner, but without the supporting richness of color. Perhaps these monochrome skeletons of the Yamato-e style were already under the influence of the Chinese monochrome style that was to sweep all before it in the Muromachi period. If so, it is only in their lack of color, for all the other decorative devices are present, if in attenuated form. The traditional attribution of the most famous of these monochrome Yamato-e, *Makura-no-sōshi,* to a Princess Shinko, calls our attention once more to qualities associated with femininity.

The Yamato-e style was as much a landscape as a figurative style. The Takayoshi Genji scrolls depict as accessories several folding screens with landscape decoration. At least one such screen, now kept at Tō-ji in Kyōto, has come down to us.[21] The origins of the screen format are surely Chinese, as witness those still preserved in the Shōsōin. The vocabulary of the landscape, trees, rocks, and hills, is also derived from T'ang China; but the ultimate appearance and flavor are Japanese and decorative. The *Kumano Mandala (mandala,* a religious diagram or chart) is an epitome of the Yamato-e version of landscape which so annoyed the anonymous Chinese critic cited above. Iconographically, this mandala is syncretic, synthesizing Buddhism and Shintoism by representing the three most famous shrines of Kumano, Nachi, Shingu, and Hongu, from top to bottom—with Buddhist deities hovering above them | 30 |. But the aerial view, with its delight in geometric pattern; the

cut-gold *(kirikane)* in the architectural members; the repetitive rhythms of the hills; and the opaque and decorative color, all speak in the gentle and pleasing accents of Yamato-e. One may justly speak of the influence of environment: "Here before his [Genji's] eyes were all those hills and shores of which he had so often dreamed since the day long ago when they had been shown to him from a far-off height."[22] The gently rolling hills of Yamato-e with their graceful, silhouetted pines and colorful autumn foliage helped to produce a decorative landscape painting style; and this in turn formed the foundations of a gardening art, not the least of the decorative achievements of the Japanese.

The Yamato-e style of painting was continued from the fifteenth century by an official court academy called the Tosa school. It traces its genealogy, with typical Japanese concern for station in the social order, to Tosa Mitsunobu (ca. 1430–1523). While its standard products, hand scrolls and albums, are largely of academic and sociological interest, a few folding screens |31| demonstrate how effective the Yamato-e tradition could be when used on a format of growing importance and of the highest significance for the seventeenth-century revival of decorative style. The combination of noble steeds, recalling the aesthetic impact of *The Fast Bulls*, with decorative architectural elements is a bold

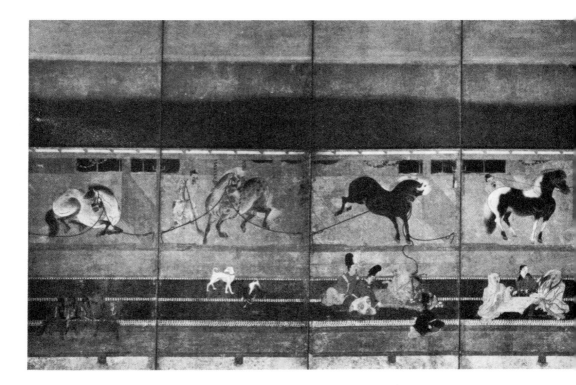

and successful one, even if eclectic and fundamentally conservative.

The Fujiwara decorative style permeated all objects made by art. It would have been unthinkable for a Genji to place his paintings or poems in a plain box, or to use a merely functional mirror |32, 33|.[23] These too must express a thoroughgoing consistency of good and, above all, up-to-date taste. We can see the variety and inventiveness of Fujiwara textile patterns in the smallest details of Yamato-e, though pitifully few original fabrics now remain. The most revealing extant decorated objects are those made of wood, painted, inlaid, but above all, lacquered.

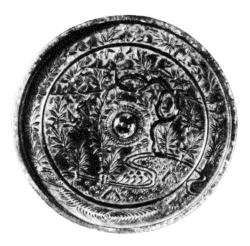

31 | *Horses and Attendants,* six-fold screen

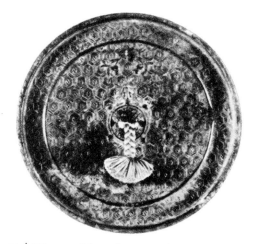

32 | Mirror, with garden scene (top)
33 | Mirror, with tortoise-shaped boss and hexagonal diaper pattern

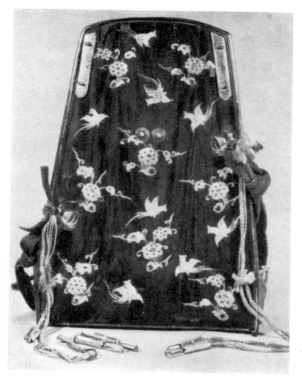

34 | Quiver for arrows.
Front (opposite page) and rear

The decoration of secular objects began conservatively, using techniques and designs inherited from T'ang China through such objects as those preserved in the Shōsō-in. One of the principal techniques was the inlay of sandalwood with mother-of-pearl |34|. The quiver for arrows was an important functional object. One needs only to think of counting the number of arrows flying on the paper of the *e-maki* scrolls depicting famous battles to realize that the bow and arrow, with the sword, was a basic military weapon. More than that it was used in hunting and sports such as *Yabu-same* involving archery from horseback, first recorded, near the time of Lady Murasaki, in 1006. The sword and the bow and arrow were sacred weapons and votive offerings of both were not uncommon. This particular richly inlaid quiver was obviously not designed for war or the hunt but most likely for ceremony. Its decorative vocabulary is most traditional, a carefully balanced composition relying heavily on the decorative effect of heraldic parakeets enclosed by floral scrolls. The back shows a more informal style, approaching a sprinkled effect. The gilt-bronze bird-form fittings recall the comparable appliqués on the Buddhist *Keman* (see Figure 15, page 20).

Lacquer is well represented in the Shōsō-in objects but the full development of the gold lacquer (*maki-e*) technique was a product of the middle and later Heian period. The box (probably for a sutra) with a design of ducks and lotus | 35 | represents the new and original decorative manner of Fujiwara *maki-e*. The motifs are certainly derived from such Buddhist usage as that on the tabernacle doors (see Figures 9–11, pages 16 and 17). But here they have become emigrés from the Western Paradise and inhabit a charming earthly atmosphere of their own. The relatively early place of the box in the development of *maki-e* technique can be judged by the limited variety of textures in the gold washes and by the bare lacquer ground devoid of sprinkled gold. The gently asymmetric design is in excellent Yamato-e taste and is subtly reinforced by the sensitive treatment of the gently curving lid and the slight reinforcement of the cover edges by a bead.

The lid from a "treasure" box | 36 | with an interior design showing *Hōrai-zan*, the legendary tortoise island, abode of the blessed, is of a slightly later date (ca. 1150–1200). The box was probably for secular use and is an almost perfect specimen of Fujiwara taste, which is not surprising for the finest artists of the day designed for the lacquer workers. In 1147, Takayoshi, the probable artist of the Genji scrolls, designed a version of this same subject to be executed in lacquer on the seventieth birthday of an ex-premier.[24] The exterior is decorated with a

35 | Box, with lotus and duck design

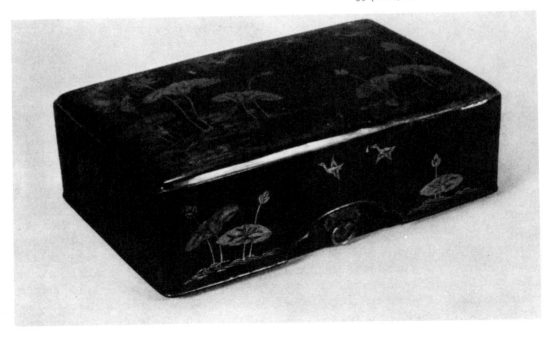

formalized four-petal flower enclosed in an elongated hexagon, alluding to tortoise shell, and recalling some of the textile patterns to be found on the Genji scroll. This richly patterned exterior encloses a scene combining the rhythmical undulations of

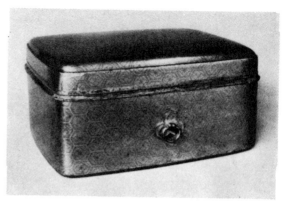

36 | Treasure Box.
Inside lid, below

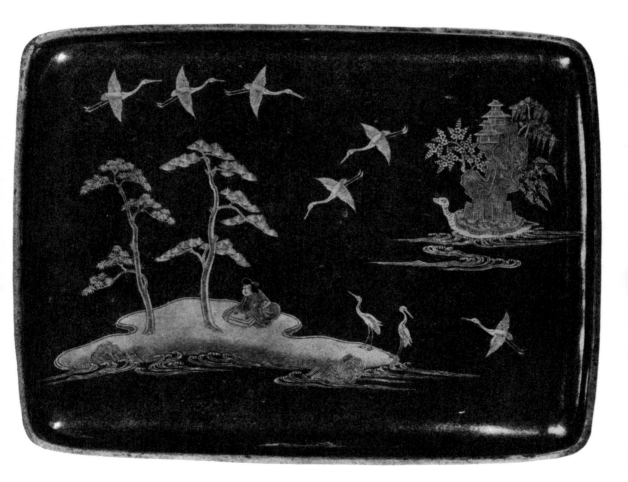

167 | Sword Guard, with plover.
Note: decorative sword guards
(Tsuba) are illustrated
in proximity to paintings
and lacquers which use
similar motifs. For a discussion
on sword guards, see page 115.

37 | Incense Burner, with plovers in flight

Yamato-e landscape elements with a carefully and asymmetrically ordered flight of cranes. The whole is placed against a gold sprinkled ground *(chiriji)*. Literary elements are provided by the flowering magic island on its tortoise and by the fisherman holding the equivalent of Pandora's box. While precious few of these great lacquers have been handed down, we must imagine that they were numerous and highly appreciated as the original and creative works they surely are. For a truly decorative style such "minor" arts assume a primary importance.

Again the word "motif" must be invoked. It is basic to this, or any comparable style. The flying bird motif could be singled out, enlarged, and made the sole subject of another lacquer. Hence the popularity in the late twelfth and thirteenth centuries of *chidori*, a small plover depicted in flocks arranged with all the order and complexity of a theme and variations by Bach | 37 |. The birds mass, move in one way, then shift and make off in another. The meticulous execution and disregard of economy, for gold lacquer was never cheap, can be properly assessed when we know that even the bottom and interior of this incense burner—although seldom if ever seen—are also decorated with gaily plunging *chidori*.

The "handy" box | 38 | of the fourteenth century continues the style with perhaps a heavier reliance on the decorative effect of gold and on the appeal of a more completely pictorial type of decoration. The flying bird motif, gently twisting trees, and butterflies are part of the traditional Fujiwara repertory. Apart from its well preserved beauty, the box is especially revealing of the varied aesthetic depths of the decorative style. The cover has the signs of spring, willow, prunus, and young bamboo. The sides

38 | "Handy" Box.
Cover, below

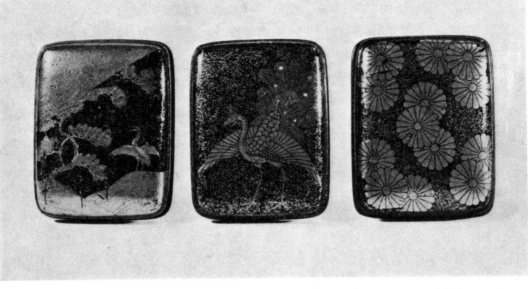

39 | Box, with crane 40 | Incense Box, with peacock 41 | Incense Box, with chrysanthemums

present the flora and fauna of autumn, asters, chrysanthemums, among others, and butterflies. The combination, spring-autumn, is synonymous in the Far East with "year." This pictorially presented idea is then combined with the three written characters cleverly worked into the rocks shown on the cover—Chōseiden—the palace of the T'ang Emperor, Ming Huang, mentioned in a rhymed couplet in Chinese style by Yoshishige-no-Yasutane (died 997).

Within the Chōseiden (Hall of Longevity)
 years are abundant;
In front of the Furomon
 (Gate of the Never-aging)
 the Sun and the Moon move slowly.[25]

In short, after this well embroidered and sophisticated path of indirection, "May Your Majesty be long-lived; may Your Majesty never grow old!" The Kyōto aristocracy did not tire of varying Chinese themes, especially if they were as romantic as that of Ming Huang and his concubine, Yang-kuei-fei.

Fujiwara decorative tradition in lacquer continued for a brief time further | 39, 40, 41 | and our last example, a table | 42 | of the early part of the Muromachi period, seems at first glance to belong in that tradition. Its gilt bronze fittings add much to its effectiveness but two factors attest to change. There is no sprinkled gold ground,

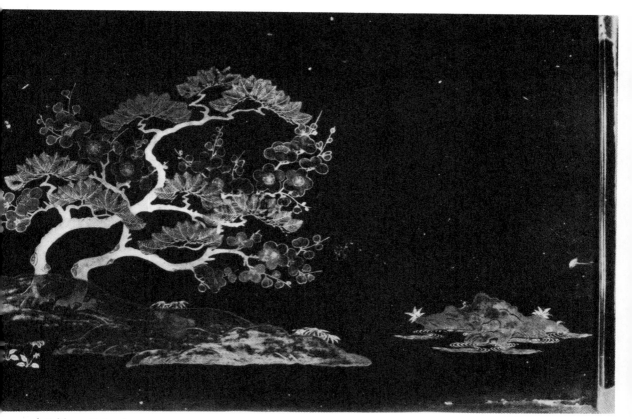

42 | Table, with landscape

indeed, the gold is sparingly used. The Imperial court had fallen on harder times. And a daring, arbitrary aesthetic device has been adopted after what must have seemed the completion of the decoration; a rolling band of silver, representing a point of land, was applied over the area from the fold of the tree roots out to the clumps of dwarf bamboo. Perhaps the artist wished to balance the silver island to the right; but he must also have wished to produce something both bolder and more sombre than anything in his traditional repertoire. In this arbitrary, even rough device, he betrays his place in time—the Muromachi period, when the Kyōto tradition was eclipsed by a new and overwhelming wave of Chinese influence symbolized in art by the dominance of monochrome ink painting, hardly the basic ingredient of a decorative style.

The Muromachi interim

Where the Japanese of the Asuka and Nara periods had absorbed the whole of a Chinese culture, the elite of the Muromachi period absorbed a religious and aesthetic part. The growing feudalism of the Japanese medieval period was totally unsympathetic to the firmly established centralization of Imperial China. The greatest impact from China at this time hit the least political areas of Japanese culture—religion and the arts. In religion, Zen (Chinese: *Ch'an*) became the dominant Buddhist sect within the actual ruling class. This anti-logical, intuitive, even non-theological faith stressed the efficacy

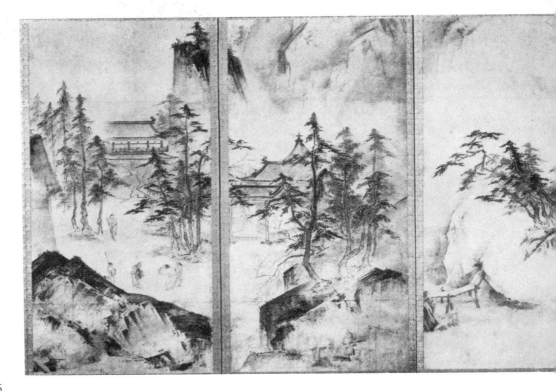

of sudden enlightenment, not through good works or ritual, but by a dramatically sudden breakthrough into awareness as abrupt as the stroke of a sword or the clap of thunder after a flash of lightning. The accompaniments of Zen were the poetry and painting styles originating in the Ch'an monasteries of South China in the Southern Sung Dynasty. They had grown to greatness in a time of troubles and it is no coincidence that the sombre and austere atmosphere of Ch'an non-thought, poetry, and art found a second home in the place of troubles that was Japan from the fourteenth through the sixteenth centuries.

Warfare among the feudal barons, monastic orders, and homeless *samurai*, was the standard condition for all but a few generations of the Muromachi period. Small wonder that the rough and ready intuition of Zen appealed to uncultured and crafty warriors when they saw the sterile, effete, and impoverished decorative way of life still practiced by the powerless imperial court at Kyōto. A great decorative style must be maintained by great wealth and most Japanese were poor at this time. The new virtues of austerity, the avoidance of rich materials and conspicuous display; of "astringency" *(shibui)* in taste; of the rough exterior with

43 | *Winter and Spring* by Shūbun, six-fold screen

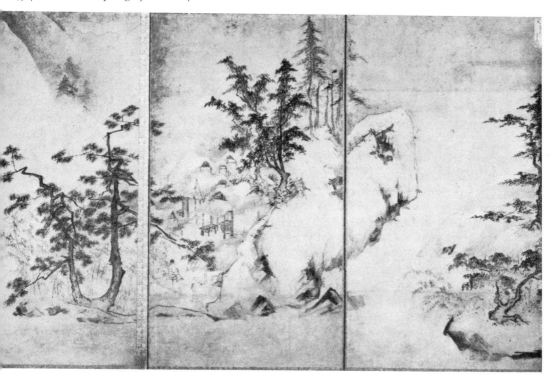

I have locked the gate on a thousand
 peaks
To live here with clouds and birds,
All day I watch the hills
As clear winds fill the bamboo door.
A supper of pine flowers
Monk's robes of chestnut dye—
What dream does the world hold
To lure me from these dark slopes?
 Zekkai (1336–1405)
 Tr. by Burton Watson[26]

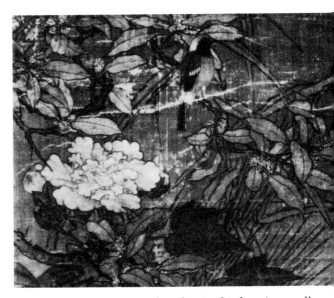

44 | *Bird and Flowers*, attributed to Sesshū, hanging scroll

a subtle interior; and of the Japanese equivalent of studied nonchalance, were a complete reaction against the grace of Fujiwara decoration as well as an economic necessity.

As the position of the Shōguns, the *de facto* rulers for the *de jure* Emperor, became rapidly weaker, their aesthetic refinement and collections of Chinese art grew stronger. The beginning of the Ōnin war in 1467, which signaled the arrival of chaos, occurred during the "rule" of the eighth Shōgun, Ashikaga Yoshimasa, who ordered the great catalogue (*Kundaikan sayū chōki*) of his art collection begun by the famous Zen monochrome priest-painter Sōami. The Chinese paintings of this collection and other smaller holdings were the greatest influence of the artistic age.

Color, if used at all, was now minimal. The old Japanese motifs were largely replaced by Chinese themes. The hand scroll and the album gave way to the hanging scroll, suitable for contemplation in an architectural innovation, a niche-like interior space called the *tokonoma*. Thus one's attention was focused on one thing, and that usually an ideal, a never-seen-in-reality Chinese mountain or river landscape. The beholder contemplated this image in an austere setting, not surrounded by a decorative environment like that provided by the screens, hangings, draperies, boxes, and other accoutrements of Fujiwara culture. Much of the poetry of the period was written in Chinese by Zen monks and parallels the intentions of the painters (left, above). Peaks, chestnut color, dark slopes, and retreat are the new lot of the Chinese-minded poet.

The new dominance of Chinese influence

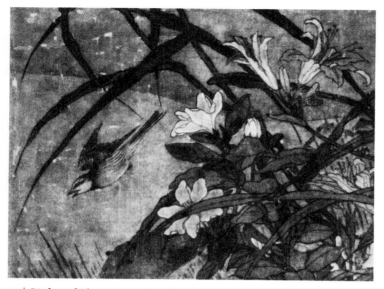

45 | *Birds and Flowers*, attributed to Sesshū, hanging scroll

was not merely superficial. While some artists mimicked and aped, others imitated and absorbed. The best of these succeeded in re-creating the great lyrical monochrome landscape style of Southern Sung in works of universal significance. And in doing so they added some important new words and rules of grammar to the quiescent language of decorative style, making possible the renaissance of that style following the Muromachi period. These masters stand somewhat outside the thread of our argument but their contribution demands attention.

Shūbun (ca. 1390–ca. 1464), the teacher of Sesshū (1420–1506), produced masterpieces which, more than any others, re-created Chinese style with the same degree of insight and inspiration that characterized the icon-makers from the seventh through the ninth century. While most of his accept-

ed work is in hanging scroll form, he did execute a few monochrome paintings on a decorative format, the six-fold screen |43, page 47 |.

Once absorbed, the new vocabulary could be transmitted and, in the next generation, transmuted into accents with decorative overtones. Sesshū, beginning with small-sized variations on Sung bird and flower painting | 44, 45 | that already depend more upon pattern and exaggerated brushwork than do their prototypes, also painted a few folding screens. While the few landscape subjects almost appear to be enlarged hand-scroll sections, the screens representing birds and flowers reveal a conscious decorative character | 46 |. The increased use of color is significant enough, but even more so is the re-appearance of arbitrarily enlarged or reduced units which are treated as motifs

to be carefully placed in relation to the vertical sections making up the standing screen. Thus, the divisions of the screen become a grid demanding a decorative treatment quite different from that which the same motifs might receive when used on the hanging scroll, hand scroll, or album leaf. The decorative format, a folding screen, begins to shift the emphasis of the idealistic Zen-Chinese idiom.

In an earlier chapter we studied details from the pair of monochrome screens by Sesson (ca. 1504–ca. 1589) for nuances betraying decorative tendencies. This pair |47| represents the third generation removed from such sources as Shūbun. Sesson is surely the most powerful of these later Muromachi monochrome painters when compared with the contemporary founders of a new hereditary academy of painting, the Kanō school. Kanō Masanobu (1434–1530) and Kanō Motonobu (1476–1559), excellent Chinese-style painters in their own right, began a tradition that became as trite and dead as did the Tosa school before them. The feeble Tosa remnants of Yamato-e and the glib paraphrases of Sung monochrome and Sesshū by the Kanō masters continued to modern times, but without creative importance. This was left to a new revival of the decorative style.

The most important developments in the useful arts are probably those to be found in the category of ceramics. The rapid rise of tea drinking as a part of Zen social life ultimately led to the formalized tea ceremony *(Cha-no-yu)*.[27] This formalization did not take full hold until the seventeenth cen-

47 | *Tiger and Dragon* by Sesson, pair of six-fold screens

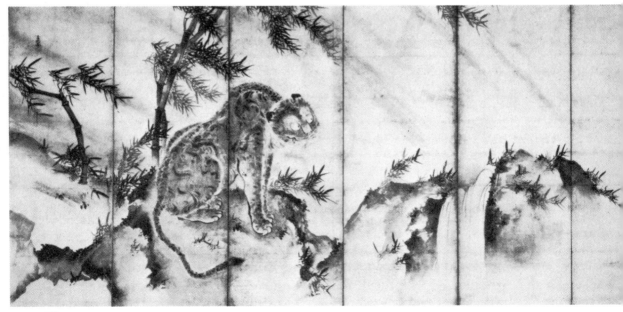

46 | *Birds and Flowers in a Landscape,* attributed to Sesshū, six-fold screen

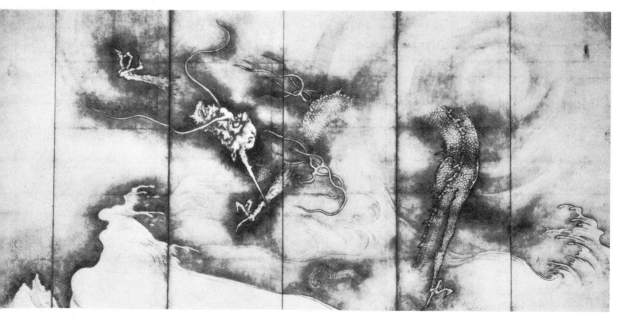

tury and it can be considered as a decorative means of making an occasion into a ceremony. But in the Muromachi and early Momoyama periods a proper informality, comparable to the tone of monochrome painting, must have been the norm. Parallel to the situation in painting, the earliest ceramics used exclusively for tea were simple tea bowls from the South Chinese coastal province of Fukien. These were then imitated at Seto, near Nagoya, where a large but informal ceramic industry developed. Small kilns, operating for individual patrons and their circle, produced a series of increasingly sophisticated wares that embodied the Zen taste we have already seen in painting.

The subtly careless shapes and somber colors of these wares are proper complements to the paintings of Sesson and the early Kanō artists. But the decorative devices show a persistence of motifs from the earlier Fujiwara style. Thus the "incomplete wheel" *(Katawa)* design, that is, a wheel partially submerged in water, is to be found on Shino-type | 48 | and Oribé-type | 49 | wares from Seto. Flying birds | 50 |, autumn grasses | 51 |, iris | 52 |, and tortoise shell | 53 |, are motifs called up from the past. These old designs are handled in a new way. Where before, in lacquer or metal-work, they were clearly defined and often sprinkled profusely over a given surface, they are now only suggested, even blurred, and they are placed with extreme asymmetry as foils to large open areas of subtly textured glaze. Such were a few of the lessons absorbed from the Southern Sung style of the Muromachi period. It is difficult to say whether the Fujiwara traits found on these ceramics present a Tosa-like persistence of Yamato-e spirit or the purposeful revival of that style by the great decorative masters of the seventeenth

48 | Shino Ware [
with design c
half-submerg
and fish net

168 | Sword Guard, with wheel motif

51 | Shino Ware Cake Plate, with wind-blown grasses

49 | Oribé Ware Plate, with half-submerged wheel motif

169 | Sword Guard, with geese and pond

50 | Shino Ware Dish, with flying birds

52 | Shino Ware Bowl, with iris

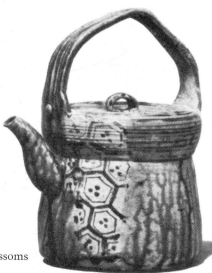

Oribé Ware Ewer, with tortoise shell motif, wheels, and plum blossoms

century. But the dominantly *shibui* character of the Shino, Oribé, Karatsu, and Ki-Seto (Yellow Seto) | 55 | variations on a ceramic theme marks them as a part of the Muromachi interim.

The major contributions of both the paintings and the useful arts of this period lie outside the boundaries of decorative style. It was the newly discovered qualities of "carelessness," extreme asymmetry, and compositional boldness combined with coloristic reticence, incorporated to the highest degree in a perfect "tea taste" ceramic | 56 |, that were essential stepping-stones to the final revival of Japanese decorative style which followed.

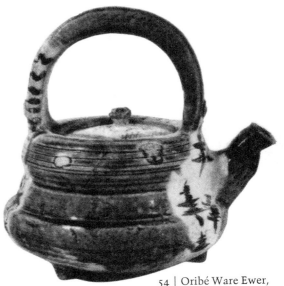

54 | Oribé Ware Ewer,
with tortoise shell motif

56 | Shino Ware Water Jar, with flowers and grasses

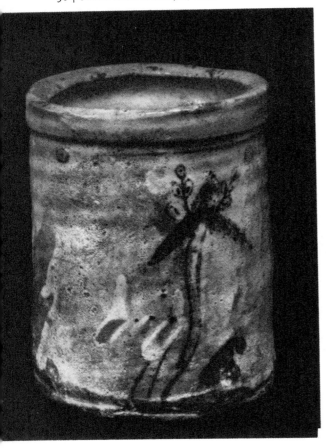

55 | Yellow Seto Bowl, with flower design

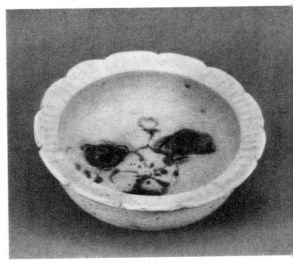

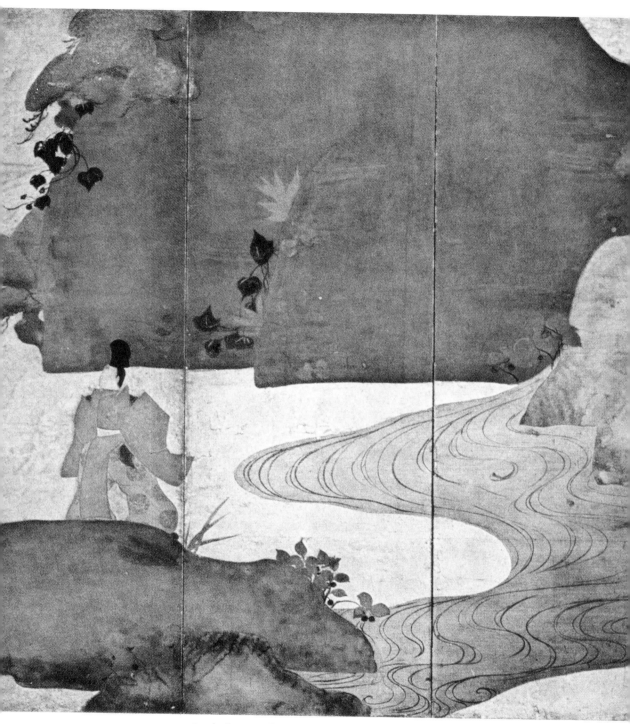

83a | *The Pass through the Mountains* by Roshū Fukaye, six-fold screen (detail)

Sambō-in Garden, Daigo-ji, Kyōto;
photograph by H. Sakamoto

64 | *Ivy Lane* by Nonomura Sōtatsu, pair of six-fold screens

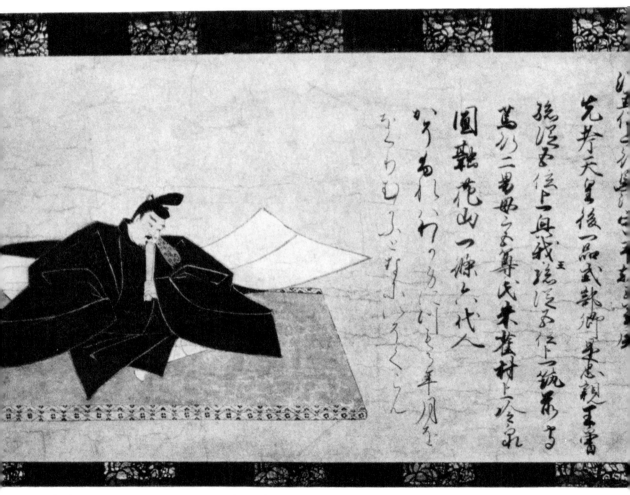

先考天皇後一品式部卿御栗忠親王當

孫渡君信上與我瑞渡子位一統那者

萬水二昌毋之舞氏未崔村上岑家弘

圓融花山一條六代人

ひりかれつつもつしころ年月を

なからむ山ふこまふくる

23 | *The Poet Taira no Kanemori,* hand scroll

The Momoyama and Edo Periods

The social conditions for a sumptuous revival of a Japanese decorative style included two particular requirements—prosperous peace and cultural isolation. The first of these was fulfilled by the reunification of the feudal order under the great generals of the late Muromachi, Momoyama, and Edo periods: Ōda Nobunaga (1534–1582), and his lieutenants, Toyotomi Hideyoshi (1537–1598) and Tokugawa Ieyasu (1542–1616). The second was accomplished by the well-implemented policies of isolation and exclusion instituted by the Tokugawa Shōguns beginning with the third Shōgun, Tokugawa Iemitsu (d. 1651).

While Hideyoshi schemed in the grand manner after his completion of reunification, attempting two expeditions to the mainland whose ultimate objective was the conquest of China, his successors concentrated on the consolidation of the Japanese feudal order. They created a new capital, Edo (modern Tōkyō), escaping the toils and intrigues of Kyōto and creating a great urban center in a strategically dominant central location. Their concept of isolation did not include the refusal of foreign trade, whether with the Far East or the West. This, with a thoroughly ruthless organization of society and a previously unheard of maintenance of peace, permitted a controlled prosperity that established the pre-conditions of a glorious artistic flowering. The *daimyo* (feudal nobles) were now rich and were forced to use their wealth for leisure activities other than war. But a new class also appeared. The merchants of the Edo period may have been beyond the feudal social pale but they were wealthy and their aesthetic tastes were backed by ready cash. The high time for the new hedonism was Genroku (1688–1703) and it will be noted that this was a pivotal period for artistic activity.

The commoner, Hideyoshi, his generals, and the now perforce loyal *daimyo* provided early and overwhelming patronage for the arts, particularly in screen paintings decorating the often vast and gloomy interiors of the new castle architecture. This stimulus was followed by that provided by the merchants, principally of Edo and Ōsaka, whose tastes were for both innovation and the aristocratic past. The former was a natural taste for a new and unprecedented class, the latter an equally natural interest in status. Despite the revived awareness of Fujiwara taste, the dominant flavor of the new age was masculine and hence the old "feminine" forms were re-formed in new molds. The various still-existing, but largely

moribund traditions, Yamato-e, E-maki, To-sa, Tea, and Kanō, provided the tools for the molds.

The most important tool for the full expression of the exuberant decorative display characteristic of Hideyoshi and his age was that provided by the best of the Kanō masters. The skillful and disciplined ink play learned in the Chinese school lay ready at hand for use in a more sensuous medium than monochrome ink. Even in ink the large-scale shapes and sweeping rhythms of the revived decorative spirit could produce screens totally unlike their Chinese forebears |57|. Kaihō Yūshō (1533–1615), though not formally of the Kanō lineage, was probably a pupil of Kanō Motonobu. Hideyoshi commissioned works from him, both in monochrome and in the combination of color and gold most characteristic of Momoyama decoration.

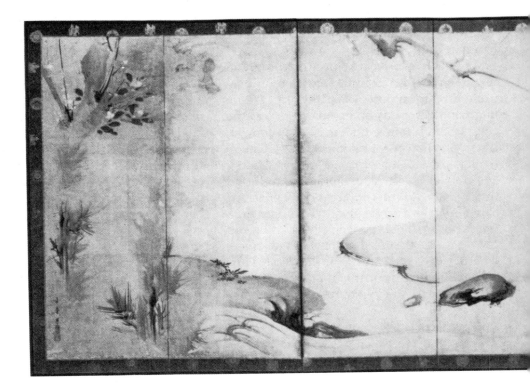

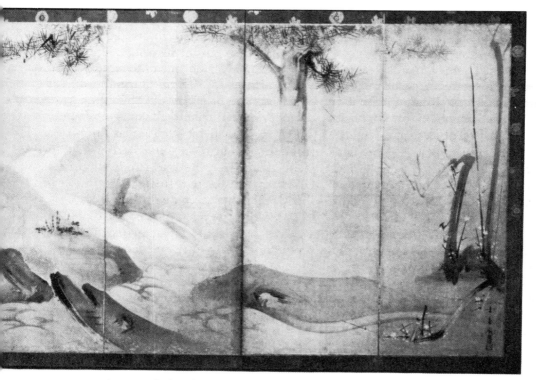

57 | *Pine and Plum by a Stream in Moonlight* by Kaihō Yūshō, pair of six-fold screens

Kanō Tōhaku (1539–1610), another of the most important painters of this time, is associated with a noted and original design—Uji Bridge—which was repeated by various unknown artists from the time of its invention. This particular version of *Uji-bashi* | 58 | is very close to Tōhaku and displays many of the characteristics of the new decorative mode at a high level. One's first impression is of a large-scale grandeur previously unknown in Japanese painting. This would be true if we saw only one screen, but the continuous composition of one scene over two large areas reinforces the bold pattern of the design. Various Japanese words are used to describe this particular variation of the decorative style, *kabi* or *gōka*, meaning luxurious beauty, or quite often, and in classical Japanese, *kenran*,

which, when reduced to its parts, means ornately *(ken)*, glittering and ripened *(ran)* as in autumn foliage, or in the morning sun. When translated, *kenran* is usually rendered as dazzling or gorgeous. The latter word, though now reduced to cheapness by Hollywood, is defined by Webster as "imposing through splendid or various coloring; magnificent; dazzling." These words, in their most laudatory sense, are a fitting description of the Momoyama screen painting style.

These effects are produced by details as well as by over-all framework. Like the products of the Fujiwara decorative style, the *Uji-bashi* relies on suggestions of decorative pattern beyond the frame of the format. Cloud bands, bridge, and trees enter and leave the painter's field at his will. Rhythmical repetition, in the waves, bridge

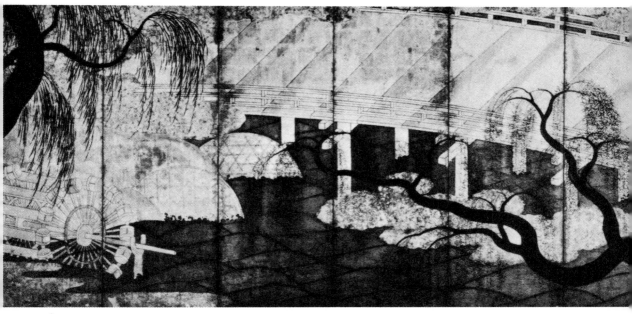

construction, the willow branches, and the wicker garden-baskets, is played against large, flowing, even undulating, movements in the silhouettes of trees, bridge, and semi-circular baskets and waves. This fugal interplay of opposites, small and large, soft and hard, provides the rich variety which contributes to *kenran*.

To these elements are added large areas of gold leaf, whether sprinkled or laid on in the large areas of overlapped squares. Now gold is not a new device. As we have seen, it was used in Buddhist painting, Yamato-e, and *maki-e,* gold lacquer. But there it was a minor note, a foil to color or to the lacquer ground. Now it has become an equal partner to color. The sudden appearance of large areas of gold as a part of the means of Momoyama painting has been attributed to

171 | Sword Guard, with bridge and pine tree, by Kakubusai Masazane

58 | *Uji River Bridge,* pair of six-fold screens

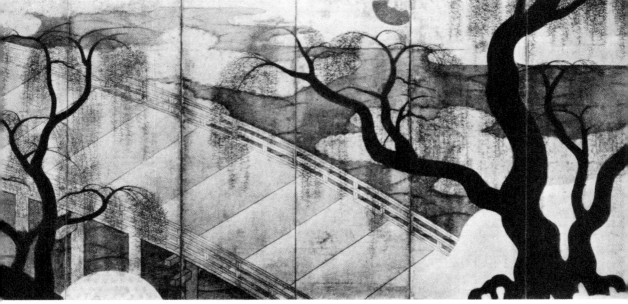

the need for light in the "thick-walled" stone, wood, and clay structure of the feudal castles, and to the influence of gold ground Christian icons supposedly imported by the Jesuits in the late sixteenth and early seventeenth centuries. But the castle walls were really thick only at the lower levels of the *donjon* (keep) and, at the upper levels, on the exterior walls facing the enemy. The screens, whether folding *(byōbu)* or sliding *(fusuma),* were used in rooms with as much light as ever entered large Japanese interiors. Further, most of these rooms had large openings to the interior courts and gardens. As for the Christian icons, those still remaining in Japan are mediocre oils on wood or canvas and conspicuously lack the gold grounds characteristic of a much earlier date than the sixteenth century in Europe. More reasonable explanations would be the expanded use of gold from the native tradition, whether from the sprinkled gold of Yamato-e or from the steadily increasing use of the precious metal in *maki-e.* The desires of such newly powerful generals as Hideyoshi and Ieyasu for splendor would naturally be satisfied by gold, and its visual embodiment of actual wealth might have been even more satisfying. Did not Hideyoshi use a hundred pairs of screens to line a street, bestow gold on trays to favorites at a party, and, worst of all, give a tea ceremony in 1587 to which everyone and anyone was invited?

The various characteristics of the Momoyama screen painting style outlined above are a natural extension of earlier Japanese decorative styles under the patronage of a powerful new ruling class. These characteristics can be understood as specialized and enlarged adaptations of decorative tradition brought to a unified style through men of genius from already existing schools, such as Yūshō, Tōhaku, and the earliest of all, Kanō Eitoku (1543–1590).

The sliding panels *(fusuma)* are especially characteristic of the age and display its varied interests and iconography. Thus Kanō Takanobu (1511–1618) uses the traditional Kanō figure style with the sumptuous gold and colored new manner in panels representing a variation of *The Four Amusements* | 59 |, a traditional Chinese and Confucian subject glorifying the scholar's *métier* of painting, games, music, and calligraphy. The left-hand panel | 59 a | offers a particularly significant juxtaposition—the richly clad scholar, seated in an even more gorgeous environment, admires a sober, monochrome hanging scroll in the style of Shūbun. The difference between Muromachi and Momoyama is visually compressed into one panel. Chinese influence, particularly within the

59 | *Lute, Chess, Calligraphy, Painting: The Four Enjoyments*, attributed to Kanō Takanobu, four sliding panels

59 a | Left Panel
from Figure 59

かつ恋て
重ねてちるこく
状のあみを
ろろ海渡す
まより
ろし泳

60 | *Sumiyoshi*,
attributed to
Nonomura Sōtatsu,
album leaf

ruling class, was far from dead. The *daimyo* and educated men particularly admired the Neo-Confucianism of Chu Hsi (1130–1200) with its great emphasis on universal order and a hierarchical system of absolute loyalty. The practical appeal to the Edo rulers of an ethic which equated evil with disorder was boundless.

Other *fusuma* painted by Kanō masters represent flora and fauna without benefit of figures. Their carefully arranged segments of nature recall the art of garden design. The two arts are related: painters sometimes designed gardens, and the delights of aesthetic subtlety were never so delectable as when one was seated inside a room simultaneously admiring a stylized simulation of nature on the paneling and the equally arranged real nature outside. Hideyoshi's Sambō-in garden near Kyōto, of slightly earlier date, is ordered in a complex and exuberant style comparable to that of Kanō Tōhaku (see photograph following page 54).

The Kanō decorative interpretations of nature are traditional in details of brushwork, but the heightened colors, heavy mod-

62

eling, and, above all, the vibrant gold-leaf backgrounds speak with new and creative accents. With few exceptions it can be said that Kanō monochrome painting, the "true tradition," after 1600 is deadly dull; these painters are effective only in their decorative efforts, and by the beginning of Genroku in 1688 creative pre-eminence had passed to other decorative modes.

The most extraordinary and original of these was almost certainly that established by the painter Nonomura Sōtatsu (1576–1643) in collaboration with the connoisseur and tea-master, Honnami Kōetsu (1558–1637). It is significant that their activity took place in Kyōto and was at least slightly connected with the old aristocracy there. Equally meaningful was Kōetsu's avoidance of service with the Shōgun at Edo. The striking and original contributions of the Sōtatsu-Kōetsu school are largely derived directly from the old Yamato-e style—by-passing the late Tosa school—rather than from the Kanō or Momoyama styles.

A small album leaf |60| from a set of about 125 pages illustrating the *Isé Monogatari* (composed soon after 951) may serve to introduce this new variation of Japanese decorative style. Representationally, the leaf shows three young nobles in old Fujiwara court costume standing near a Shintō shrine amidst groves of trees depicted in the old Yamato-e manner. A poem by Ariwara-no-Narihira is incorporated into the composition and is written in cursive *hiragana*. The technique, however, is in the new fashion —arbitrarily used gold ground and bright color. The most obvious new elements are the subtle maintenance of a flat, decorative surface and the markedly loose and blurred handling of the wet washes of opaque and slightly translucent pigment. This latter technique is almost surely derived from the

61 | *Crow* by Nonomura Sōtatsu, hanging scroll

monochrome ink-play characteristic of the *haboku* (flung ink) paintings of the Muromachi period by such Zen priest-painters as Sesshū and Sōami. Sōtatsu created *haboku* works, but composed in a decorative framework of his own |61, 62, 63|. These varied elements are not eclectically added, one to the other, but are fused in a personal and original style.

The choice of the *Isé Monogatari* as a source of motifs was a happy one. This collection of love poetry, largely by Ariwara-no-Narihira, loosely arranged by connecting prose settings or narrative vignettes, was popular with the medieval Kyōto court. But it was even more popular in non-Confucian literate circles of the Edo period. It combined decorative language with a sadly nostalgic atmosphere. The Sōtatsu-Kōetsu school used it as a source for motifs—not merely "illustrating" the tales but expressing the flavor of their poetry and prose by subtle and decorative treatment of specialized and enlarged details. A poem, even a phrase, was enough to produce large pairs of screens, usually combining a scene or motif with the related texts in *hiragana*.

One of the painter's masterpieces, *Ivy Lane (Tsuta-no-hosomichi)* |64, following page 54 |, makes use of but one phrase from the ninth section of the *Isé Monogatari*, "When they arrived at Mount Utsu, the road they were about to enter was very dark and narrow; ivy and maples grew densely there . . .,"[28] for its striking malachite green and gold contrasts. The solid and sharply defined green of the grass provides a dominant thrust which by contrast makes the transparent, amorphous, and wetly painted ivy even more striking and delicate. How different is the simple boldness of Sōtatsu from the complex grandeur of his Momoyama predecessors!

63 | *The Zen Priest Chōka*
by Nonomura Sōtatsu,
hanging scroll

Once there was a man. Tired of living in the capital he went to Azuma. When he went along the beach [on the border] between Isé and Owari, he saw the waves rising very whitely and recited [the following poem]:

> More and More
> I long
> For the regions which I have passed through;
> How I envy you —
> Oh, waves that are [ever] returning![29]

The second pair of screens, *Sea at Isé* |65|, is based on section seven of the tales (left). The waves of the Sōtatsu style should be compared with those in the *Uji Bashi* (see Figure 58, pages 58 and 59), for only then can one realize the originality of the later artist's free and loose brushwork, sacrificing nothing of rhythmical repetition but adding much liveliness and variety. Further deviation from his predecessors can be seen in Sōtatsu's flat treatment of rocks and islands. Where the Kanō decorators maintained the traditional Chinese brush-modeling of trees, rocks, and mountains, Sōtatsu insisted on a consistent and unified flat decorative character within and without the subsidiary units of the picture. The result is as rich as the Momoyama style but substitutes for inner tension a free and easy informality. This Sōtatsu style is equally effective without color in a single panel screen painted

170 | Sword Guard, with pine and cloud, by Masakata

65 | *Sea of Isé* or *Returning Waves* by Nonomura Sōtatsu, pair of six-fold screens

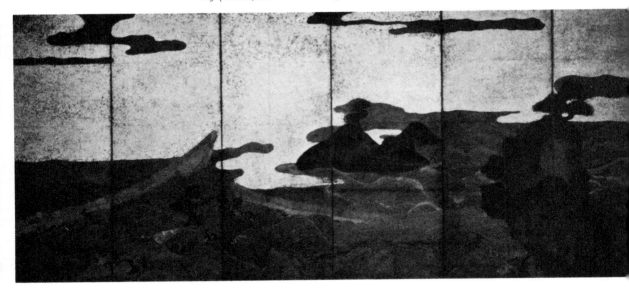

with ink on a gold background |66| and representing another of the literary motifs that became the stock-in-trade of the school —*Sano-no-watari*, the Sano Ford.

Not a shelter to stop the steed
In the snowy dusk at Sano-no-watari.

The conscious formalism of the arc shape in such parts as the horse's neck, and the arbitrary gesture of the page as he holds his cloak over his head in the pelting golden snow, should be noted as well as the wet and blurred ink technique.

Not all paintings by Sōtatsu have literary overtones. One of the most beautiful of all his works represents a simple floral motif— *Poppies* |67|. To fully savor its delicious and subtle flavor one should compare it with a similar subject |68| by a much later follower of the school, Suzuki Kiitsu (1796– 1858). Sōtatsu uses transparent and fluid color where Kiitsu's color chords are more opaque and heavily defined. The difference between a great and a good work is a matter of nuances and, while explainable up to a point, is ultimately ineffable. How does Sōtatsu make his leaves look youthful and still capable of growth? Why do the poppies seem to be opening before our eyes? What is the source of the lilting movement, vertical in essence but modified by the springing curved diagonals of the leaves? Wherein lies the secret of the resonant harmony of warm pinks, cool greens and varied gold? Like Velasquez, Sōtatsu astounds us with the mystery of his means as if he could breathe a work into being.

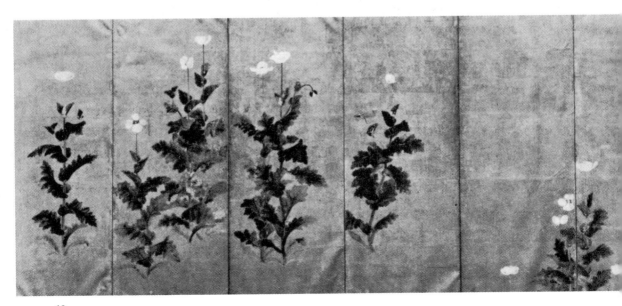

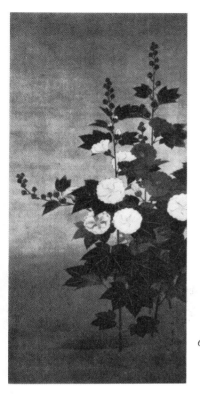

68 | *Hibiscus Flowers*
by Suzuki Kiitsu,
hanging scroll

67 | *Poppies* by Nonomura Sōtatsu, pair of six-fold screens

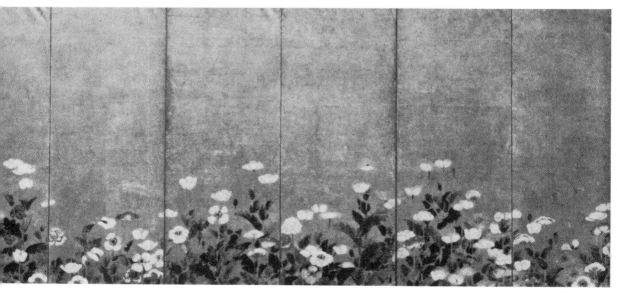

70 | *Lotus and Calligraphy* by Nonomura Sōtatsu, section of hand scroll

Sōtatsu and Kōetsu collaborated on a few hand scrolls that embody their artistic principles in a particularly choice and rarified way. These combine, in equal parts, literature, calligraphy, and decorative painting. Unlike the more feminine Fujiwara style of writing, that used by Kōetsu combines Chinese and Japanese writing in varied weights of ink, from the heaviest black to the palest gray. This is written over designs by Sōtatsu, freely brushed in gold and silver, representing herds of deer |69| or lotus in various stages of bloom |70|. These pictorial backgrounds are decorative not only in their rich material but because they are never allowed to interfere with the calligraphy. As one unrolls and handles the scrolls, the silver and gold catch the light in varied ways, now coming forward, now receding. The washes describing the stylized deer are varied as much as the ink of the calligraphy. The continuous composition seems influenced by the ebbing and flowing method of painting the long narrative scrolls (e-maki); and this continuity is suggested vertically by the old Yamato-e device of implying continuation of the figures above and below the borders of the scroll, even to the extent of showing only the lower limbs at the top of the scroll in some places. It would

69 | *Poem Scroll with Herd of Deer* (detail) by Nonomura Sōtatsu, hand scroll

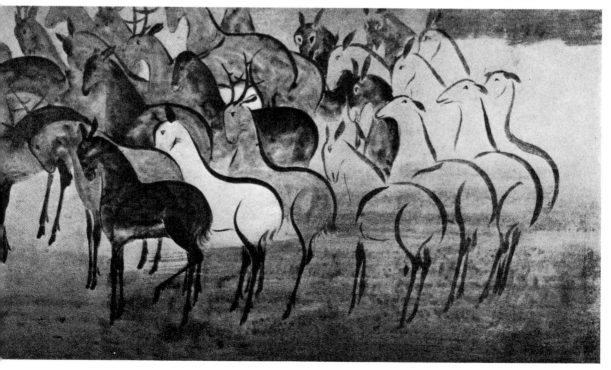

71 | *Chrysanthemums*
by Kitagawa Sōsetsu,
hanging scroll

72 | *Chrysanthemums* by Kitagawa Sōsetsu,
hanging scroll

be difficult to imagine a more consummate embodiment of the highest and most subtle ideals of this peak of decorative style.

From this to the circle and immediate followers of Sōtatsu and Kōetsu must be a downward movement of consolidation and specialization, whether in the charming fluidity of the *Chrysanthemums* |71, 72| by Sōsetsu, the son of Sōtatsu, or the relatively bold and partially integrated patterns of *The Corn and Cockscomb* screen |73|.

Further development within this particular mode depended upon variations inherent in personal creativity and on a demanding patronage. The rich merchants of Kyōto and Edo found their most sophisticated tastes satisfied by a second great master, Ogata Kōrin (1658–1716), the son of a Kyōto draper. Where Sōtatsu seemed especially refined and subtle, Kōrin supplied sharper, more solid color and pattern. His art seems "wealthier" and more consciously formed. Where the older artist breathed paint onto paper, the younger man painted with vigorous virtuosity. Kōrin's banishment from Kyōto to Edo in 1701 for ostentatiously defying the sumptuary laws of 1698 by throwing away gold painted bamboo-leaf food wrappers symbolizes the character of his art. (See Figures 74 and 75 for similar incidental decorative paintings.) But in this confident daring he rose above his contemporaries.

73

73 | *Corn and Cockscomb*, School of Sōtatsu, six-fold screen

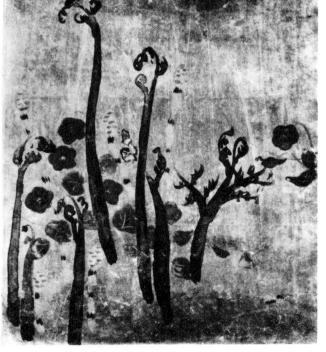

74 | *Young Shoots and Small Plants* attributed to Ogata Kōrin, decoration from a sword rack

74

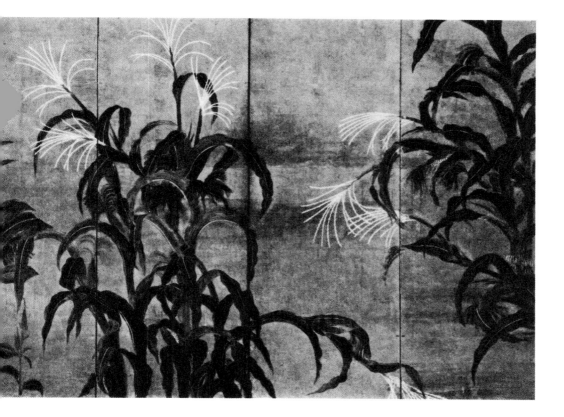

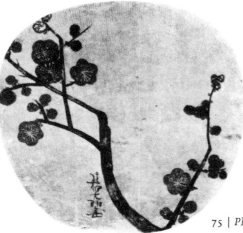

75 | *Plum Spray* by Ogata Kōrin, fan painting

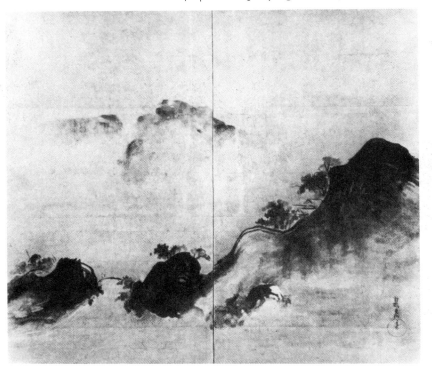

Kōrin's earlier works, like many by other artists of the school including his pupil Watanabe Shikō (see Figure 85, pages 86–87), are often monochrome ink paintings that have strong Kanō touches |76|. The view over the hill to a Buddhist temple is almost pure Kanō. But the choice of a gold ground as well as the flat washes of dazzling ink with their rolling contours indicate his fundamentally decorative interests. These are even more clearly evident in the two mono-

76

chrome hanging scrolls depicting herons, reeds, and chrysanthemums |77|. The sharp edges of his washes and brush strokes are quite different from the paler and softer effects of Sōtatsu. The thin, graceful brush strokes defining the herons seem especially self-conscious and stylized. This was a deliberately assumed manner as we know from at least one hand scroll with studies after nature in a more realistic style.[30]

The two-fold screen of waves |78| is per-

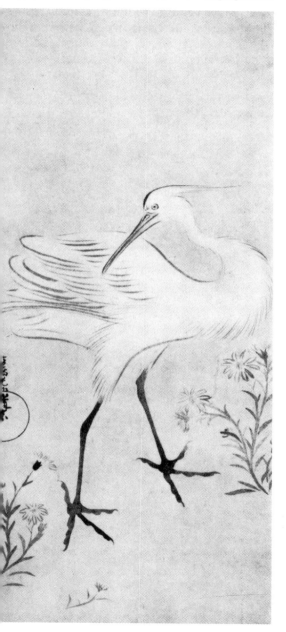
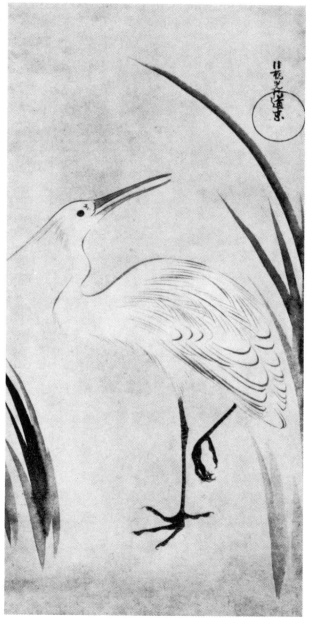

haps the most decorative monochrome painting ever produced in Japan. Whether waves or clouds, the ribbons of ink coil and uncoil with flowing and ebbing movement that becomes an apparently ever changing pattern which is enjoyable for itself alone. In the bounding shore or foam the ink is sprinkled as if it were gold. This wave—or better, swirling ripple—pattern occurs often in other contexts in Kōrin's art.

Waves were a natural motif for this decorative school. Their fascination for man from early times attests to the infinite variety of their natural patterns. This natural im-

78 | *Waves* by Ogata Kōrin, two-fold screen

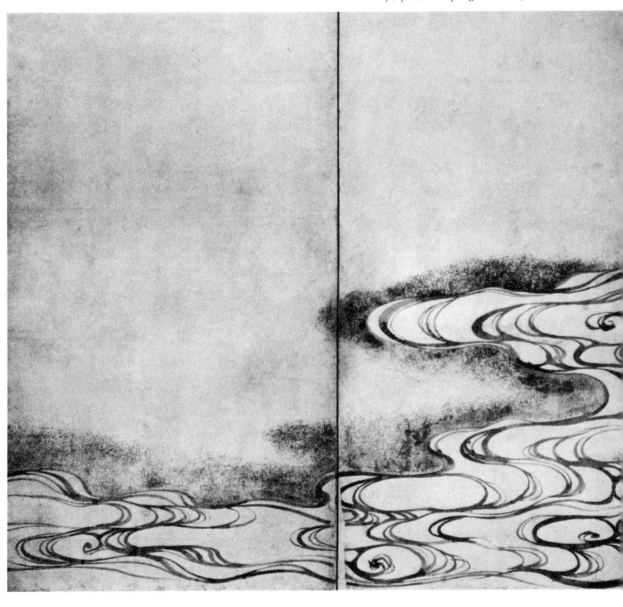

pression given by the small six-fold screen of *Waves* |79| is heightened by the addition of subdued green and gold. The forceful stylization depends on the patterned use of dominant waves as point, and the now blackened silver curling foam as counterpoint. And it is pattern, for we can imagine it stretching as far as eye can reach beyond the lacquered wood borders of the screen.

The combination of motifs with the necessary accompaniment of varied placement, spacing, different view-points, contrasts of shape, color, and texture, is well shown in the marvelously well-preserved screens of

172 | Sword Guard, with dragon and waves, by Issan

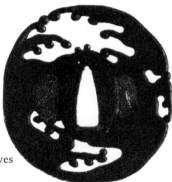

173 | Sword Guard, with waves

79 | *Waves* by Ogata Kōrin, Six-fold screen

Chrysanthemums by a Stream | 80 |. Here the wave pattern becomes light on dark, gold on azurite. The flowers are modeled in paste in actual relief (*moriage* technique) and the artist willingly accepts a limited color range, lime and emerald green, deep azurite blue, and gold. These screens repay patient study and contemplation, for in them decorative nuance is everything. Follow, for example, the pairs, triads, and quartets of the circular, many-petaled chrysanthemums. Then shift to the larger nuances of placement; the clumps of flowers in relation to each other and the always present grid made by the joints of the screen panels. Divorce the plants from the sharp straight edges and reflex curves of the stream of water and realize how much the fresh vigor of the former depends on the crystal-clear plane of the latter. Then the waves—here one can see especially clearly how they *are* like a pattern on a textile arbitrarily cut in the shape of the stream—almost as if this were a *collage* made of real plants and a wave-patterned textile flatly applied to a gold ground.

Even when assaying serious figure subjects, the decorative style and hedonistic

175 | Sword Guard, with plum and cherry blossoms

pleasure-seeking of the Genroku period transforms the old meanings. Kōrin painted a two-fold screen of *The Thirty-Six Poets* which was copied, with minor variations, by several of his followers. One cannot help but see a certain humor in such representations. The exaggerated, almost caricatured features and poses may derive from the details of Yamato-e and the narrative *e-maki* art, but at any rate this humor is as much a part of the Sōtatsu-Kōrin style, as racy and irreverent thoughts and passages are a part of the rising contemporary art of the novel. Ihara Saikaku's (1642–1693) *The Japanese Family Storehouse,* written in 1688,[31] bears the subtitle *The Millionaire's Gospel Modernized* and contains numerous passages which are marked by humorous irony and tell us much of this surprisingly materialistic merchant society (right, its beginning).

Heaven says nothing, and the whole earth grows rich beneath its silent rule. Men, too, are touched by heaven's virtue; yet, in their greater part, they are creatures of deceit. They are born, it seems, with an emptiness of soul, and must take their qualities wholly from things without. To be born thus empty into this modern age, this mixture of good and ill, and yet to steer through life on an honest course to the splendors of success—this is a feat reserved for paragons of our kind, a task beyond the nature of the normal man.

But the first consideration for all, throughout life, is the earning of a living. And in this matter, each one of us must bow before the shrine of the Heavenly Goddess of Thrift (not Shintō priests alone, but samurai, farmers, traders, artisans, and even Buddhist bonzes), and we must husband gold and silver as the deity enjoins. Though mothers and fathers give us life, it is money alone which preserves it.

80 | *Chrysanthemums by a Stream* by Ogata Kōrin, pair of six-fold screens

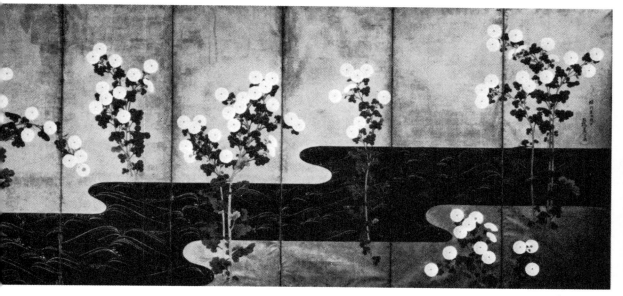

81 | *Branch of Cherry Blossoms* by Ogata Kenzan, hanging scroll

Kōrin's younger brother, Ogata Kenzan (1663–1743), was apparently of a somewhat different character. A confirmed devotee and expert of the tea ceremony, his most characteristic creations are tea bowls and other ceramics for tea ceremony use | 136, following page 118 |. Though these are sober in shape, they follow the decorative style in their colorful and rich enameled decoration, using the usual motifs of the Sōtatsu-Kōrin tradition. His few paintings also show an austere and somewhat uncompromising nature. Whether a small album painting of a single spray of cherry | 81 |, or a very rare, large, and imposing pair of six-fold screens | 82 | of hollyhocks and plum branches, Kenzan's paintings express a compromise between the charms of decorative style and the sometimes more rigorous ideals of the tea master. In this matter, a comparison of the hollyhock screen with Kōrin's chrysanthemum screens is most revealing.

The later artists of this school worked with variations or combinations based on the personal styles of the two giants, Sōtatsu and Kōrin. Occasionally they rise to the level of their models. Roshū (1699–1755), until recently thought to be a contemporary of Sōtatsu, is represented today by a very few works whose freedom and bold color give good reasons for the chronological error.

82 | *Hollyhocks and Plum Branches* by Ogata Kenzan, pair of six-fold screens

83 | *The Pass through the Mountains* by Roshū Fukaye, six-fold screen.
See also Fig. 83a, following page 54.

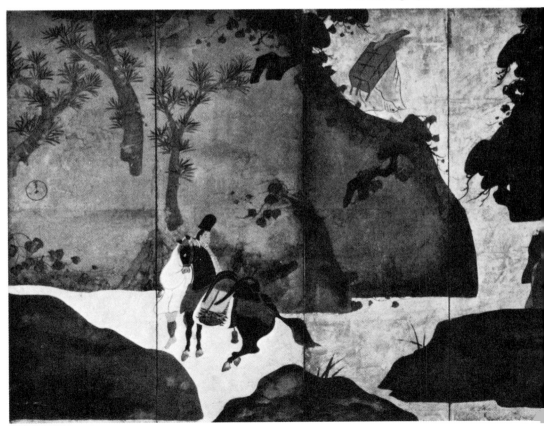

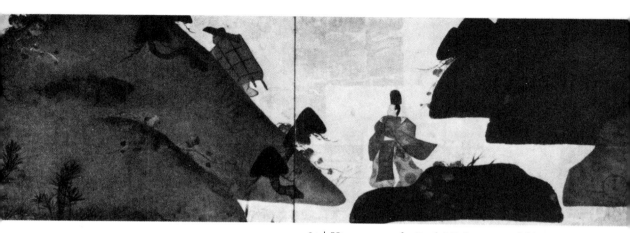

84 | *Utsunoyama*, by Roshū Fukaye, two-fold screen

Three of his masterpieces, two of which are represented here, are variations of the same subject, *Utsunoyama: The Pass Through the Mountains,* from the same passage in the *Isé Monogatari* as Sōtatsu's *Ivy Lane.* The subject motifs—travelers, horse, mendicant priest, and mountain-bound pass—are varied in color and placement though retaining the color scheme of cherry and rust red, pale blue and green, and gold, peculiar to Roshū's screens. The stage-flat character of the mountains is already less accomplished than that of the older master. The curling stream motif at the right of the Cleveland screen | 83, also 83a, following page 54 | must derive from Kōrin and is the only note that betrays the eighteenth-century date of the painting. The little tea-ceremony screen | 84 | shows how the Utsunoyama motif, or any other, could be appropriately adapted to any format, even a circular fan.[32]

Others followed their immediate prede-

cessor, Kōrin, more closely. Watanabe Shikō (1683–1755), who began as a skillful Kanō-style monochrome painter,[33] painted at least one masterwork on a favorite theme of Kō-rin's—*Yatsuhashi,* from the *Isé Monogatari* (right).

Kōrin's version, now in The Metropolitan Museum of Art, made telling use of the combination of foot-bridges and iris, as did Hōitsu in the nineteenth century | 91 |. His second version abandoned the bridges and concentrated on a gorgeous large-scale com-position of the green, blue, and purple of the iris.[35] Shikō, wisely, did not attempt to rival the rich, almost florid design by Kō-rin but, in a stage sense, played it down. His iris | 85 | are made smaller, as if they were just appearing above the water or a mist on its surface. Like musical notations, they make a nervous and sprightly pattern a-

gainst the gold. These screens repay close technical examination for they are among the best preserved of all old Japanese screens.

Tatebayashi Kagei (flourished first half, eighteenth century) was a physician who became a pupil of Ogata Kenzan. He too followed Kōrin and is the probable painter of a close variation of one of Kōrin's most daring and amusing two-fold screen compo-sitions—*The Thirty-Six Poets* | 86, following page 90 |. Both the subject and the style are derived, as we have seen, from the Fujiwara court style, but the humorous elements have been enormously exaggerated and the com-plex patterning of the draperies in the older painting has been transferred to the over-all composition. The staccato repeats of bizarre shapes and colors reinforce the representa-tional caricatures and give an effect of witty visual irony. Should one ask, the thirty-sixth

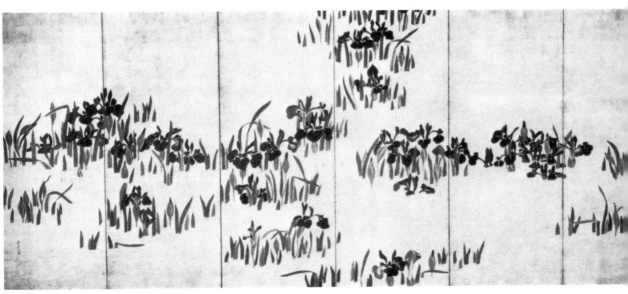

Once there was a man. That man regarded himself as a useless person and did not want to live in the capital [anymore]. He went [away] in the direction of Azuma with the intention to seek a province where he could dwell. He traveled together with one or two men who had been his friends for a very long time. There being no one who knew the way, they roamed about. They reached a place called Yatsuhashi in the Province of Mikawa. As to [the fact that] that place is called Yatsuhashi, because the rivers in which the water flows [from the swamp] branch [there] like the legs of a spider, [people] have placed eight bridges across [these branches]; therefore it is called Yatsuhashi. Having dismounted and being seated in the shade of a tree in the vicinity of that swamp, they ate dried boiled rice. In that swamp *kakitsubata* [iris] were blooming very pleasantly. Looking at them someone said: 'Compose a poem on [the subject of] "Travel Feelings," putting [one of] the five syllables of the word *kakitsubata* at the beginning of each line.' Because he had said this [that man] recited:

> As I have got a wife
> To whom I have become attached
> Just as one gets used to and fond of
> The skirt of a beautiful garment
> While wearing it—
> I feel miserable about this very journey
> On which I have come so far.

When he had thus recited, they all shed tears on the dried rice and it became soppy.[34]

85 | *Irises* by Watanabe Shikō, pair of six-fold screens

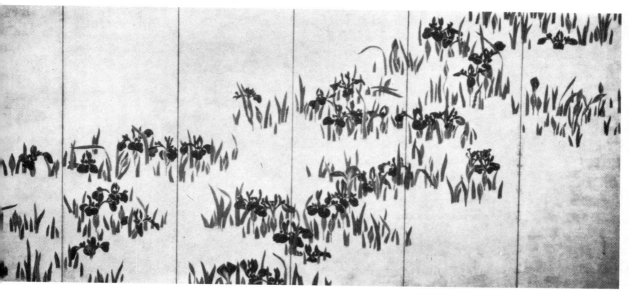

poet, the Princess Saigu-no-Nyogo (928–985) must be imagined as hidden behind the textile screen, seated on the imperial mat. Certain astringent colors, notably a peculiar orange, a mossy green, and tart pink, seem to confirm the attribution of this screen to Kagei when we compare it with a signed screen with chrysanthemums and snowy hills | 87 |.

The last really interesting master of the Sōtatsu-Kōrin line is Sakai Hōitsu (1761–1828), younger son of a *daimyo*, the Lord of Himeji. While he studied Chinese literaryman's painting *(bunjinga)*, and the plebeian Ukiyo-e style, his adopted and most characteristic manner is that of Kōrin. He made a compilation of wood-block reproductions of Kōrin's most famous compositions[36] and painted his most beautiful work, *Summer Rain and Autumn Wind*, on the back of a pair of two-fold screens by Kōrin.[37]

Traditional motifs by Hōitsu are not only interesting in themselves but also as the last successful essays in *Isé Monogatari* motifs—again *Yatsuhashi* | 90, 91 |. The two-fold screen is especially fine and compares favorably with the versions by earlier artists (see Figure 85, page 87). It is one of the rare examples of a screen painted on silk, and this, with the very wet pigments used, gives an effect of softness and subtlety quite unlike the sharper qualities of the paintings on paper and gold. Hanging scrolls on this ground were more common |88|.

Hōitsu's highly refined variation of Kōrin's art is just short of pretty. At its best, as in the two-fold screen *Ducks in Snow* | 89, following page 90 |, it is extremely beautiful with a touch of realism in the modeling of the rocks, tree trunk, and the ducks. Perhaps this is due to Western influence already clearly present in the wood-block prints of his day. But this realism foretells

88 | *Plum Blossoms* by Sakai Hōitsu, hanging scroll

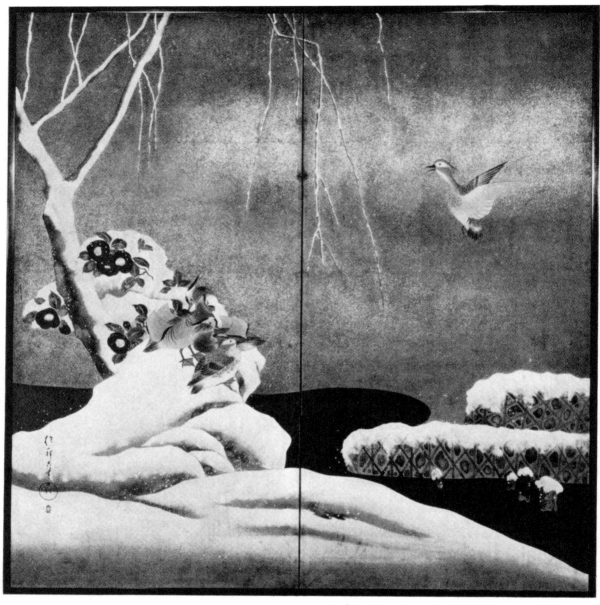

89 | *Ducks in Snow* by Sakai Hōitsu, two-fold screen

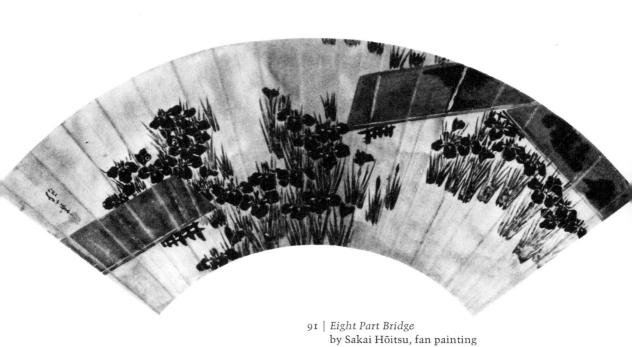

91 | *Eight Part Bridge*
by Sakai Hōitsu, fan painting

174 | Sword Guard, with iris

the death of the decorative style. The combination only succeeds here because of the complete dominance of the decorative mode. The later and modern academicians were forced to an ever harder compromise and the ultimate defeat is evidenced in the weak and pretty works of the contemporary Imperial Academy.

Nothing is so disturbing to a newly rich generation as the equally or more successful second generation. The crystallization of the Sōtatsu-Kōrin style, patronized at first by late aristocracy and newly-successful merchants, then by the still more successful merchants, accompanied the emergence of another artistic mode which can be loosely termed *Ukiyo-e*, pictures of the "floating" world. To traditional Buddhist eyes, this was the nature of the transient, all-too-human, and all-too-frail world of the newly created

92 | *Ideal Portrait of Fujiwara no Asatada* by an unknown artist, Tosa School, panel painting

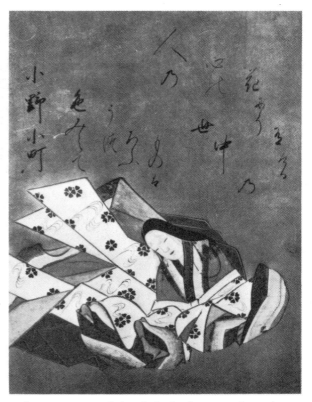

93 | *Sosei Hōshi* by Shōkadō Shōjō, panel painting 94 | *Ono no Komachi* by Shōkadō Shōjō, panel painting

urban centers, particularly Edo. We have already seen the financial orientation of Saikaku's *The Millionaire's Gospel Modernized.* This new class could support a Kōrin, who was somewhat more than they bargained for, or more directly appealing, understandable artists. These were the masters of Ukiyo-e, who reversed the emphasis of the great decorative artists by illustrating with the language of decorative style.

The early motifs had already been made available to the new class in the popularization of such aristocratic subjects as the *Thirty-Six Poets.* Some were in the form of votive tablets painted on wood | 92 | which arbitrarily combined the Tosa style of the figure with the wave pattern of Kōrin. These directly popular works are not without such unusual subtleties as the prunus above, light gold on a dark background on one panel becoming dark gold on light in the next. Others show a new orientation in their added emphasis on the patterns of the textiles worn by the poets and in the darkened and heavier lines used to define these draperies | 93, 94 |. Tosa screens representing such

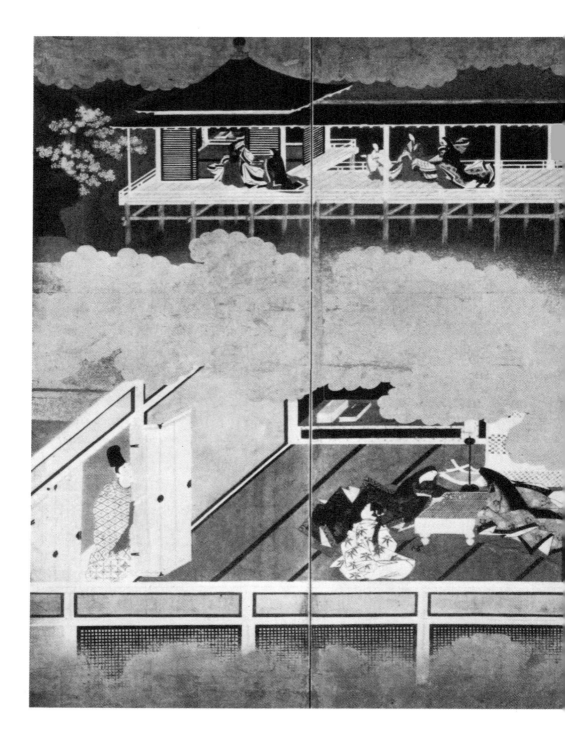

Scenes from The Tale of Genji by an unknown artist
of the Tosa School, pair of six-fold screens

classical subjects as the *Genji Monogatari*
|95| were produced in some quantity, and,
while the architectural patterns recall the
old manner, the delight in large and bold
textile patterns is more than merely a pass-
ing fancy. Again Saikaku sets the stage
(right).

The Tosa school, with its combination of
the old Yamato-e manner and overtones of
the realistic, narrative *e-maki* style, was ide-
ally suited to be a seedbed for the now be-
ginning Ukiyo-e. When the Japanese were
confronted with the novel problem of the
aesthetic utilization of the visually strange
and entrancing aspects of foreign trade, the
Tosa artists rose to the occasion. The appear-
ance of the Portuguese with their accom-
panying Jesuits at Nagasaki led to more than
religious persecution and financial benefit.
It became fashionable to dress in the Por-
tuguese manner and to paint pictures, usu-
ally in screen form, embodying these new
experiences in the Tosa style. In the process
of combining, something like fusion took
place and the result was a category, *Namban
Byōbu*, screens of the Southern Barbarians,
which are among the most satisfying prod-
ucts of late Tosa style. These screens |96|
are a completely convincing union of ob-
servant realistic detail in a large decorative
framework. The wave patterns, the strange-
ly flattened merchant ships, and the always
present schematic architecture and gold
clouds, produce an unforgettable and in-
exhaustible union of narration and deco-
ration.

Ancient simplicity is gone. With the growth of
pretense the people are satisfied with nothing
but finery, with nothing but what is beyond
their station or purse. You have only to look at
the way our citizens' wives and daughters dress.
They can hardly go further. To forget one's
proper place is to invite the wrath of heaven.
Even the august nobility are satisfied with
clothes of nothing more splendid than Kyōto
habutae silk, and in the military class the formal
black dress of five crests is considered ill-suited
to none, from minor retainers to the greatest
daimyo. But of recent years, ever since some
ingenious Kyōto creatures started the fashion,
every variety of splendid material has been used
for men's and women's clothes, and the drapers'
sample-books have blossomed in a riot of colour.
What with delicate Ukiyo stencil-patterns,
multi-colored 'Imperial' designs, and dappled
motifs in wash-graded tints, man must now seek
in other worlds for an exotic effect, for every
device on earth has been exhausted. Paying for
his wife's wardrobe, or his daughter's wedding
trousseau, has lightened the pocket of many a
merchant, and blighted his hopes in business.
A courtesan's daily parade of splendour is made
in the cause of earning a living. Amateur
beauties—when they are not blossom-viewing
in spring, maple-viewing in autumn, or being
married—can manage well enough without
dressing in layers of conspicuous silks.[38]

96 | *Southern Barbarians* by an unknown artist,
pair of six-fold screens

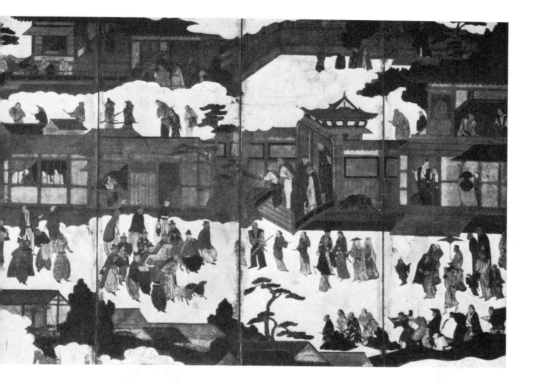
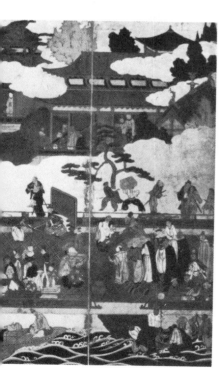

With tools such as these and the cultural climate of the rising urban classes, a new and creative variation on the decorative style was at hand. Its first unique manifestations are to be found in a group of screen and panel paintings representing charming ladies of the new pleasure-loving milieu. One set | 97, pair below and opposite this page | might also be an illustration to passages of another novel by Sai-

97 | *Dancing Girl* by an unknown artist, two of a set of six screen panels

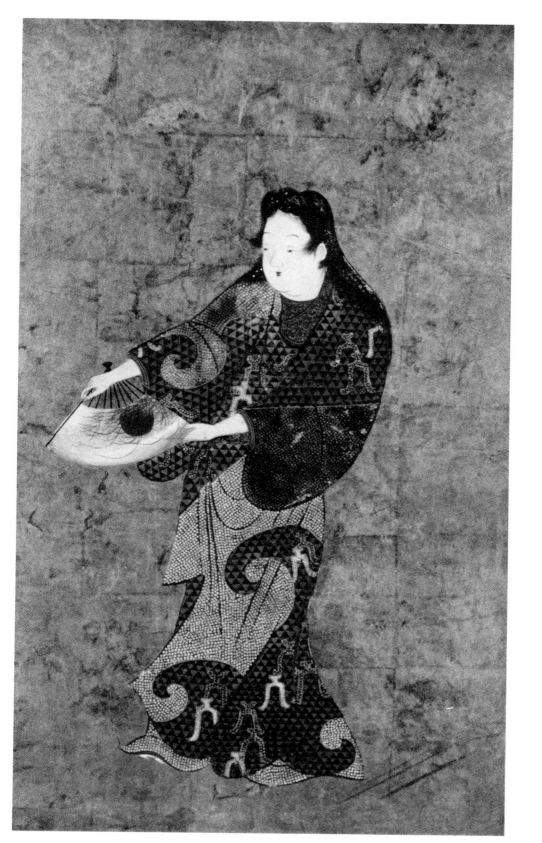

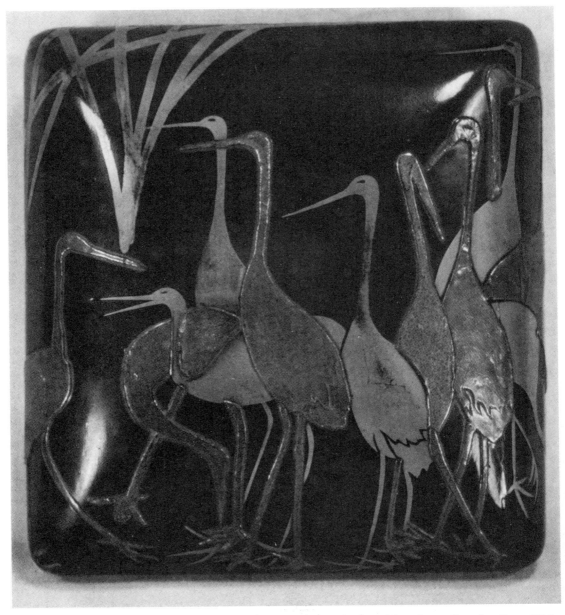

127a | Writing Box, with cranes and reeds, attributed to Ogata Kōrin

kaku in which leisure-possessing males an-alyse the merits of the passing parade (right).

What is important to realize here is that the representation carries the flavor of this urban *demimonde* but the aesthetic devices are remarkably similar to those used by the Sōtatsu-Kōrin school. Instead of waves patterned to the edges of a boundary, there are the omnipresent textile patterns, obsessions of a society concerned as much with the up-to-date as was that of Lady Murasaki. The gold ground, the varied silhouettes, and the ringing, pure color are common to Kōrin and the unknown early Ukiyo-e master of the dancing girls. The fans they hold might well be after designs of the Kōrin school.

Occasional screens of early Ukiyo-e carry subject realism to a point that might well have amused Saikaku. *The Innkeeper Presents His Bill* | 98 |, attributed to the school of Matabei, a leading, if shadowy, master

of the early years of Ukiyo-e, is a decorative small screen which could certainly not have been used for the tea ceremony!

Next, with a litter borne luxuriously beside her, came a thirteen- or fourteen-year-old girl whose hair was combed out smooth, curled a bit at the ends, and tied down with a red ribbon. In front her hair was parted like a young boy's and held in place by five immaculate combs and a gold hair-clasp. Her face was perfectly beautiful, and I shall not tire you with needless details. A black inkslab pattern adorned her white satin chemise; a peacock design could be perceived in the iridescent satin of her outer garment. Over this hung lace made from Chinese thread and sleeves which were beautifully designed. A folded sash of twelve colors completed her ensemble. Her bare feet nestled in paper-strap clogs, and one of the litter-bearers carried a stylish rainhat for her.[39]

| *The Inn-Keeper Presents His Bill* by an unknown artist of Matabei School, two-fold screen

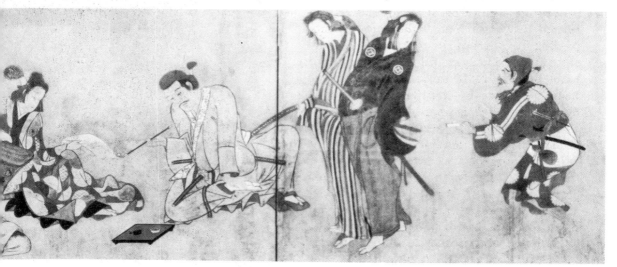

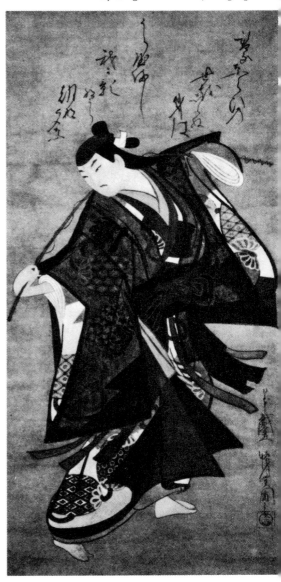

As time went on even the urban masses became a market for the bold new style in painting, but especially for the rising manufacture of economical wood-block prints. The heros and heroines of the day were the actors in the popular *Kabuki* drama and the courtesans of the Yoshiwara in Edo. A group of artists around the originator of the school, Kaigetsudō Ando (active 1680–1717), were among the first to hammer out a style which can be clearly described as *Ukiyo-e*, rather than as a near derivative of the Tosa or other schools. Actors are rarely the subjects of paintings by the Kaigetsudō group, but one of Sanjō Kantaro |99| may introduce us to the new fashion. If one compares it with other scrolls representing courtesans |100, 101|, one device leaps to the eye. This is decorative motif painting specialized and turned inwards. The silhouette encompassing the poses of the figures is relatively stereotyped. There are minor variations but basically they are the same twisting postures heavily cloaked by the masses of drapery. Everything depends upon what happens inside the boundaries, even if it is partially hidden by the translucent overgarment worn by Sanjō Kantaro. Blossom and lattice, flying geese, varied colors, sinuously flowing drapes, or angular and nervous ones—these are the means of variation. It is an art for those concerned with fashion and part of a culture that can afford a decorative style.

Despite the usual attribution of coarse and plebeian qualities to the Kaigetsudō

100 | *Portrait of a Woman Wearing a Kimono*
Decorated with Orange and Blue Blossoms
by Kaigetsudō Ando, hanging scroll

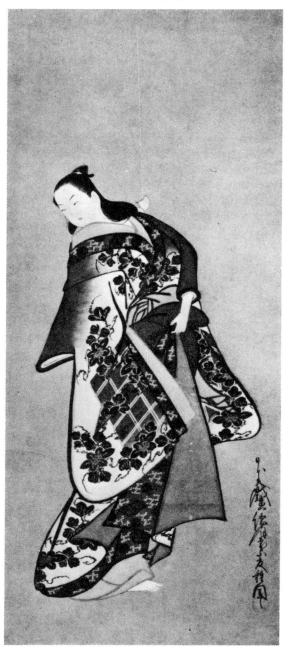

101 | *Portrait of a Woman Wearing a Kimono*
Decorated with Flying Geese
by Kaigetsudō Dohan, hanging scroll

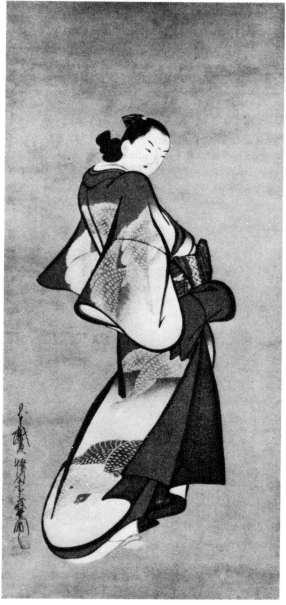

and other early Ukiyo-e artists, one can hardly fail to note that at least one of their technical devices is drawn from the Sōtatsu-Kōrin tradition. The broad, flat brush outlines around the shapes served them, as it did the others, as a means of maintaining the essentially flat and decorative character of their work. The more complicated problems of placement and relationship are outside the given limits of their art. However charming the later Ukiyo-e paintings may be | 102 | they cannot avoid being somewhat incongruous. Two elegant courtesans in a decorative architectural and cloud setting going back seven hundred years to the world of Lady Murasaki seem somehow out of place. If we had no knowledge of the evolution and ramifications of Japanese decorative style, then that of Shunshō's small painting would open a new vista in the history of art. And so it did for the European art world of the late nineteenth century. But one of the most original artists of the school, Sharaku (active 1794–1795) was an interloper whose aristocratic and ironical works were evidently not popular. His excessively rare paintings | 103 | are a masterful combination of decorative style and ironic realism. But they stand quite alone, and for the most creative productions of the *Ukiyo-e* artists one must turn to their wood-block prints.

The wood-block printed book usually accepted as the first popular and successful

102 | *Two Courtesans Writing a Letter* by Katsukawa Shunshō, hanging scroll

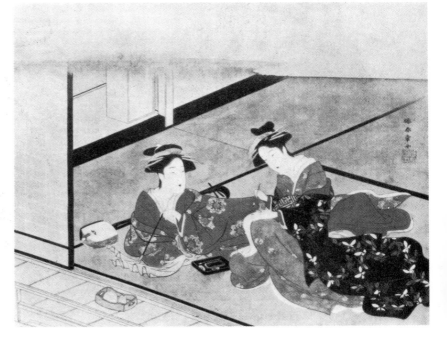

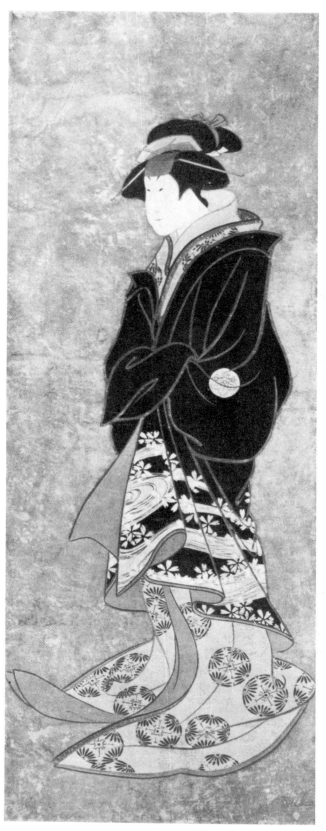

103 | *The Actor Nakayama Tomisaburō*
by Saitō Sharaku, hanging scroll

106 | *Girl Holding a Small Lantern and Fan*
by Ishikawa Toyonobu, woodblock print (left)

107 | *Feeding the Carp at Kameido*
by Isoda Koryūsai, woodblock print (right)

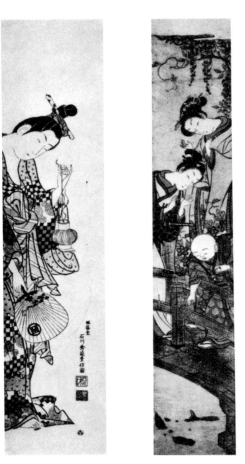

105 | *The Actor*
Fujimura Handayu
as a Woman
by Torii Kiyomasu, I,
woodblock print

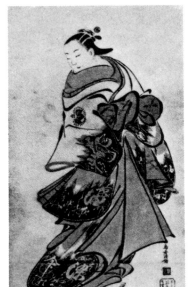

104 | *Happy Ending* by Okumura Masanobu, woodblock print

exploitation of the new genre was an *Isé Monogatari* of 1608. The remote delights of aristocratic literature and feeling were now to be offered to the economically under-privileged. It must always be remembered that the wood-block production was only possible by collaboration among artist, designer and the numerous technicians, the block cutters, and those who applied the colors, at first by hand and later by means of separate blocks for each color. Fame was the designer's reward; but it was dependent upon success with the urban masses.

108 | *An Eagle on a Cliff Near a Kiri Tree,* attributed to Kiyomasu, I, woodblock print

At first the wood-block prints were largely derived from the illustrated book tradition of the Tosa school but they soon became reproductions of paintings in the rising Ukiyo-e style | 105 | which we have seen in the work of the Kaigetsudō artists. The patterned motifs of the costumes sometimes employ decorative calligraphy integrated with the draperies, just as the earlier lacquer artists incorporated cursive writing in their rocks (see Figure 38, page 43). Some early prints develop the decorative script to a point where it becomes the costume | 104 |, supplementing the accompanying cursive text. But this device was of passing and specialized interest. Other specializations in the Ukiyo-e prints led to extreme peculiarities of format, notably in elongated, asymmetrically designed "pillar" prints | 106, 107 |.

Another popularized art was the Kanō tradition, at first in rather coarse, almost folk-art productions | 108 | and later in technically elaborate productions which rival the Momoyama screen paintings in their rich decorative effects | 109 |.

Some idea of the rapid development of the art of wood-block printing can be gained by comparing two prints illustrating the *Tale of Genji*, one of ca. 1710 | 110 |, the other of 1792 |111|. From a simple printing in black ink *(sumizuri-e)*, decorative only in such details as the old motifs of butterfly and pine, the publishers moved to multicolored prints which express a unified style exploiting in eclectic fashion the decorative elements of the Yamato-e (clouds, architecture, rocks, and cloth screen), and Kanō (drawing of trees and foliage) traditions. The figures,

110 | *Genji, the Kiri Chamber*
by Okumura Masanobu, woodblock print

111 | *The Maple Fete* by Chōbunsai Eishi, triptych, woodblock print

however, express admiration for the courtesan beauties of the day. No wonder the Kyōto aristocrats, *daimyo*, and merchants looked down on such a vulgarization of a classic work of literature, titled *Genji Presented in Popular Fashion*.

The classic period of Ukiyo-e printing began with the development of multicolor printing *(nishiki-e)* about 1765 and ended about 1800 when Western influences and more realistic interests produced the art of Hiroshige and Hokusai. The first great master, Harunobu (1725–1770), set the tone for almost all of the artists in this heyday of the print. He was the first to design prints using decorative effects appropriate to the medium—velvety black backgrounds |112| or rhythmically repetitive engraved lines |113| which complement the by now traditional patterned garments of the delicate lower-class beauties. Harunobu's works reflect an impeccable taste, popular, but not unlike that of the Yamato-e painters, particularly in the just-so placement of his pictorial units and the delicate lines and patterns in his figures. Later designers maintained

112 | *Looking for Insects at Night*
 by Suzuki Harunobu, woodblock print

113 | *A Young Woman in a Summer Shower*
 by Suzuki Harunobu, woodblock print

his tradition with personal variations | 114, 115, 116, 117 |, but a tendency to decorative exaggeration, notably in the elongation of the figures | 118 | and the multiplication of environmental detail | 115 | is progressively evident. The print by Kiyonaga also shows a growing realism in the space setting, in the drawing of the tables, mats and grille, and in the moonlit view across the bay. The publishers knew, as the Marxists do now, that popular art is realistic art.

The backgrounds used on many of the single-figure prints were a particularly fertile area for decorative development in the old tradition. Since gold and silver were prohibitive in cost and were prohibited by the government, other techniques were developed. The most elaborate and effective solid color backgrounds were applied in mica, usually dark gray-black | 119 | or, more rarely, colored—pink in the case of the ravishing print by Utamaro | 117 |.

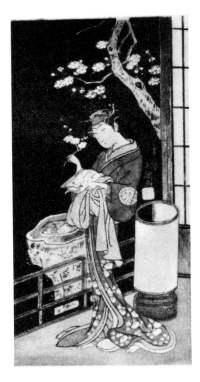

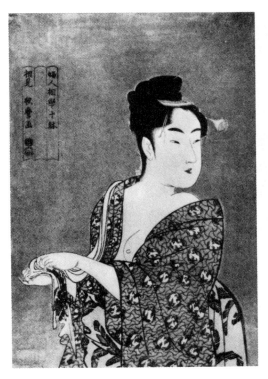

TOP ROW, LEFT TO RIGHT
114 | *Segawa Kikunojō, II, as the Courtesan Hitachi*
by Ippitsusai Bunchō, woodblock print
115 | *The Ninth Month* by Torii Kiyonaga, woodblock print
116 | *A Lady and a Child at Night Catching Fireflies*
by Eishōsai Chōki, woodblock print

BOTTOM ROW, LEFT TO RIGHT
117 | *Uwaki* by Kitagawa Utamaro, woodblock print
118 | *Portrait of the Actor Iwai Hanshirō, IV, as Sakurai*
by Utagawa Toyokuni I, woodblock print
119 | *The Actor Segawa Tomisaburō as Yadorigi*
by Saitō Sharaku, woodblock print

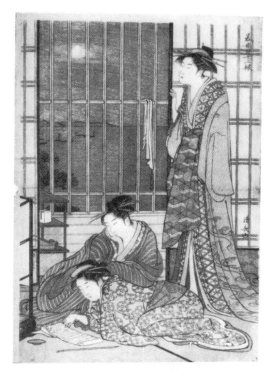

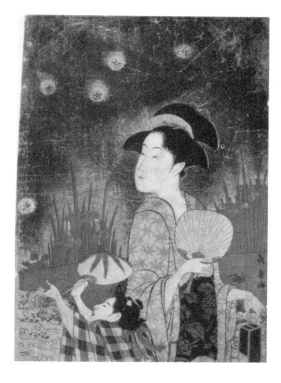

After 1800 the two famous names of Hokusai (1760–1849) and Hiroshige (1797–1858) dominate the print scene. The former's voracious artistic appetite led to an enormous and varied production. His views of specific scenic places in Japan | 120 | were considered to be the last word in realism, though today they clearly display strong Chinese influence combined with powerful decorative designs. These are much dependent on the dominance of one much enlarged and stylized unit: Mount Fuji, a wave, or, in this instance, a waterfall. This is primarily a decorative device and is used in his "ideal" prints as well as in his scenic views. Hiroshige's prints are usually more seductive and more realistic with their low horizons and atmospheric effects | 121 |. Still, today they seem primarily decorative, especially in their simple silhouettes, carefully placed and varied in tone.

A series of three iris prints, one of them the old Yatsuhashi motif, may serve to demonstrate the rapid decline of the traditional decorative style in the face of a rising interest in realism and the accompanying striking visual effects. Chōki's night scene | 116 | is still in the old vein, the representation of the iris not far removed from that of the Sōtatsu-Kōrin school. This ancient feeling pervades the print, whether in the rippling water, or the mica ground with its carefully spaced fireflies. Hokusai's *Yatsuhashi* | 122 | is a more realistic view, pleasantly exaggerated to be sure, but still a "scene" in which the motif is absorbed into its prosaic setting. The gazetteer-like title informs us, "The Eight Section Bridge in Mikawa Province in Olden Days," from the series, "Novel Views of Famous Bridges in Various Provinces." Hiroshige's *Iris Flowers at Horikiri* | 123 | is almost a "gimmick," beautifully drawn, decorative, but at least

120 | *The Waterfall of Ono on the Kisokaidō* by Katsushika Hokusai, woodblock print

partly an ancestor of striking and unusual photography. The beholder's viewpoint has shifted from recognizing an idea expressed in a motif, to sharing the eye of the artist in his search for novel effects.

The Ukiyo-e prints were the last effective Japanese pictorial expression before modern times and, in part, represent the end of Japanese decorative style as expressed in painting. Seeing this style, even remotely mirrored in its last works, the Western artist and connoisseur recognized an art comparable to one of their pictorial aims, the making of handsome pictures for eyes conscious of design and nuance.

121 | *Morning Mist at Mishima*
by Ichiryūsai Hiroshige, woodblock print (top)

123 | *Iris Flowers at Horikiri*
by Ichiryūsai Hiroshige, woodblock print

122 | *The Eight Section Bridge in Mikawa Province in Olden Days* by Katsushika Hokusai, woodblock print (top)

124 | *The Poet Li Po Admiring the Waterfall of Lu-Shan* by Katsushika Hokusai, woodblock print

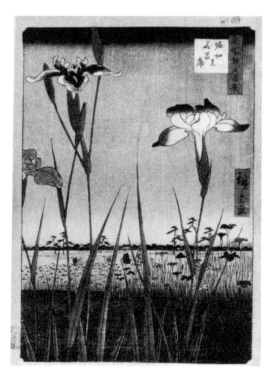

126 | Charcoal Brazier, with crests and grasses

The useful arts made in the second major period of Japanese decorative style, like those of the late Heian period, bear the same aesthetic stamp as do the pictorial arts. They are the products of varied but related tastes of a culture with an integrated way of arranging things. As one might expect, the age-old tradition of wood and lacquer-work usually present a more conservative appearance than the newer mediums of fancy metalwork and, particularly, porcelain.

Large, carved and pierced wooden panels (*ramma*) were used in large rooms to fill the

space between the lintel immediately above the sliding panels and the roof joist. These were rather simply treated before the Momoyama period. The vigorous and rich tastes of Hideyoshi and his successors, brilliantly served by the Momoyama screen painting style, were also satisfied by the virtuoso development of the *ramma* made for their buildings. Elaborately carved and colored, they are pictorial sculptures, repeating the motifs and gorgeous appearance of the screen paintings by Kanō Tōhaku, Kanō Takanobu (see Figure 58, page 59; and Fig-

ures 59 and 59a, page 54) and others. Momo-yama lacquer also uses Kanō subjects, but with patterned, overlapping arrangements recalling late works in Fujiwara style. Again one notes the profuse, rich decoration in typical Momoyama taste. The most commonly repeated motif in Momoyama lacquer is the flower or grass spray, covering most of the lacquer surface. This sometimes delicate, web-like representation is often contrasted with larger gold areas, either arbitrary angular flat areas of plain and sprinkled gold |125|, or crests of imperial or *daimyo* usage |126|.

Nearly all of the sophisticated gold lacquer work of the Edo period expresses a taste for wealth. The Momoyama designs are gradually replaced by eclectic Tosa and Kanō combinations unified by a quantitatively rich use of gold. The common method of judging the quality of these objects made for the *daimyo* and wealthy merchants depends largely on the weight of the individual piece. Despite the often superb craftsmanship, the creative and aesthetic worth of late maki-e can usually be measured in inverse proportion to the verdict of the scales.

The most interesting lacquers of this time were made or designed by the leading masters of the Sōtatsu-Kōetsu-Kōrin school. The names of Kōetsu and Kōrin in particular are associated with a number of unusual boxes, usually for writing *(suzuri-bako)*. These employ new techniques and materials reflecting the modified tea-taste of the school. Lead, pewter, grainy wood, and mother-of-pearl are combined with gold lacquer on these boxes in overlapping, collage-like silhouette designs recalling the screen paintings of their makers. The motifs are from the usual sources of this group of artists, Heian poetry, the *Isé Monogatari,* and other tales. Many of the designs are repetitions of those

125 | Incense Burner with Cover, with flowers of autumn

127 | Writing Box, with cranes and reeds, attributed to Ogata Kōrin. See also Fig. 127a, following page 98.

129 | *Writing Box*, with cart

already used in existing screen paintings— Kōrin, for example, used the crane motif and *Yatsuhashi* for both screens and lacquer work | 127, 127a, following page 98 | . Even the shapes of the boxes reflect the original bent of the artist's mind. Instead of the traditional flat or very gently curving surfaces, the boxes by Kōetsu and Kōrin exaggerate curving surfaces to produce a dome-like effect. This sculptural treatment, combined with the sparing use of gold and the use of sober materials expressing *shibumi*, produces an effect that is in complete

harmony with the Sōtatsu school paintings.

Slightly later, artists specializing in lacquer work, like Ritsuo (1663–1747), exploited the new vocabulary of materials, adding glazed ceramic bits and reintroducing finely wrought gold lacquer | 129 | . However, his productions and those of his numerous imitators seem more a tasteful but calculated *mélange* of academic Tosa and tea-taste styles than a creative continuation of the original contributions of Kōetsu and Kōrin.

In metalwork we find the same wide-ranging interest in such exotic materials as

128 | *Writing Box,*
with boat among reeds,
attributed to
Honnami Kōetsu

inlays in bronze, iron, or steel. As the sword became more a badge of honor than a much-used weapon of war, more and more attention was lavished on the decoration of its accoutrements—scabbard, small knife *(kozuka)*, the handle with its decorative inserts *(menuki),* and the sword guard *(tsuba).* The latter in particular became a specialized decorative format. Like the bronze mirrors of the Fujiwara period, their almost circular field became a standard parade ground for the display of effective decorative design. The literary motifs used were the common property of all artist-designers, whether poets, painters, lacquer-makers, or metalworkers. One can find the whole range of Japanese decorative style patterns and motifs in these *tsuba.* Eleven have been illustrated in proximity to paintings and lacquers which use the motif shown in a particular *tsuba.* By the Edo period numerous wood-block printed copybooks of design motifs were available and used by all craftsmen. While this resulted in consistency, it also led rapidly to the fossilizing of once creative design.

130 | Nō Robe, with flowers of the four seasons and landscapes; detail, above

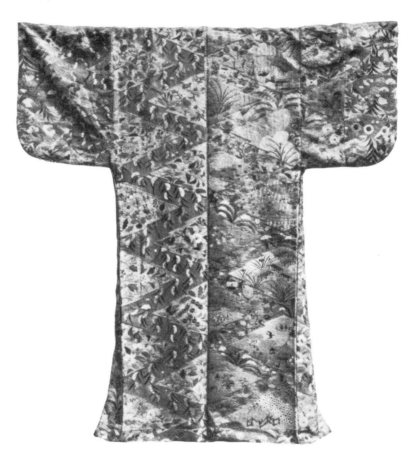

The early Ukiyo-e style exploited the decorative possibilities inherent in the gay patterns worn by the beauties of the *demimonde*. Textile design was one of the most important outlets for decorative style in the Momoyama and Edo periods. The more common patterns for normal wear can be studied in the paintings, but certain important costumes reached a higher artistic level, especially the robes used in the Nō drama | 130, 131, 132 |, and the ceremonial wedding *furisode* | 133 |. As in other media, a wide variety of complex techniques was developed in the textile arts and used for presenting the familiar motifs. Thirty-one panels of an unusually gorgeous Momoyama Nō robe are devoted to representations of flowers and landscapes from the *Isé Monogatari*. Figure 130 shows the most popular of *Isé* motifs, *Yatsuhashi*.

The diapered background or framework of the design is comparable to that on a lacquer box of the same period (see Figure 125, page 113). Single motifs, again the omnipres-

132 | Nō Robe, with autumn flowers

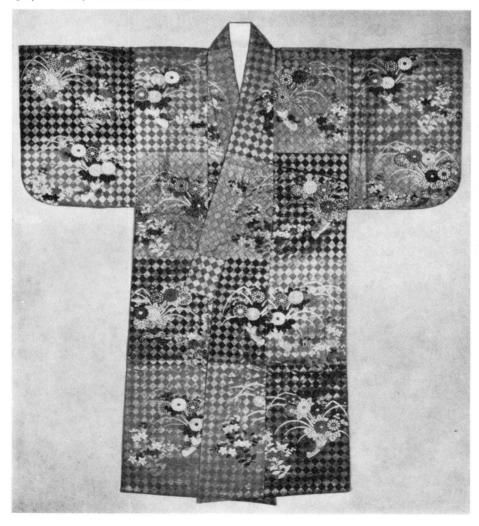

ent iris motif, were used as well, much enlarged but held to the surface of the cloth by a reinforcing allover pattern derived from the art of basketry | 131, following the opposite page |. The coloring of this robe is worthy of a great screen painting. The gorgeousness of these costumes was a clever contrast to the severely controlled, subtle text and movements of the Nō dance-drama. It should be remembered that the richly decorated costumes indicate traditional aristocratic characters and that the brilliant display of the costume was enhanced by the ideal, almost expressionless masks worn by the players in human and divine roles. The Nō play, like so much of Momoyama and Edo art, reflects Japanese taste

filtered through the Zen tastes of the Muromachi period.

Like lacquers and ceramics, some costumes were designed and executed by important artists such as Kōrin and Tanyū. These are usually in the form of paintings on a plain or satin-weave cloth | 134 |, and with few exceptions the attributions to individual artists are based on uncertain traditions. Nevertheless, we are again reminded of the fundamental decorative unity of much Japanese art. Everything done or used in life was a possible means of decorative expression.

If the traditional arts of lacquer and woodwork were relatively conservative, the newly acquired art of making true porcelain

133 | Furisode of a ceremonial wedding costume, with storks (or cranes) of the pine-grove of Chiyo

134 | Robe painted with *The Three Friends*

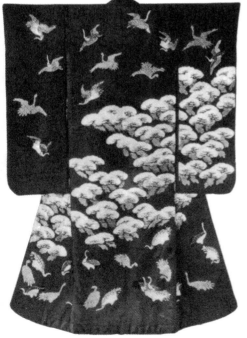

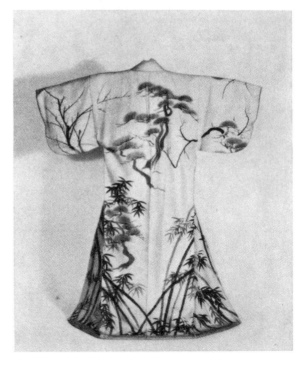

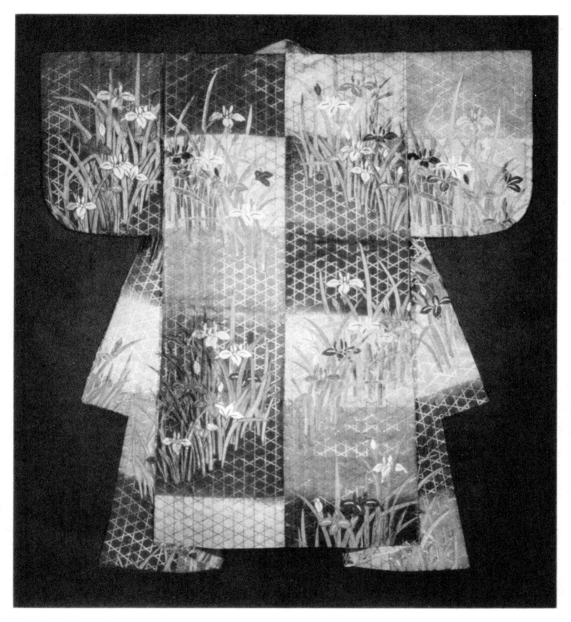

131 | Nō Robe, with iris

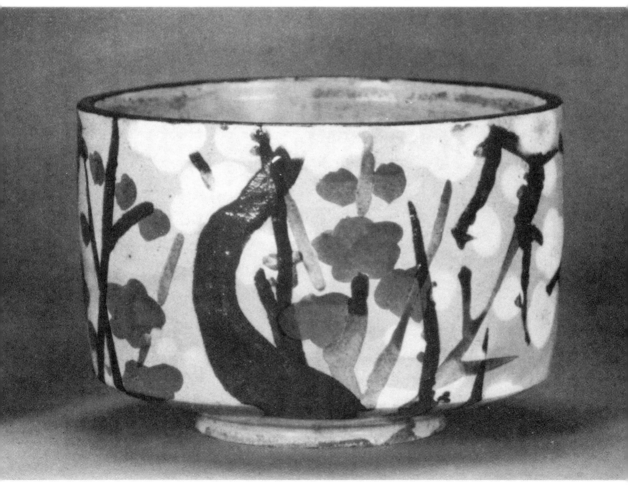

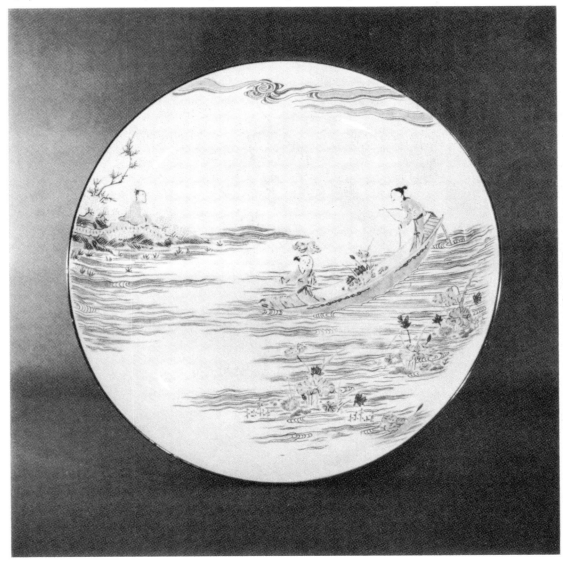

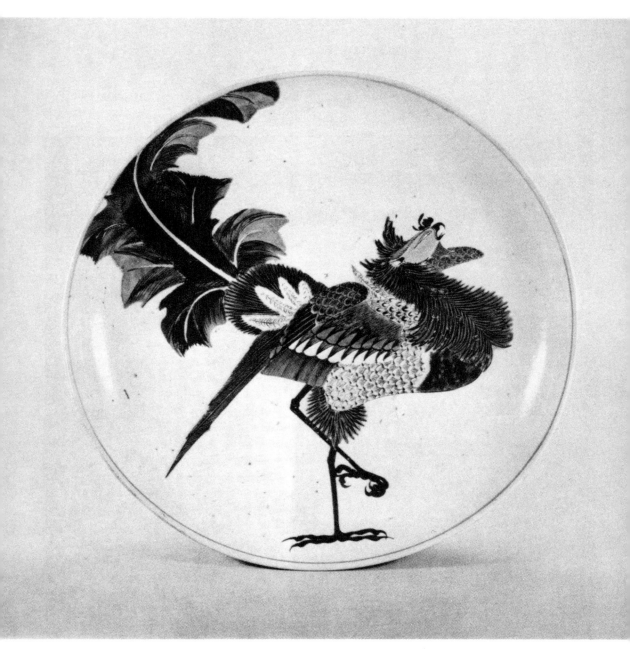

156 | Kutani Ware Plate, with phoenix

stimulated a remarkable burst of creative activity. The earthenware and stoneware tea tradition of the Muromachi period was by now tired and unproductive, save for the work of a very few artist-potters. The deliberately rough and sober art of the tea-master potter was hardly adaptable to the rising demand for decorative color and design in all the arts. Again we find the Sō-tatsu tradition providing a creative thrust. Naturally Kyōto would be the center for a ceramic art in this style and flourishing workshops developed there in the mid-seventeenth century. These are principally associated with the monk-artist-potter called Ninsei (died after 1677) who was responsible for the first ceramics that reflected the developing decorative tastes in the period. Most of his surviving works are large jars for storing tea or smaller water jars. One of these latter ceramics is a splendid combination of Sōtatsu style and Momoyama gorgeousness |135|. Ninsei succeeded in fusing overglaze enamels with a control of shape, tone, and hue which is nothing short of miraculous. The soft transparent greens and the brilliant reds are reinforced with gold, a technique probably derived from both the gold grounds of the screens and gold lacquer. The old Yamato-e technique of using sprinkled cut gold squares and gold powder is further evidence of his close relation to the Sōtatsu school.

Note, too, the decorative style device of arbitrarily cutting and framing an asymmetrical and natural floral picture with a richly developed allover pattern related to textile designs. The shape of the panels and of the framing patterns is derived from such furniture forms as the Chinese garden seat

135 | Water Jar by Ninsei, with peonies in panels

138 | Arita Ware Porcelain Jar,
with floral design

and Japanese lacquered pedestal-stands. The allusion to other media confirms the broad unities of seventeenth century style.

The artist-potter stoneware tradition was continued by the brother of Sōtatsu's successor, Kōrin. Ogata Kenzan (see Figure 82, page 83) was especially famous for his decorated tea-ceremony wares | 136, following page 118 |. These wares maintain the sober Muromachi tradition espoused by Kōetsu in shape and glaze, but add rich decoration in accordance with the taste of the Genroku period. Unlike Ninsei's more careful work, Kenzan's pots, dishes, and bowls are painted in a very free manner, emphasizing happy accidents of the brush in flowing color. The decoration, in keeping

with Japanese decorative taste, is seldom self contained, but is usually in the form of segments or sections of a pattern or motif designed, nevertheless, for the particular shape of the ceramic. The tea bowl with red prunus *(Yari-umé)* is one of his finest efforts. Other anonymous artists and tea masters followed this tradition in low-fired, glazed earthenware tea bowls called *raku* ware, using motifs such as the crane, derived from Kōrin and his school | 137 |. Kenzan's line continued through eight generations of artists using the same name, but their works are repetitions of his original contribution.

The greatest ceramic activity in decorative style was in porcelain, first produced in Japan about 1616 by a Korean potter, Ri Sam-

120

pei. Ri was one of the numerous Korean craftsmen who immigrated to Japan under the auspices of Hideyoshi and his immediate successors. Ri made the first discovery in Japan of white porcelain clay in 1615, near present-day Arita, and this area became the principal center of Japanese porcelain production although other deposits were found elsewhere. The early porcelains were principally white with rough underglaze blue decoration in a loose Korean or southern Chinese manner. But this decoration was soon modified in accordance with Japanese tastes. Thus, about 1650 a subtle overglaze colored-enamel style developed, called *Kakiemon* after its traditional originator. At the same time a quite different decorative style, more akin to early Ukiyo-e, developed in association with the name of the Kyūshū port of exportation, Imari. The Lord of Nabeshima ordered the founding of a special kiln in 1722 and this produced carefully controlled porcelains restricted to *daimyo* use. Other types followed, and it is quite impossible to clearly distinguish the origin of all the extant examples. The earliest wares can be described as Arita porcelain, while the later Arita productions can at least be classified as to three major types according to the style of their decoration—Kakiemon, Imari, and Nabeshima.

The early Arita polychrome porcelains are roughly but strikingly decorated with mixed motifs—in these cases, Chinese late Ming-type floral decoration | 138 |, or Kanō-style tiger and bamboo | 139 |. Both pieces, however, use the red enamel "chain-mail" pattern in a way that is quite un-Chinese or un-Korean, particularly in the cloud pattern of the dish. These traces of native decorative taste indicate the nature of the achievements to follow.

137 | Raku Ware Tea Bowl,
with crane on the outside, turtle inside

139 | Arita Ware Porcelain Plate, with running tiger motif

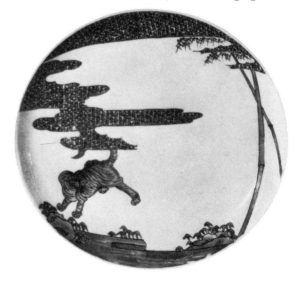

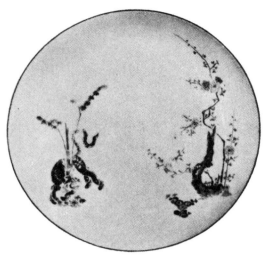

141 | Kakiemon Ware Plate,
with tiger, bamboo, and flowering tree

The developed Kakiemon style is well known to collectors of European porcelain for it was the inspiration | 142 | for much Meissen decoration and, through the famous Dresden products, of some French and English porcelain and soft-paste. The Kakiemon ground, a warm bone white, is ideal for delicately colored enamel painting in Kanō style | 141, 144 |, and this comprises a high proportion of Kakiemon production. Rarer types take advantage of the ware's natural qualities of delicacy and refinement in almost pure Yamato-e decoration | 140, following page 118 |. Rocks, curling cloud strips, and particularly the rippling water,

142 | Kakiemon Ware Bottle, with sprays of blossoms

143 | Kakiemon Ware Sake Bottle, with fox and vine

all seem to be a re-creation of Fujiwara compositions (see Figure 35, page 40; Figure 36, page 41; and Figure 38, page 43). The boating plate could never be confused with a decorated Chinese porcelain. The Japanese potter also experimented with "odd" asymmetric shapes bearing sympathetic decoration |143| recalling the soft washed backgrounds of Sōtatsu and Kōetsu. Another Japanese shape is seen in the pair of bowls with heavily everted rims |145|. Again, the asymmetric decoration of the unusual shape is more un-Chinese than usual, combining a net pattern and a floral spray in a design recalling textiles like those used in *furisode*.

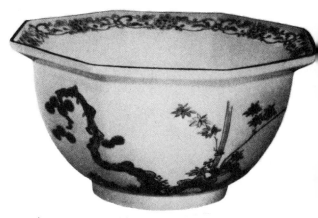

144 | Kakiemon Ware Bowl, with *The Three Friends*

145 | Kakiemon Ware Bowl, with blossoms, berries, branches, and textile motif

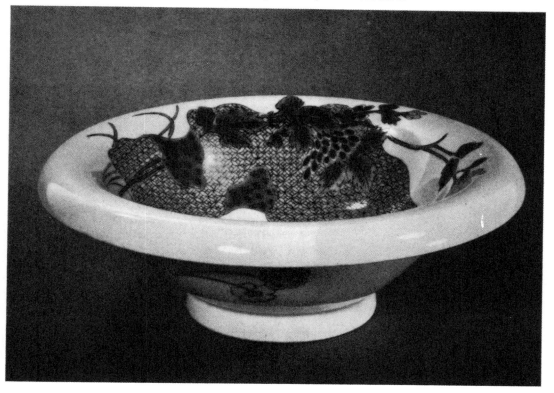

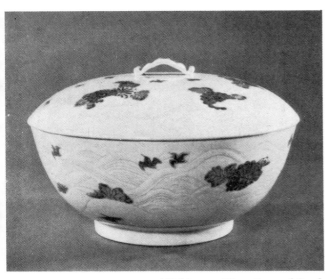

147 | Kakiemon Ware Covered Bowl,
with chrysanthemums and chidori

146 | Kakiemon Ware Bowl,
with eight-petaled rim, dragons, and clouds

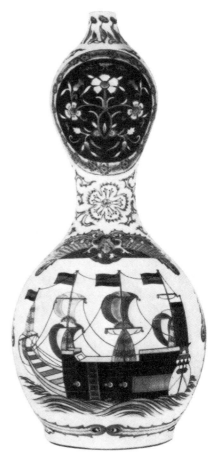

148 | Imari Ware Vase,
with Dutchmen and foreign vessel

As technical skill became more highly prized, the Kakiemon ware makers experimented with molded designs supplementing the enameled decoration | 146 |. The raised design here is derived from Chinese examples while the delightfully spaced painted decoration of the running boy and flowers seems completely Japanese. A slightly later and extremely rare example of a covered bowl | 147 | unifies the two ceramic decoration techniques in completely traditional Japanese taste—molded waves with *chidori* and sprinkled flowers in enamel and gold.

149 | Imari Ware Rice Container

Imari-type porcelains are more heavily decorated than Kakiemon ones, usually using a seal-wax red enamel and a dull underglaze blue sometimes supported with a mat black enamel and gold. The Imari decorative taste is comparable to that of Ukiyo-e and one category, often exported, uses the *Namban* or Southern Barbarian motifs so characteristic of early seventeenth-century screen painting | 148 |. The base of this double gourd vase has an engraved tulip decoration filled in with black which was probably added in Holland or the Dutch East Indies. Other Imari wares combine European style decoration such as that on the flange of the rice container | 149 |, with such hoary motifs as the turtle-shell pattern. Still others are completely Japanese, displaying a sprinkled chrysanthemum pattern reinforced with gold in lacquer style | 150 |.

151 | Nabeshima Ware Plate, with textile design

152 | Nabeshima Ware Plate, with lotus and leaves
in *ju-i*-head shaped cartouches

153 | Nabeshima Ware Plate, with blossoming branch of camellia

If Kakiemon represents Kanō or Yamato-e taste and Imari is akin to Ukiyo-e, Nabeshima ware displays a *daimyo* taste for a cold and perfect version of Momoyama decorative style. The Nabeshima kilns were the most rigidly controlled of all factories. Production was secret and limited, and the careful bookkeeping records of the house of Nabeshima seem a proper counterpart to the cold white perfection of the ceramic results. Most of the decorative patterns used were derived from the numerous copybooks published in Ōsaka and Edo, and were scrupulously codified and handed down. Rich "brocade" patterns used the clear underglaze blue and overglaze red, turquoise blue, and yellow enamels for excellent results | 151 |. Traces of the bold Imari style are sometimes found | 152 |, but are presented with much greater perfection. The most beautiful pieces temper this perfection with brightly colored asymmetrical floral designs | 153, 154 | which recall the brilliant decorative style of Kōrin (see Figure 75, page 75, and Figure 80, page 81), Shikō (see Figure 85, page 87), and Hōitsu (see Figure 89, following page 90).

The most original and purely handsome decorated porcelains were made at the Kutani kilns far from Arita in central Japan under the lords of Maeda in Kaga prefecture. The Kutani wares are most distinctive in their powerful masculinity and in their fusion of the roughness of tea-taste, the deep and somber colors of Momoyama decoration, and daring decorations recalling the finest efforts of Sōtatsu and his school. The best period of production for these wares was from about 1650 to 1700 and the magnificent examples of this time are traditionally designated as Ko-(old) Kutani.

Beginning with porcelains that conform to stoneware standards of appearance | 155 |, the potters soon produced enameled porce-

155 | Kutani Ware Plate, with leaf in reserve

154 | Nabeshima Ware Plate, with cockscomb

158 | Kutani Ware Plate, with bird and flower

159 | Kutani Ware Plate, with quail on a rock, and peon

157 | Kutani Ware Plate, with landscape

lains, usually without the use of underglaze blue, that are similar to, and often confused with, early Arita wares.

The large Ko-Kutani ware plate with the decoration of a proudly strutting phoenix | 156, following page 118 | is one of the world's ceramic masterpieces and a complete epitome of the best and most forceful Genroku period decorative taste. Other examples of the same period and style use more traditional and less bold designs, either landscapes | 157 | or decoration of birds and flowers | 158, 159 |. The Kutani artisans often enhanced these designs with strongly conceived textile-like patterns held within geometric boundaries and occasionally they made use of such motifs in an allover decoration.

160 | Kutani Ware Plate,
with over-all scroll and branch of leaves

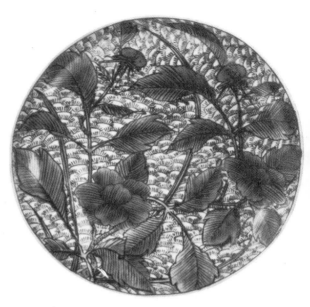

161 | Kutani Ware Plate,
with leaves laid on allover imbrication

The end of the early period of Kutani production saw the development of an even stronger and richer decorative scheme designated as "green" Kutani. These wares, usually dishes and plates, combine large areas of green and mustard yellow with the more usual notes of aubergine and blue |160|. Some of these are gray-buff stonewares; but even when the body is white porcelain, little, if any, white is permitted to show. The large-scale designs of patterned leaves and flowers |161| are thrown against more delicate, small-scale, but freely drawn patterns painted under the green or mustard ground |162|. The results are powerful and florid, and have been much imitated in nineteenth- and twentieth-century Kutani production.

162 | Kutani Ware Square Plate, with floral spray

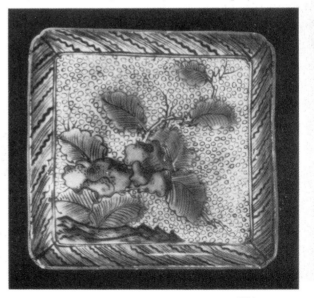

The unique and original character of Japanese decorative style, beginning with the later Heian period and developing, with interruptions, through the eighteenth century, can be visually summarized in single ceramics from each of the four most important types of the early Edo period when the Japanese decorative language was most complete—the feminine grace of Yamato-e as revived in Kakiemon decoration | 163 |, the Yamato-e—become Tosa—become Ukiyo-e patterning in the Imari plate | 164 |, the stylized and "lovely" Yamato-e landscape motif of curving willow crossed by cloud bands in the later perfection of Nabeshima ware | 165 |, and the truncated fans conveying the flavor of the Sōtatsu and Kōrin school in the Green-Kutani dish | 166 |. The primarily decorative intent of these designs and their integrated use of Japanese tradition speak eloquently for this truly original Japanese contribution to the world of art.

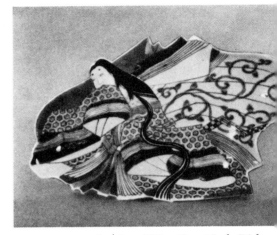

164 | Imari Ware Court Lady Dish

163 | Kakiemon Ware Bowl, with flowers and rocks outside, lion inside

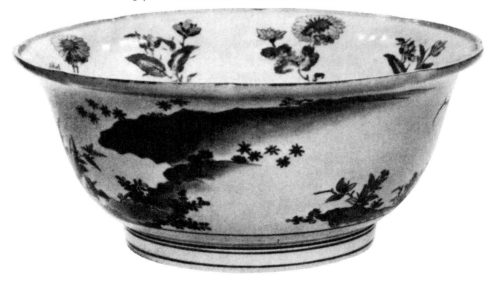

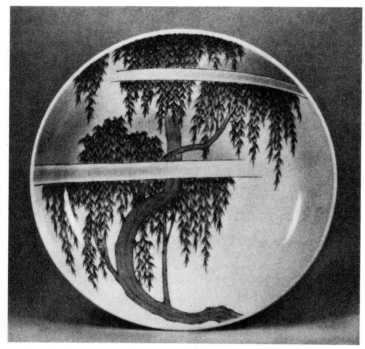

165 | Nabeshima Ware Plate, with willow

166 | Kutani Ware Plate, with fan design

176 | Sword Guard, with fans

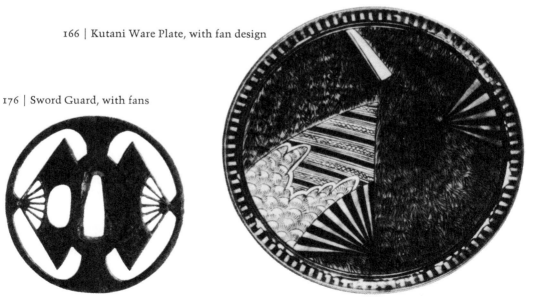

Notes to the text

[1] Henri Focillon, *The Life of Forms in Art*, trans. Hogan and Kubler (New Haven: Yale University Press, 1942), pp. 1–18.

[2] *Ibid.*, pp. 63–76.

[3] See particularly the recent study by E. H. J. Gombrich, *Art and Illusion* (New York: Pantheon Books, 1960).

[4] Part of the listing in J. Harada, *A Glimpse of Japanese Ideals* (Tokyo: The Society for International Cultural Relations, 1937).

[5] See for example Ruth F. Benedict, *The Chrysanthemum and the Sword* (Boston: Houghton, 1946).

[6] We hope to consider this other contribution at a later time. It would include the caricature sketches beneath the surface of early Buddhist art, the narrative hand scrolls of the twelfth and thirteenth centuries, portrait sculpture and painting of the Kamakura and Ashikaga periods, portrait painting of the later periods, and, of course, the Ukiyo-e, pictures of the floating world best known to the West in the form of Japanese wood-block prints.

[7] Readily available in a classic English translation by Arthur Waley of *The Tale of Genji* by Lady Murasaki, 6 vols. (London: G. Allen & Unwin, 1926–33).

[8] Recently made available in a scholarly English translation by Frits Vos in *A Study of the Isé-Monogatari (with the Text According to the Den-Teika-Hippon and an Annotated Translation)*, 2 vols. (The Netherlands: Mouton & Co., 1957).

[9] See the excellent chapter "Shintō and the Arts" in Langdon Warner, *The Enduring Art of Japan* (Cambridge, Mass.: Harvard University Press, 1952).

[10] Jean Buhot, *Histoire des Arts du Japon* (Paris: Van Oest, 1949), pl. 54.

[11] A third decorative element, not germane here, is a strong influence of late Sung esoteric Buddhist painting from South China. This particular regional style is vigorous if a little coarse in comparison to the refinements of Yamato-e.

[12] See Alexander C. Soper, "The Rise of Yamato-e," *The Art Bulletin*, XXIV, No. 4 (Dec. 1942), pp. 351–379.

[13] *Ibid.*, p. 358. This article is the finest analysis of the Heian transition known to me. Heavy reliance has been placed on it.

[14] The *Diary* is translated by A. Omori and K. Doi as part of *Diaries of Court Ladies of Old Japan* (Boston and New York: Houghton Mifflin Co., 1920); and by A. Beaujard, *Les Notes de Chevet de Sei Shōnagon* (Paris, 1934).

[15] As quoted by V. S. Pritchett in "Lost in the Stars," *The New Yorker*, March 18, 1961, p. 172.

[16] Vos, I, pp. 8 ff.

[17] Waley, I, Ch. IV, pp. 100–101.

[18] The remaining fragments are now kept in the Reimei-kai, Nagoya, and in the Masuda Collection. See I. Tanaka, *Genji Monogatari emaki*, Vol. I in the series *Nippon emakimono zenshū* (Japanese Scroll Paintings [Tōkyō: Kadokawa Shoten, 1958]). This section of the famous *Genji Monogatari*, a National Treasure of Japan, is not exhibited.

[19] See A. Soper, "The Illustrative Method of the Tokugawa 'Genji' Pictures," *Art Bulletin*, XXXVII, No. 1 (March, 1955), 1–16.

[20] Soper, "The Rise of Yamato-e," p. 374.

[21] See *Pageant of Japanese Art*, I (Tōkyō National Museum, 1952), pl. 23, p. 77.

[22] Waley, II, p. 127. Genji is reminiscing.

[23] The decoration on these mirrors is integral with the style of other decorations such as those on lacquer. See, for example, the tortoise island mirror (Figure 33, page 37) in comparison with the box (Figure 36, page 41) of the same subject. Or compare the mirror (Figure 32, page 37) with the lacquer table (Figure 42, page 45) of about the same date.

24 Soper, ". . . Tokugawa 'Genji' Pictures."

25 This translation and the information on the "handy" box is from K. Tomita, "A Japanese Lacquer Box of the Fourteenth Century." *Bulletin of the Museum of Fine Arts*, XXIX, No. 172 (April, 1931), pp. 23–24.

26 As given in *Anthology of Japanese Literature*, D. Keene, ed., I (New York: Grove Press, 1955), 313.

27 A comparable formalization occurred in drama and accounts for the rise of Nō out of the informal musical-dramatic sketches called *sangaku*. The simplicity of the music, the carefully controlled restraint of the text and action are a part of the general Muromachi cultural ethos. One should note, however, that even in this stronghold of the new taste, the costumes were extremely rich and decorative in the Fujiwara tradition. Later, particularly in the Momoyama and Edo periods, these costumes were one of the most important outlets for extreme expressions of an unusually gorgeous decorative style: Figure 131, following page 118 (detail shown on page 116); Figure 130, page 116; Figure 134, page 118.

28 Vos, I, p. 173.

29 *Ibid.*, p. 171.

30 See I. Tanaka, ed., *The Art of Kōrin* (Tōkyō: Nihon Keizai Shimbun, 1959), pls. 50, 52, 53.

31 Translated by G. W. Sargent in *The Japanese Family Storehouse or The Millionaire's Gospel Modernized* (England: Cambridge University Press, 1959), p. 13.

32 A recently recognized fan painting by Kōrin at the Freer Art Gallery, Washington, D. C., represents the Utsunoyama theme with the same cast of characters placed somewhat differently.

33 Sliding panels in this style of Shikō are at Hokke-ji in Nara, while a single landscape screen has recently entered the Oriental Collection of the Cleveland Museum of Art.

34 Vos, Section IX, pp. 171–172.

35 Good color reproductions are available in *Pageant of Japanese Art*, II, pl. 80, pp. 78–79.

36 *Kōrin Hyakuzu (One Hundred Pictures of Kōrin* [Kyōto, 1815]). A supplement was issued in 1826. Ikida Kōson, a pupil of Hōitsu, added a third volume in 1864, *Kōrin Shinsen Hyakuzu (A New Compilation of One Hundred Pictures by Kōrin*).

37 Yukio Yashiro, 2,000 *Years of Japanese Art*, ed., Peter C. Swann (London: Thames & Hudson, 1958), pls. 159 and 160, painted on the backs of *Thunder and Wind Gods* screens by Kōrin.

38 Sargent, p. 26.

39 From *What the Seasons Brought to the Almanac Maker (Kōshoku Gonin Onna*, Book III, 1686) in *Anthology of Japanese Literature*, I, p. 339.

Sources for the quotations

Quotations from the following literary works have been included with the text.

Ise Monogatari (ca. 951), a collection of love poetry largely by Ariwara-no-Narihira (see note 8)—from Section IX, on p. 64; from Section IX, on p. 87; from Section VII, on p. 66.

Murasaki, Lady (d. 1031?), *The Tale of Genji* (see note 7)—from Vol. I, on p. 28; from Vol. II, on p. 36.

The Thirty-Six Immortal Poets, a combination of literature, calligraphy, decorative costume, and painting which originated in the Fujiwara Court. Three poems from the leaf showing the poet Mibu no Tadaminé (d. 965) appear on p. 31.

Saikaku (1642–1693), *The Japanese Family Storehouse or The Millionaire's Gospel Modernized*, a collection of short stories published in 1688 (see note 31)—on pp. 81 and 95.

Saikaku, *What the Seasons Brought to the Almanac Maker* (see note 39)—on p. 99.

Zekkai (1336–1405), Zen monk-poet. One of his poems, written in Chinese, appears on p. 48. This translation by Burton Watson is given in *Anthology of Japanese Literature* (see note 26).

Notes on the illustrations

1 | Ornamental Tile, with phoenix
 Hakuhō Period
Gray fired clay. H. 12", W. 8 1/2". From the ancient capital at Nara. See the National Treasure example kept at Tsubosaka-dera, Nara and published in *Japanese Temples and Their Treasures* (Tokyo, 1915), I, 127; II, pl. 249. PUBL: Bibl. 21, p. 85; 28, No. 23. Seattle Art Museum, Thomas D. Stimson Memorial Collection.

2 | *Canon Law of the Great Order*
 (Mahasangha Vinaya)
 Late Heian Period, 12th Century
Hand scroll; gold and silver on dark blue paper. H. 10 1/4", L. 50' 10 1/4". The end paper represents the Buddha preaching in Rajagriha, the ancient capital of Magadha. Similar to the sutra at, and possibly from, Jingo-ji. Three famous sets among others are known: at Chūson-ji, at Jingo-ji, and at the Museum on Kōyasan. Honolulu Academy of Arts, Gift of Robert Allerton.

3 | *Further Discourses on the Supreme Truth*
 (Abhidharmakosha-bhāshya)
 Late Heian Period, 12th Century
Hand scroll; gold and silver on dark blue paper. H. 10 3/8", L. 22'. The end paper represents the Buddha surrounded by Bodhisattvas, monks, and devotees. The text, written by the great Indian scholar Vasubhandhu in the fourth century, holds a position in Buddhism similar to that of the *Summa Theologiae* of Thomas Aquinas in the Roman Catholic Church. The Cleveland Museum of Art, Worcester R. Warner Collection.

4 | Sutra Cover
 Late Heian Period
Woven of split bamboo and threads, textile border,

three gilt bronze butterflies; one serving as a pin, two at the corners. H. 17 5/8", W. 12 1/4". John M. Crawford, Jr., New York City.

5 | Cover for a Sutra Box
 Heian Period, 10th Century
Lacquer. H. 3", L. 14 3/16", Depth 8 1/16". The design of symmetrically disposed but freshly drawn arabesques uses a favorite Buddhist flower form, *hosogé* (precious image flower), an invented rather than a real flower. Similar in technique and design to the famous National Treasure Box owned by the Ninna-ji, Kyōto. See: *Japanese Temples and Their Treasures* (Tokyo, 1915), I, p. 145; II, pl. 326; or Bibl. 11, I, pl. 44, fig. 215. Inosuke Setsu, Tōkyō.

6 | Fragment Mounted as a Box Cover
 Late Heian Period
Lacquer on wood. H. 1", W. 3 1/16", L. 5 13/16". From the same fragmented large box as the smaller piece in the Museum of Fine Arts, Boston, which shows a bodhisattva on a cloud. This example seems to indicate a Western Paradise scene. Cleveland Museum of Art, Purchase, John L. Severance Fund.

7 | Sutra Box *(Sue-bako)*
 Late Heian or early Kamakura Period,
 13th Century
Black lacquer on wood with gilt bronze appliqués. H. 3 1/2", W. 11 3/4", L. 14/18". Metal mounts, applied dragon design on each side; raised foot rim with compressed ju-i head motives. Lined with contemporary brocade in alternating square and octagonal floral motives. PUBL: *Treasures from Japan: Sculpture and Decorative Arts*, Loan Exhibition at the Honolulu Academy of Arts in 1957, No. 49, pp. 23, 55. Honolulu Academy of Arts, Gift of Mr. John Wyatt Gregg.

8 | Hanging Icon (Kakebotoke),
 with Monjū, Lord of Wisdom
 Early Muromachi Period, 14th Century

Lacquer, gold, and color on wood. Dia. 21 7/8". A hanging icon is often suspended above the area of the high altar. PUBL: Bibl. 39, p. 92. Bibl. 28, No. 62. Seattle Art Museum, Eugene Fuller Memorial Collection.

9 | Shrine Panel, with trident-bearing Bishamonten
 Late Heian Period

Lacquer on wood. H. 26 3/16", W. 9 13/16". Probably a door, to judge from the remaining indications of a brace on the upper face of the panel. The representation of Bishamonten, Guardian of the North, would have been placed to the inside. Inosuke Setsu, Tōkyō.

10 | Shrine Panel, with lotus and calligraphy
 Late Heian Period

Lacquer on wood. H. 34 15/16", W. 7 9/16". The inscription reads: "May I be reborn to the Land of Supreme Bliss to acquire the wisdom that comes from evoking Buddha. With the power of my vow I will return to the earth to receive those who qualified themselves for salvation." Inosuke Setsu, Tōkyō.

11 | Shrine Panel, with lotus and calligraphy
 Late Heian Period

Lacquer on wood. H. 27 3/16", W. 7 1/4". The inscription, which is damaged, reads in part:

 [Listen], all you men and devas of the present and the future!
 (I ?) now fondly entrust to you in good earnest ... the supernatural power and the skillful means (Upāya)

Inosuke Setsu, Tōkyō.

12 | Covered Cinerary Jar,
 with scenes from the Western Paradise
 and a fanciful earthly realm
 Early Heian Period

Gilt bronze. H. 9 3/4". Dia. of the opening 4 7/8"; of the widest part, 9 5/8". The design incised. The cover, though old, seems to be a later replacement. The Cleveland Museum of Art, Purchase from the J. H. Wade Fund.

13 | Alms Bowl, with flowers and butterflies
 Late Heian Period

Gilt bronze with design incised. H. 5", W. 9 3/8". The butterfly is both a Taoist and Buddhist symbol of

136

transience. The Cleveland Museum of Art, Purchase from the J. H. Wade Fund.

14 | Flower Tray (Keko),
 with floral arabesques in open work
 Kamakura Period, ca. 1200

Gold and silver on bronze. Dia. 11 3/8". Similar to the National Treasure examples owned by Jinsho-ji, Shiga Prefecture. The Keko is used in Buddhist flower strewing ceremonies. See National Treasures of Japan, Series III, 1953, Commission for Protection of Cultural Properties, p. 20 and pl. 30. Honolulu Academy of Arts, Wilhelmina Tenney Memorial Collection.

15 | Hanging Ornament (Keman)
 Late Heian Period

Gilt bronze. H. 12 3/4", W. 15 9/16". Two parrot-like phoenixes, peony scrolls ajouré; simulated hanging bow cords in silver and gilt. PUBL: Bibl. 27, 1960, pl. IXb. John M. Crawford, Jr., New York City.

16 | Hanging Ornament (Keman),
 with music-playing Apsara
 Early Muromachi Period,
 14th or 15th Centuries

Color and gold on wood. H. 12", W. 11 5/8". Apsaras are heavenly beings analogous to angels. PUBL: Bibl. 28, 52 a b. Seattle Art Museum, Thomas D. Stimson Memorial Collection.

17 | Amida Descending from His Heaven (Raigō),
 Kamakura Period, 14th Century

Hanging scroll, color and gold leaf on silk. H. ca. 51 1/8", L. 24". Raigō (coming to welcome) illustrates the descent of Amida Buddha from his Western Paradise to welcome the souls of the faithful to the Pure Land. The lavish use of kirikane (cut gold), an elaborate decorative technique of applying thread-like thin strips of gold leaf in place of drawn lines, contributes to the radiant effect of the painting. PUBL: Treasures from Japan: Paintings, A Special Loan Exhibition (Honolulu Academy of Arts, February, 1955), No. 10, p. 26. Tōkyō National Museum, Tōkyō.

18 | Benten Playing on a Biwa
 Late Heian Period, 12th Century

Hanging scroll; ink, color, and gold on silk. H. 47 1/2", W. 27". PUBL: Exhibition of Japanese Art (Mills College, 1936), No. 26, pl. 7. Oriental Art in America (The New Oriental Society of America), pl. 17. Revue des Arts Asiatiques, June, 1936, pl. 38. American Magazine of Art, June, 1936, pl. 379. Bibl. 101, fig. 19. Nelson Gallery-Atkins Museum (Nelson Fund).

19 | *The White Path to the Western Paradise*
 Across Two Rivers (Nika byakudō)
 Kamakura Period, 13th Century

Hanging scroll; ink, gold, silver, and color on silk. H. 48 5/8", W. 19 15/16" without mount. EX. COLL: T. Hara, Yokohama. Compare with the same subject in *Exhibition of Japanese Painting and Sculpture* (Washington, D. C., 1953), No. 13. The Cleveland Museum of Art, Gift of the Norweb Foundation.

20 | *The History of the Yūzū Invocation*
 of the Buddha's Name (Yūzū nembutsu engi)
 Kamakura Period

Hand scroll (roll 2); ink, gold, and color on paper. H. 11 5/16", L. (over-all) 45' 3/4". The first roll is in the Art Institute of Chicago. The two are the earliest known examples of this famous theological creation of the Nembutsu sect of Jōdō (Pure Land) Buddhism. PUBL: *Kokka*, No. 744, Vol. 63, March, 1954, pls. 2–7. The Cleveland Museum of Art, Purchase, Mr. and Mrs. William H. Marlatt, John L. Severance, and Edward L. Whittemore Funds.

21 | Page of Calligraphy
 Late Heian Period, 12th Century

Poems by Ki no Tsurayuki (d. 946), one of the Thirty-Six Immortal Poets. Ink, on paper block printed in silver and gray ink. H. 8", W. 6 1/4". The text includes two poems and reads:

The wind that is endlessly wafted—
That is what I wish from my heart
That I could offer to my lord, the Emperor,
As a fan [with which he might cool himself].

 To the daughter of Fujiwara no Okikata Governor of Owari Province, I offered this poem together with a sacred wand, a silk garment and other things on her departure from the capital:
Even the Gods enshrined by the roadside
[Along which you will pass]
Know what deep feelings I have for you
As I present this wand on your departure.
 Tr. Ivan Morris and Sei Itō

PUBL: Gyorgy Kepes, *The New Landscape in Art and Science* (Chicago, 1956), p. 213, No. 252. Bibl. 28, No. 41. Seattle Art Museum, Eugene Fuller Memorial Collection.

22 | Second illustration to the Azumaya chapter
 of the *Genji Monogatari*
 Late Heian Period

Hand scroll; color on paper. H. ca. 8 3/4", W. ca. 19". The scene is one of nineteen surviving from a famous hand scroll of the Heian period of which this and fourteen others are now in the Reimei Foundation in Nagoya; a National Treasure which does not leave Japan. Kaoru, son of Genji's wife, is shown paying a surprise visit much to the consternation of the ladies in the room at the left. Haoru sits on the veranda with an open fan in his hand.

23 | *The Poet Taira no Kanemori* (d. 990)
 Kamakura Period

Hand scroll; black, white, and slight color on paper. H. 11 1/4", W. 18 3/8". A portion from the "Agedatami" hand scroll of the Thirty-Six Immortal Poets, traditionally attributed to Fujiwara no Nobuzane (1176–1265?). The poem, written in Chinese characters on the right, and cursive, phonetic Japanese on the left, reads: "As I count, the years and the months have piled on me. Why should anyone prepare for biding farewell to one year and welcoming another?" (Tr. by K. Tomita.) EX. COLL: Marquis Satake; T. Inoue, Tōkyō. PUBL: Y. Shirahata, "On the Pictures of the Thirty-Six Master Poets," *Kokka*, April, 1952, No. 721, pl. 3. Sherman E. Lee, "The Poet Taira no Kanemori," *The Bulletin of the Cleveland Museum of Art*, January, 1953, p. 7–9. The section belongs to the same Agedatami set as do those in the Freer Gallery of Art in Washington, see Bibl. 67, pl. 64. The poets in this scroll were depicted seated on mats (*tatami*). The other famous "Nobuzane" set, called "Satake" from its former owner, shows the poets alone, seated on an imaginary floor. The Cleveland Museum of Art, Purchase, John L. Severance Fund.

24 | *The Thirty-Six Immortal Poets*
 (Sanjuroku Kasen)
 Kamakura Period, ca. 1200

Hand scroll; color on paper. H. 11 7/8", L. 27' 10". The calligraphy traditionally ascribed to Godyogo-ku Yoshitsuné, 1169–1206. The poets illustrated are Oshikochi no Mitsune (d. 907), and Isé (d. 939). Spencer Collection, The New York Public Library.

25 | *Ideal Portrait of Mibu no Tadaminé* (d. 965)
 Kamakura Period, early 14th Century

Album leaf; ink on paper. H. 11 1/4", W. 9 1/8". Mibu no Tadaminé was one of the Thirty-Six Immortal Poets. PUBL: Sherman E. Lee, "Seven Early Japanese Paintings" *Art Quarterly*, Autumn, 1949, fig. 8, p. 323; Bibl. 39, p. 91; Bibl. 21, p. 98; Bibl. 28, No. 139. Seattle Art Museum, Thomas D. Stimson Memorial Collection.

26 | *One of the Ten Fast Bulls*
Kamakura Period, mid-13th Century

Section of a hand scroll; ink and slight color on paper. H. 10 5/8″, W. 12 1/4″. The second bull from the beginning of the scroll. EX. COLL: Baron Masuda, Odawara. PUBL: Bibl. 21, p. 89; Bibl. 28, No. 72; Bibl. 39, II, No. 1, Winter 1949–50, fig. 10, p. 95; Bibl. 92, p. 102; Bibl. 67, p. 73, pl. 65. E. Grilli, *Sōtatsu* (1956), p. 84. *Art in Asia and the West* (San Francisco Museum of Art, 1957), ill. p. 25. Bibl. 27, pl. XIII, No. 21. Seattle Art Museum, Gift of the late Mrs. Donald E. Frederick.

27 | *One of the Ten Fast Bulls*
Kamakura Period, mid-13th Century

Section of a hand scroll; ink and slight color on paper. H. 10 3/4″, W. 12 5/8″. From this famous scroll seven bulls are known to be extant (in the order they held in the painting): second bull, Seattle Art Museum; third bull, The Cleveland Museum of Art; fifth bull, Tanaka Collection, Tōkyō; seventh bull, National Museum, Tōkyō; eighth bull, Fujita Museum, Ōsaka (see *Kokka*, No. 771, June, 1956, pl. 4); tenth bull, Setsu Collection, Tōkyō. One of the known bulls is unlocated at present. EX. COLL: Tanaka Shimbi, Tōkyō. PUBL: Y. Mori, "Sungyu zukan ni tsuite," *Meihin teicho*, ed. M. Oguchi (Tōkyō, 1944), p. 97. Briefly mentioned, Bibl. 92, p. 102. Sherman E. Lee, "One of the Ten Fast Bulls," *The Bulletin of the Cleveland Museum of Art*, Nov. 1953, p. 199. The Cleveland Museum of Art, Purchase, John L. Severance Fund.

28 | *Legends of the Kitano Shrine*
 (Kitano Tenjin engi)
 Kamakura Period, early 14th Century

Fragment of a hand scroll; ink on paper. H. 11 1/4″, W. 23 1/8″. Yamato-e in style. PUBL: *Treasures from Japan: Paintings*, Catalogue of a Special Loan Exhibition held at the Academy in February, 1955 (Honolulu Academy of Arts, p. 12, No. 14. Honolulu Academy of Arts, Gift of Mr. John Wyatt Gregg.

29 | *Legends of the Kitano Shrine*
 (Kitano Tenjin engi)
 Kamakura Period, early 14th Century

Fragment of a hand scroll; two tones of ink on paper. H. 11″, W. 18 1/2″. PUBL: Bibl. 90, *Zoku*, pp. 86–7 (when in scroll form); Bibl. 4, XII, 1958, p. 77, fig. 3. The Brooklyn Museum, Frank L. Babbott Fund.

138

30 | *Religious Diagram of the Shrines of Kumano*
 [Nachi, Shingū, and Hongū]
 (Kumano Mandala)
 Kamakura Period, ca. 1300

Hanging scroll; ink and color on two pieces of silk joined by a vertical seam. H. 52 3/4″, W. 24 3/8″ (painting); over-all H. 85 1/2″, W. 31 1/2″. EX. COLL: Kaoru Inoue, Tōkyō. PUBL: Y. Kondo, "On Kumano Mandala," *Kokka*, No. 708, March, 1951, pl. 2. Sherman E. Lee, "Kumano Mandala," *The Bulletin of the Cleveland Museum of Art*, Part 1, June, 1954, p. 116, on cover in color, detail on p. 122. Bibl. 64, I, Part 1, p. 57, fig. 76. The Cleveland Museum of Art, Purchase, John L. Severance Fund.

31 | *Horses and Attendants*
 Muromachi Period, late 15th Century

Pair of six-fold screens; color on paper. H. 5′ 4 1/4″, W. 12′ 1″. EX. COLL. The Tokugawa Family, Shima. PUBL: *Catalogue of the Twentieth Anniversary Exhibition of the Cleveland Museum of Art* (Cleveland, 1936), Nos. 384, 385, pl. LXXIX. *Catalogue of the Tokugawa Collection, Catalogue of the Shima Sale, 1934*, No. 82. Howard C. Hollis, "A Pair of Japanese Screens", *The Bulletin of the Cleveland Museum of Art*, January, 1937, p. 5. The Nelson Gallery in Kansas City owns a similar screen, smaller and of later date. Compare a pair of screens in the Boston Museum's "Special Loan Exhibition of Art Treasures from Japan," No. 67 in the Catalogue. The poses of three horses from each screen are identical. The Cleveland Museum of Art, Purchase, Edward L. Whittemore Fund.

32 | Mirror, with garden scene
 Kamakura Period

Bronze. Dia. 4 5/16″. The mirror is round with a raised rim, the *wakyō* or Japanese shape which developed in the Heian Period, in contrast to the *kagami* or Chinese form which had a cusped rim. The design presents an aged pine, bamboos, and rock chrysanthemums; two birds circle at the left and waves break on the shore; the motives of water, bamboo, and pine are repeated in the narrow border. The boss is ringed with a circle of pine needles (?), their sheaths facing out. The Cleveland Museum of Art, Gift of D. Z. Norton.

33 | Mirror, with tortoise-shaped boss and
 hexagonal diaper pattern
 Muromachi Period

Bronze. Dia. 4 1/2″. The diaper pattern is called tortoise-shell *(kikkō)* tessellation and with the tortoise

recalls Hōraisan (Mt. Hōrai) the land of immortality set on one of three islands in the Eastern Sea and supported by an enormous, ageless tortoise, a subject derived from Chinese Taoist traditions. The shape which developed in the Heian Period is a *wakyō* or Japanese type. The Cleveland Museum of Art, Gift of D. Z. Norton.

34 | Quiver for arrows (*Yanagui*)
 Heian Period

Mother-of-pearl inlay on wood. H. 12 3/16", W. 5 11/16" (at base), D. 2 3/8". Similar implements with inlaid lacquer design are in the Treasury of Isé Shrine and the Tsurugaoka Hachiman Shrine of Kamakura. Inosuke Setsu, Tōkyō.

35 | Box, with lotus and duck design
 Heian Period

Gold lacquer (*maki-é*) on wood. H. 4 1/8", L. 12 5/16", W. 7 15/16". PUBL: Bibl. 53, Vol. VII (Lacquer Art), p. 76, no. 47. EX. COLL: Masuda, Odawara. Inosuke Setsu, Tōkyō.

36 | Treasure Box
 Late Heian or early Kamakura Period

Gold lacquer (*maki-é*) on wood, pewter rim. Over-all H. 6 1/4", L. 11 1/2", W. 9 5/8". The scene inside the cover presents an ancient tale told in the *Manyōshū (Collection of Ten Thousand Leaves)* compiled in the mid-eighth century of poems going back to the fourth century. Urashima was a fisher lad taken in gratitude by a tortoise he had saved to Hōraisan, land of immortality, a mountain supported on the back of a huge tortoise. Here he married a fairy princess. When he wished to visit his home she gave him a box which he was not to open. At home no one knew him and he recognized nothing. Forgetting, he opened the box hoping it would help to find his way back to his princess. Nothing but a tiny cloud of smoke rose from the box and disappeared. Urashima aged in a trice and fell to dust, nothing was left on the shore but the lacquer box. The subject, nominally Japanese, is ultimately derived from the Taoist concept of an island of immortals in the Eastern Sea, a favorite subject in Chinese culture of the Han Dynasty. The outside of the box is decorated in gold lacquer with the tessellated diaper pattern called tortoise-shell *(kikkō)*. EX. COLL: Baron Yoshitaro Kawasaki. PUBL: Yoshitaro Kawasaki, *Chōshunkaku kanshō: Masterpieces of Far Eastern Art from Baron Kawasaki's Collection* (Tōkyō, 1913), Vol. V. Bibl. 21, p. 89; Bibl. 28, No. 46. Seattle Art Museum, Gift of the late Mrs. Donald E. Frederick.

37 | Incense Burner,
 with plovers (*chidori*) in flight
 Kamakura Period

Gold lacquer on wood, bronze cover. H. 3", W. 4 1/4". Similar in style and technique to the cosmetics boxes belonging to Fumihide Nomura, Kyōto, Bibl. 64, V, fig. 79, and to the Ogiwara Collection in Ōsaka, *Nippon bunka-shi taikei (Cultural History of Japan)*, V, Heian Period Part II (Tōkyō, 1956–58), p. 317, No. 387. The bronze cover is probably of slightly later date. A poem from the *Kokinshū (Collection of Ancient and Modern Poems*, ca. 905), is generally accepted as the literary origin of the popular motif of the *chidori*:

In the Shio-no-yama (Mountain of Salt),
Along the thrusting seashore,
Sing the plovers,
'The reign of my emperor
Will last forever and ever!'

EX. COLL: Inosuke Setsu. The Cleveland Museum of Art, Purchase from the J. H. Wade Fund.

38 | "Handy" Box (*Te-bako*)
 Kamakura Period, 14th Century

Lacquer and gold (*maki-é*) on wood, silver inlay, pewter rim. H. 6 1/6", W. 9 1/4", L. 12 3/16". On the cover: plum and willow tree with rocks, dwarf bamboos, dandelions on a hillock; birds and sun in the sky, a spring scene. On four sides: plants of autumn, the whole group suggesting the joys of spring and of autumn; the term "Spring-Autumn" in the Far East signifies the "year." Inside the cover are branches of plum and weeping willow. Lined with brocade presumably of the period. One of the beauties of this box is the variety and excellence of the lacquer techniques: *togidashi*, layers of lacquer rubbed down for most of the design; *takamaki-e*, raised gold lacquer for the rocks, birds, and butterflies; inlaid silver for the sun and ideographs; *chiriji*, particles of gold sprinkled on a black ground; *hiramaki-e*, flat gold lacquer on the inside of the cover. EX. COLL: the Marquis Yoshichika Tokugawa, Baron Yoshitaro Kawasaki. PUBL: *Chōshunkaku kanshō: Masterpieces of Far Eastern Art from Baron Kawasaki's Collection* V (Tōkyō, 1913). *Kokka*, No. 266, July, 1912, p. 10. Bibl. 95 figs. 1–4. The Museum of Fine Arts, Martha A. Silsbee Fund.

39 | Box, with crane
 Muromachi Period

Lacquer on wood. L. 3 3/8", W. 2 5/8". Howard C. Hollis, Cleveland.

40 | Incense Box, with peacock
Early Muromachi Period

Lacquer on wood. L. 3 3/8", W. 2 5/8". Howard C. Hollis, Cleveland.

41 | Incense Box, with chrysanthemums
Early Muromachi Period

Lacquer on wood. L. 3 3/8", W. 1 1/2". Howard C. Hollis, Cleveland.

42 | Table, with landscape
Early Muromachi Period

Gold and silver on lacquered wood. H. 4", W. 14 1/2", L. 23". EX. COLL: M. Sorimachi. PUBL: *Jidai makie kyushitsu (Collective Catalogue of Ancient Silver and Gold Lacquers* V [Tōkyō, 1934–43]), pls. 287, 288. The Cleveland Museum of Art, Purchase, Edward L. Whittemore Fund.

43 | *Winter and Spring*
Shūbun, ca. 1390–ca. 1464
Muromachi Period

Six-fold screen; ink and slight color on paper. H. 46 1/4", W. 12' 7 1/2". EX. COLL: Shimazu, Tōkyō; Osborne and Victor Hauge, Washington, D. C. PUBL: Sherman E. Lee, "Winter and Spring by Shūbun," *The Bulletin of the Cleveland Museum of Art*, October, 1959, p. 173 ff. H. Nakamura, "The Landscape Screens attributed to Shūbun," *Museum* (Tōkyō), May, 1952, p. 20 (part only). The Cleveland Museum of Art, Gift of Mrs. R. Henry Norweb.

44 | *Bird and Flowers*
Attributed to Sesshū, 1420–1506
Muromachi Period

Hanging scroll. One of a pair; color on silk. H. 12", W. 15 1/2". A small bird, possibly a finch, sits on a branch of the cassia-flower tree, a spray of tree peony at the left. PUBL: *Bijutsu kenkyu* No. 185 (March, 1956). A copy by Kano Tanyū in sketchbook dated 1666 (Tōkyō National Museum) is published also in *Nippon bijutsu taikei*, Vol. V, and in *Tōyō bijutsu bunko* volumes on Tanyū and Sesshū (the latter published before rediscovery of the original painting). Victor Hauge, Washington, D. C.

45 | *Bird and Flowers*
Attributed to Sesshū
Muromachi Period

Hanging scroll. One of a pair; color on silk. H. 12", W. 15 1/2". Swooping bird with lilies and magnolia. PUBL: See No. 44, above. Victor Hauge, Washington, D. C.

46 | *Birds and Flowers in a Landscape*
Attributed to Sesshū
Muromachi Period

Six-fold screen; ink and color on paper. H. 69", W. 147" (extended), panels: 24 1/2". The signatures have been re-written over older ones of the same content: Se-shū. The screens are comparable to the well-known unsigned National Treasure screens formerly in the Kosaka Collection. EX. COLL: D. Konoike, Ōsaka. The Cleveland Museum of Art, Gift of Mrs. A. Dean Perry.

47 | *Tiger and Dragon*
Sesson Shūkei (b. 1504, active 1589)
Muromachi Period

Pair of six-fold screens, ink on paper. H. 67 1/2", L. 144". EX. COLL: Baron Mitsui, C. Satomi. PUBL: Sherman E. Lee, "The Tiger and Dragon Screens by Sesson," *The Bulletin of the Cleveland Museum of Art*, April, 1960, p. 65 ff. *Nippon teikoku bijutsu ryokushi (Outline History of Art in the Empire of Japan* [Imperial Household Museum, 1908]), pl. 146. *Tōkyō Teishitsu Hakubutsukan bijutsu reppin shashin mokuroku (Illustrated Catalogue of the Imperial Household Museum* [Tōkyō, 1919]), Nos. 2553, 2554. Yusaku Imaizumi, *Shoga kotto sosho (A Connoisseur's Guide to Calligraphy, Painting, and Antiquities*, I [Tōkyō, 1920]), 138. Shizuya Fujikake, "Tiger and Dragon by Sesson," *Kokka*, August, 1953, p. 224. Bibl. 4, XIV, 1960, p. 66, fig. 5. The Cleveland Museum of Art, Purchase from the J. H. Wade Fund.

48 | Shino Ware Dish,
with half-submerged wheel and fish net
Momoyama Period

Stoneware with white glaze; design in iron oxide. H. 2 7/16", Dia. 7 3/8", 7 1/4". The "half-submerged wheel" is a representation of a wheel partially submerged in water and recalls a familiar sight in Japan where wheels and other wagon parts were put in water to prevent them from drying out. The name Shino is said to have come from a dilettante patron named Shino Sōkyū. Inosuke Setsu, Tōkyō.

49 | Oribé Ware Plate,
with half submerged wheel design
Momoyama Period, 17th Century

Stoneware with green and transparent glazes; the painted decoration in brown slip. Dia. 7 3/4" × 8". PUBL: Bibl. 28, No. 124. Bibl. 5, p. 17, No. 40. Seattle Art Museum, Eugene Fuller Memorial Collection.

50 | Shino Ware Dish, with flying birds
Momoyama Period

Stoneware with gray glaze and design in white slip.
H. 2", Dia. of dish, 6 15/16"; Dia. of base, 5". The
Cleveland Museum of Art, Gift of Mrs. A. Dean Perry.

51 | Shino Ware Cake Plate,
with wind-blown grasses
Momoyama Period, 16th Century

Stoneware with mouse-gray (nezumi) glaze, design
inlaid with white slip (mishima technique derived
from Korea). W. 9 1/8". PUBL: Bibl. 42, No. 19. Kani-
chiro Morikawa, Shino, Koseto, Oribé (Commemora-
tive Catalogue, Exhibition of Shino, Karatsu, Oribé
Ware [Tōkyō, 1936]), pl. 32. Seattle Art Museum, Gift
of Mrs. John C. Atwood, Jr.

52 | Shino Ware Bowl, with iris
Momoyama Period, 17th Century

Stoneware, milky white glaze, design in iron oxide.
H. 2 3/8", top Dia. 6 1/2" x 6 7/8". Seattle Art Mu-
seum, Eugene Fuller Memorial Collection.

53 | Oribé Ware Ewer, with tortoise shell motif,
wheels, plum blossoms
Momoyama Period

Stoneware with green and transparent glaze; designs
in brown slip. H. 10 1/2", W. 8 1/2". The ware is said
to have originated at the suggestion of Furuta Oribé,
a master of the tea ceremony. PUBL: Bibl. 94, V,
pl. 22. "Recent Ceramic Acquisitions Selected from
Four American Museums," Far Eastern Ceramic Bul-
letin, December, 1959, pl. 9. The Art Institute of Chi-
cago Quarterly, February, 1960, p. 23. Art Institute of
Chicago, Gift of Robert Allerton.

54 | Oribé Ware Ewer, with tortoise shell motif
Momoyama Period, early 17th Century

Stoneware; H. 8 1/4", Dia. of mouth 5". The decora-
tion is interrupted by a dripping green glaze. The
Cleveland Museum of Art, Gift of Mrs. R. Henry
Norweb.

55 | Yellow Seto (Ki Seto) Bowl,
with flower design
Momoyama Period

Glazed clay; H. 2 1/8", Dia. 6 3/8". The design is on
the bottom of the bowl. The foliated rim has an
impressed repeat which appears to have been made
by a wood spatula. From the Seto kilns in Owari
Province, the oldest ceramic center in Japan. Mr. and
Mrs. Richard E. Fuller, Seattle.

56 | Shino Ware Water Jar,
with flowers and grasses
Momoyama Period

Buff stoneware with ash-gray glaze; design painted
in iron oxide on the outside. H. 7". PUBL: Bibl. 42,
not illustrated, cat. No. 19 a. Bibl. 28, No. 121. Bibl. 5,
not illustrated, cat. No. 38. Seattle Art Museum, Eu-
gene Fuller Memorial Collection.

57 | Pine and Plum by a Stream in Moonlight
Kaihō Yūshō, 1533–1615
Momoyama Period

Pair of six-fold screens; ink and slight color on paper.
H. 66 1/2", W. 139". Signature in the lower left and
right. PUBL: Kokka, No. 640, January, 1942, pls. 3, 4.
Meihō Tenrankai zuroku, No. 6 (Catalogue of the
Sixth Annual Exhibit of Famous Treasures [Ōsaka
City Museum]), Nos. 15, 16. Bibl. 4, XIII, 1959, p. 103.
Bibl. 5, Nos. 4, 5. Nelson Gallery-Atkins Museum
(Nelson Fund).

58 | Uji River Bridge (Uji Bashi)
Unknown artist
Momoyama Period

Pair of six-fold screens; color and gold on paper. H.
each screen 67 1/2", W. 133 1/4". Nelson Gallery-At-
kins Museum (Nelson Fund).

59 | The Four Enjoyments: Lute, Chess Game,
Calligraphy, Painting (Kin-ki-sho-ga)
Attributed to Kanō Takanobu, 1511–1618
Late Momoyama Period

Four sliding panels (fusuma); color and gold on paper.
H. 68 1/2", W. 5' 55". The subject is a favorite Chi-
nese one where music, chess or other board games,
and the arts of the brush (painting and calligraphy)
are called "The Four Elegant Accomplishments." All
figures in the panels representing these arts are dress-
ed in Chinese garments. On the left a gentleman of
leisure looks at a landscape painted on a hanging
scroll held up by an attendant. In the next panel a
game of checkers (go) is in progress. The third panel
pictures calligraphy at the left and music with a
gentleman playing a table lute at the right. The last
panel shows the Taoist Immortal Chang Kuo-lao
(Chōkarō). He had many miraculous skills. In 723
the T'ang Emperor Ming Huang invited him to live
at his court, but Chang Kuo-lao preferred the life of
a wanderer with his fabulous white mule. This an-
imal lived in a gourd and came out when the sage
dampened it to carry his master wherever he wished
to go. In the Japanese version of the tale the animal

is a miniature horse and the fourth panel puns on the word *koma* (horse), the knight in a chess game. The four panels that once backed these four are now in the British Museum. They show a pond, with ducks and geese flying and at rest, fringed with trees, shrubs and flowers; pines and bamboos in snow are beyond them. See: *The British Museum Quarterly*, XII, No. 1, 1936, pl. XVI, p. 47, where they are attributed to Kanō Sanraku, and are said to have come from the Tonomine Temple near Nara, and more lately from the Kawaguchi Collection. PUBL: Bibl. 28, No. 101. Seattle Art Museum, Eugene Fuller Memorial Collection.

60 | *Sumiyoshi*
 Attributed to Nonomura Sōtatsu, 1576–1643
 Early Edo Period

Album leaf from an *Isé Monogatari*; gold and color on paper. H. 9 5/8″, W. 8 1/4″. Figures and poem (by Ariwara-no-Narihira [825–880]) in cursive Japanese script. The episode and the poem are:

> Once a man went to the province of Izumi. When he went along the beach of Sumiyoshi [in] the District of Sumiyoshi, [the scenery] was so very pleasant that, having alighted [from his horse], he went [on foot]. One of his fellow-travelers said [to him]: 'Compose [a poem of the subject of] the beach of Sumiyoshi.' [Here follows the poem]:
>
> > Although there is [that marvelous] fall
> > When wild geese cry
> > And chrysanthemums bloom,
> > It is good to live
> > By the sea-side in springtime—
> > On the beach of Sumiyoshi.
>
> Because he recited thus, all others kept silent. Bibl. 100, I, 225, Section LXVIII.

EX. COLL: T. Masuda, Odawara. PUBL: S. Mizusawa, *On the "Picture Tableaux, the Isé Monogatari" which are said to be drawn by Sōtatsu* (Tōkyō, 1947), illus. Sherman E. Lee, "Sōdatsu and the Tale of Isé," *The Bulletin of the Cleveland Museum of Art*, April, 1953, p. 62. The Cleveland Museum of Art, Purchase, John L. Severance Fund.

61 | *Crow*
 Nonomura Sōtatsu
 Early Edo Period

Hanging scroll; ink on paper. H. 43 3/8″, W. 20″. Seal of Sōtatsu at lower left. PUBL: Bibl. 28, No. 141. Seattle Art Museum, Eugene Fuller Memorial Collection.

62 | *Jittoku*
 Nonomura Sōtatsu
 Early Edo Period

Hanging scroll; ink on paper. H. 37 1/2″, W. 15 1/4″. Signature and seal. Jittoku is a legendary Buddhist ascetic the embodiment of the contemplative life and the needs of the spirit. He was found in the woods by the Buddhist priest Bu-kan Zen-shi who employed him as a servant in the refectory of a monastery. He usually carries a broom. Howard C. Hollis, Cleveland.

63 | *The Zen Priest Chōka*
 Nonomura Sōtatsu
 Edo Period

Hanging scroll; ink on paper. H. 37 3/4″, W. 15 1/4″. PUBL: Kowu Aimi, "Black and White Paintings of Buddhist Monks and Hermits by Sōtatsu," *Yamato bunka (Quarterly Journal of Eastern Arts)*, October, 1952, p. 27–34, illustrated pl. X, fig. 9 on p. 33. The Cleveland Museum of Art, Purchase, Norman O. Stone and Ella A. Stone Memorial Fund.

64 | *Ivy Lane (Tsuta-no-hosomichi)*
 Nonomura Sōtatsu
 Early Edo Period

Pair of six-fold screens; color on paper. H. 62 5/8″, W. 141 3/4″. The screens illustrate the mention of the ivy-bound lane leading past Mt. Utsu in the *Isé Monogatari* Section IX:

> Traveling along they reached the Province of Suruga. When they arrived at Mt. Utsu, the road they were about to enter was very dark and narrow; ivy and maples grew densely, they felt sad and lonely. While they thought what unforeseen and bitter experiences they were encountering, an itinerant priest came from the opposite direction. 'How is it that you are on such a road?' he asked, and, when they looked at him, it was a man they knew by sight.
>
> Intending to send a message to the capital, to his beloved, he wrote a letter and entrusted it to the priest.

For the poem see No. 83, below. Bibl. 100, I, 173. EX. COLL: Kosaka. PUBL: Tōkyō National Museum, *Illustrated Catalogue The Exhibition of the Sōtatsu-Kōrin School*, 1951, No. 28. *Illustrated Catalogue the Exhibition of National Treasures by Kōetsu, Sōtatsu, and Kōrin* by the Mainichi Shimbun, 1957. Junkichi Mayuyama, Tōkyō.

65 | *Sea of Isé* or *Returning Waves*
Nonomura Sōtatsu
Early Edo Period

Pair of six-fold screens; color and gold leaf on paper. H. 61″, W. 148″, each. Signature and seal on each. The screens illustrate Section VII of the *Isé Monogatari*. EX. COLL: Fukui, Kyōto. PUBL: Bibl. 5, Nos. 8, 9. Howard C. Hollis, Cleveland.

66 | *Crossing at Sano (Sanō nō watari)*
Attributed to Nonomura Sōtatsu
Early Edo Period

Single panel screen (*tsuitate*); color and gold on paper. H. 51″, W. 49 1/8″. The scene illustrates a poem by Fujiwara Teika: "Not a shelter to stop the steed / In the snowy dusk at Sanō nō watari." The crossing was probably in Kii Province. EX. COLL: T. Ooka; R. Hara, Yokohama. PUBL: *Sōtatsu-gashū* (Tōkyō, 1913) ill. The Cleveland Museum of Art, Purchase, John L. Severance Fund.

67 | *Poppies*
Nonomura Sōtatsu, 1796–1858
Early Edo Period

Pair of six-fold screens; color and gold leaf on paper. H. 5′ 6″, W. 24′ 1/2″. An old label on the back says "Presented by Lord Maeda to Tentoku-in," a temple of Mt. Kōya. Sōtatsu worked for the Maeda family, lords of the province of Kaga. In 1622 an older temple was renamed Tentoku-in to house the ashes of Lady Tentoku, wife of Maeda Toshinaga (1562–1614). Was the screen a gift at this time? PUBL: Robert T. Paine, Jr., *Ten Japanese Paintings in the Museum of Fine Arts* (Japan Society of New York, 1939), No. VII, color; Bibl. 65, I, 14a, 14b; "an Exhibition of Japanese Screens," *Bulletin of the Museum of Fine Arts*, December, 1935, fig. 3. Bibl. 67, pl. 99 (b), and p. 116. The Museum of Fine Arts, Boston, Gift of Mrs. W. Scott Fitz.

68 | *Hibiscus Flowers (Fuyo)*
Suzuki Kiitsu
Edo Period

Hanging scroll; color on silk. H. 48 3/4″, W. 22 3/8″. Signature. Victor and Osborne Hauge, Washington, D. C.

69 | *Poem Scroll with Herd of Deer*
Nonomura Sōtatsu (painting)
 Honami Kōetsu, 1558–1637 (calligraphy)
Late Momoyama or early Edo Period

Hand scroll, calligraphy in ink, gold and silver on paper. H. 12 1/2″, L. 30′ 3 3/4″. Signature of Kōetsu.

Seal "Inen." A large portion of the other half of this painting is in the Hakoné Art Museum, Japan; small fragments of the remainder of the scroll are in other Japanese collections. EX. COLL: Baron Masuda. PUBL: Japanese *Sōtatsu Hogashu Kōetsu* Album. Otto Kümmel, *Die kunst ostasiens* (Berlin, 1921), pl. 150. Bibl. 102, p. 68, fig. 61. Bibl. 67, p. 115, 116, pl. 99 A. Bibl. 28, No. 140. Bibl. 105, p. 235, pl. 148. Bibl. 5, p. 14, No. 10, ill. p. 33. Seattle Art Museum, Gift of the late Mrs. Donald E. Frederick.

70 | *Lotus and Calligraphy*
Nonomura Sōtatsu and Honami Kōetsu
Early Edo Period

Section of a hand scroll; calligraphy in ink; gold and silver on paper. H. 13 1/8″, W. 32 5/8″. Various sections from this large hand scroll are in private collections in Japan. Inosuke Setsu, Tōkyō.

71 | *Chrysanthemums*
Kitagawa Sōsetsu
Edo Period, mid-17th Century

Hanging scroll; color on paper. H. 41″, W. 18 1/4″. Signature and seal "Inen." Howard C. Hollis, Cleveland.

72 | *Chrysanthemums*
Kitagawa Sōsetsu
Edo Period, mid-17th Century

Hanging scroll; ink and color on paper. H. 42 3/4″, W. 15 3/4″. Signature and seal "Inen." The Avery Brundage Collection, San Francisco.

73 | *Corn and Cockscomb*
School of Sōtatsu
Edo Period, late 17th Century

Single six-fold screen; color and gold paper. H. 66 3/4″, W. 23 3/8″, each panel. PUBL: Bibl. 4, XIV, 1960, p. 66, fig. 5. Art Institute of Chicago, Kate S. Buckingham Fund Purchase.

74 | *Young Shoots and Small Plants*
Attributed to Ogata Kōrin, 1658–1716
Edo Period

Four paintings, decorations from a sword rack; color on gold paper. (a) H. 4 1/2″, W. 9 1/2″; (b) H. 11 7/8″, W. 9 1/2″; (c) H. 4 1/8″, W. 9 1/2″; (d) H. 11 13/16″, W. 9 5/8″. (a), (b), and (c) belong to Mathias Komor, New York City; (d) to Georges de Batz, New York City.

75 | *Plum Spray*
 Ogata Kōrin
 Edo Period

Fan painting; color and gold on paper. H. 9 3/8", W. 9 1/2". Signature. PUBL: Bibl. 5, not reproduced. Howard C. Hollis, Cleveland.

76 | *Landscape*
 Ogata Kōrin
 Edo Period

Two-fold screen; ink on gold paper. H. 52 3/4", W. 29 3/4". Signature and seal of Kōrin. PUBL: Bibl. 5, p. 15, ill. p. 35. Bibl. 28, No. 143. Seattle Art Museum, Thomas D. Stimson Memorial Collection.

77 | *Herons*
 Ogata Kōrin
 Edo Period

Pair of hanging scrolls; ink on paper. H. 32 3/4", W. 15 1/8"; H. 33", W. 15". Two of four known from a set of hanging scrolls. Signature and seal. PUBL: Bibl. 89, figs. 33, 34. Hōitsu, *Kōrin hyakuzu*, 100 *Kōrin Drawings*, ca. 1820. Box authentication of Sakai Hōitsu. Certificates of Hōitsu's pupil Kibyoku and of Kishi Kokei. Mr. Peter W. Jostin and Mr. Stephen Spector, New York City.

78 | *Waves*
 Ogata Kōrin
 Edo Period

Two-fold screen; ink on paper. H. 60 1/8", W. 67 1/2". PUBL: Bibl. 89, fig. 17. Aimi Koame, *Kōrin genshokuban* (Bijutsu Library, 1958), pl. 6. Exhibited in "300th Anniversary Exhibition," Tōkyō, 1958. Mr. and Mrs. Aschwin Lippe, New York City.

79 | *Waves*
 Attributed to Ogata Kōrin
 Edo Period

Six-fold screen; ink, blue, and gold on paper. H. 49 3/4", W. 9' 5". Two seals of Kōrin. PUBL: Bibl. 5, p. 15, No. 40. Bibl. 28, p. 97, No. 144. *Exhibition and Sale of Ancient Screens and Ukioye Paintings Partially from the Bigelow Collection.* Yamanaka & Co., Tōkyō, 1933, Vol. 1, No. 65. Seattle Art Museum, Eugene Fuller Memorial Collection.

80 | *Chrysanthemums by a Stream*
 Ogata Kōrin
 Edo Period

Pair of six-fold screens; color and gold on paper. H. 67", W. 148". Signed "Sensen Mappa Inshi Hōkyō

144

Kōrin." Circular seal reads "Hoshuku." White blossoms in relief, a technique called "moriage." EX. COLL: Hiromi, Mikage. PUBL: The *Bulletin of the Cleveland Museum of Art*, March 1958, no text. The Cleveland Museum of Art, Gift of Hanna Fund.

81 | *Branch of Cherry Blossoms*
 Attributed to Ogata Kenzan, 1663–1743
 Edo Period

Mounted as a hanging scroll; color and gold on paper. H. 13 1/2", W. 18 3/4". Seal of Kenzan. PUBL: Bibl. 28, No. 146. Seattle Art Museum, Eugene Fuller Memorial Collection.

82 | *Hollyhocks and Plum Branches*
 Ogata Kenzan
 Edo Period

Pair of six-fold screens; color and ink on paper. H. 43 1/2", W. 75 3/4". The hollyhocks are inscribed: "A hermit in the capital Shi-sui, Shin-sei, painted at eighty-one years"; the other screen; "The vagrant fellow in the capital Shi-sui, Shin-sei." Seals. Inosuke Setsu, Tōkyō.

83, 83a | *The Pass through the Mountains (Utsunoyama)*
 Roshū Fukaye, 1699–1755
 Edo Period

Six-fold screen; color and gold on paper. H. 53 3/8", W. 17 5/8", each panel; over-all W. 107". Round red seal at left reads "Ro-shū." The screen illustrates section IX of the *Isé Monogatari*. The poet and his companions arrive at Mt. Utsu and meet an itinerant priest (see No. 64 above). "Intending [to send a message] to the capital, to his beloved, he wrote a letter and entrusted it [to the priest], [the poem in that letter ran as follows]:

> Neither while being awake
> Nor in my dreams
> By the side of Mt. Utsu
> In Suruga
> Do I meet my love."
> (Bibl. 100, I, p. 173)

Similar compositions by Roshū are in the Seihin Ikeda Collection, see *Illustrated Catalogue of a Special Loan Exhibition of Art Treasures from Japan* (Museum of Fine Arts: Boston, 1936), pl. 88; and in the Hikokaro Umezawa Collection in Kamakura, see *Kokka*, June, 1960, No. 819, p. 225. EX. COLL: T. Hara, Yokohama. PUBL: Sherman E. Lee, "Roshū's 'Utsunoyama: The Pass Through the Mountains,'" *The Bul-*

letin of the Cleveland Museum of Art, December, 1955, p. 219. *Kokka*, No. 819, June 1960, p. 22. Bibl. 42, No. 18 a. *Art Quarterly*, Spring, 1956, pp. 86–7. The Cleveland Museum of Art, Purchase, John L. Severance Fund.

84 | *Utsunoyama*
 Roshū Fukaye
 Edo Period

Small two-fold screen; color, ink, and gold on paper. H. 24 1/2", W. ca. 73". The subject is from section IX of the *Isé Monogatari*, see No. 83, above. PUBL: *Kokka*, No. 767, February, 1956; No. 819, June, 1960, p. 225. Mrs. Caral Greenberg, New York City.

85 | *Irises*
 Watanabe Shikō, 1683–1755
 Edo Period

Pair of six-fold screens; color and gold on paper. H. 67 1/4", W. 149 1/2". Painting only, H. 60 5/8", W. 142". Signed and sealed, on the outer edge of each screen. The subject is taken from the Yatsuhashi section IX of the *Isé Monogatari*. EX. COLL: Shosaku Matsukata. PUBL: *Illustrated Catalogue of a Special Loan Exhibition of Art Treasures from Japan* (Museum of Fine Arts: Boston, 1936) cat. No. 91, A, B. Sherman E. Lee, "Irises by Watanabe Shikō," *The Bulletin of the Cleveland Museum of Art*, April, 1955, p. 63. *Museum*, Tokyo National Museum, June, 1955, p. 28. The Cleveland Museum of Art, Gift of the Norweb Foundation.

86 | *Thirty-Six Immortal Poets (Sanjuroku-Kasen)*
 Attributed to Tatebayashi Kagei
 (fl. first half of the 18th Century)
 Edo Period

Two-fold screen; ink, color, and gold on paper. H. 68 1/4", W. 73 1/2". The same subject and almost identical composition is to be found in the National Treasure screen by Kōrin in the Ino Dan Collection (published, Bibl. 36), and in a screen by Sakai Hōitsu in the Robert Simmons Collection. The Cleveland Museum of Art, Purchase, Mr. and Mrs. William H. Marlatt Fund.

87 | *Chrysanthemums and Snowy Hills*
 Tatebayashi Kagei
 Edo Period

Two-fold screen; color and gold on paper. H. 42", W. 42 7/8". Signature: "Tsuruoka Isshi Kagei," and circular seal. Victor Hauge, Washington, D. C.

88 | *Plum Blossoms*
 Sakai Hōitsu, 1761–1828
 Edo Period

Hanging scroll; color on silk. H. 42 1/4", W. 16 1/4". Signature and seal. Victor and Osborne Hauge, Washington, D. C.

89 | *Ducks in Snow*
 Sakai Hōitsu
 Edo Period

Two-fold screen; color and gold on paper. H. each fold, 67 3/8", W. 32 3/8". PUBL: *The Art Institute of Chicago Quarterly*, Feb. 1, 1958, ill. p. 15, text p. 16. The Art Institute of Chicago, Gift of Robert Allerton.

90 | *Irises*
 Sakai Hōitsu
 Edo Period, Summer 1801

Two-fold screen; ink and color on silk. H. 70", W. 72 6/8". Signature and seals. From the Yatsuhashi section IX of the *Isé Monogatari*. Mr. and Mrs. Aschwin Lippe, New York City.

91 | *Eight Part Bridge (Yatsuhashi)*
 Sakai Hōitsu
 Edo Period

Fan painting; color on gold ground paper. H. 7", Chord 21 5/8". Signature and seal. From the Yatsuhashi section IX of the *Isé Monogatari*. PUBL: Bibl. 28, No. 172. Seattle Art Museum, Eugene Fuller Memorial Collection.

92 | *Ideal Portrait of Fujiwara no Asatada (?)*
 910–966
 Unknown artist of the Tosa School
 Edo Period

Panel painting; color and gold on wood. H. 23", W. 15". Fujiwara no Asatada was one of the Thirty-six Immortal Poets. PUBL: Bibl. 27, cover and pl. XXIII, No. 72. Osborne Hauge, Falls Church, Virginia.

93 | *Sosei Hōshi*
 Attributed to Shōkadō Shōjō, 1584–1639
 Early Edo Period

Panel painting; ink and color on paper, mounted on wood. H. 18 5/16", W. 13". Sosei Hōshi (9th century) is one of the Thirty-six Immortal Poets. The poem reads:

> I am coming, she had said.
> And for this reason alone
> In September
> Until the moon of dawn
> I have waited in vain.

From the *Kokinshū (Collection of Ancient and Modern Poems)*, the first of the anthologies of Japanese poetry compiled by imperial order, completed in 905. Lillian M. Kern, Cleveland.

94 | *Ono no Komachi*
 Attributed to Shōkadō Shōjō
 Early Edo Period

Panel painting; color on paper, mounted on wood. H. 18 5/16", W. 13". Seal of the artist. Ono no Komachi (9th century) is one of the Thirty-six Immortal Poets. The poem, written on hearing that the heart of a man had changed, reads:

 In the world
 'Tis the heart, the flower of man,
 That fades unobserved.

From the *Kokinshū*, translated by Kojiro Tomita. Lillian M. Kern, Cleveland.

95 | *Scenes from the Tale of Genji*
 Unknown artist, Tosa School
 Edo Period, 17th Century

Pair of six-fold screens; ink and color on paper. H. 59 1/2", L. 144". The Avery Brundage Collection, San Francisco.

96 | *Southern Barbarians*
 Unknown artist
 Momoyama or early Edo Period

Pair of six-fold screens; color and gold on paper. H. 57 5/8", W. 139 1/4". Illustrating the arrival of European merchant ships at Nagasaki: loading and unloading, Portuguese merchants, and the reception of a Christian missionary. EX. COLL: Ogiwara Yasunosuke Collection. PUBL: *Momoyama shōheki-ga-meisaku-ten (Exhibition of Masterpieces of Screen and Wall Paintings in the Momoyama Period* [Tokyo, May, 1957]), No. 14. *Ukiyoye* (Tōkyō, 1931), Vol. I, pls. 108, 109, 110. *The Bulletin of the Cleveland Museum of Art*, December, 1960, p. 225. *Hōun*, No. 4, 1932, pp. 64–83, ill. The Cleveland of Art, Purchase, Leonard C. Hanna, Jr., Bequest.

97 | *Dancing Girls*
 Unknown artist
 Early Edo Period, 17th Century

Six small panels; color and gold on paper. H. 24 13/16", W. 14 9/16". Early Ukiyoe type. Probably the six companion panels to the six-fold screen in the National Museum, Kyōto. See: *Kinsei shoki fuzokuga (Genre Painting of Early Modern Japan* [Kyōto, 1957]), pl. 84, fig. 7. Inosuke Setsu, Tōkyō.

98 | *The Inn-Keeper Presents His Bill*
 Unknown artist, Matabei School
 Edo Period, 17th Century

Two-fold screen; ink and color on paper. H. 23 3/4", W. 60 1/2". PUBL: *Bulletin of the Fogg Art Museum Harvard University*, November, 1935, p. 4. The Fogg Art Museum, Harvard University, Gift of Denman Ross.

99 | *The Actor Sanjō Kantaro*
 Kaigetsudō Ando, active early 18th Century
 Edo Period, ca. 1714

Hanging scroll; color on paper. H. 41 5/8", W. 23 3/8". PUBL: Bibl. 98, II, No. 227. The Cleveland Museum of Art.

100 | *Portrait of a Woman Wearing a Kimono Decorated with Orange and Blue Blossoms*
 Kaigetsudō Ando
 Edo Period, ca. 1715

Hanging scroll; color on paper. H. 36", W. 15". Mr. and Mrs. Richard P. Gale, Mound, Minnesota.

101 | *Portrait of a Woman Wearing a Kimono Decorated with Flying Geese*
 Kaigetsudō Dohan, active early 18th Century
 Edo Period, ca. 1715

Hanging scroll; color on paper. H. 42 1/2", W. 18 1/4". PUBL: Bibl. 29, fig. 2. Mr. and Mrs. Richard P. Gale, Mound, Minnesota.

102 | *Two Courtesans Writing a Letter*
 Katsukawa Shunshō, 1726–1798
 Edo Period, ca. 1775

Hanging scroll; color on silk. H. 13 1/2", W. 16 3/8". PUBL: Bibl. 29, fig. 10. Mr. and Mrs. Richard P. Gale, Mound, Minnesota.

103 | *The Actor Nakayama Tomisaburō*
 Attributed to Saitō Sharaku
 Edo Period, 1794

Hanging scroll; color on paper. H. 43 1/2", W. 16". PUBL: Bibl. 29, fig. 16. Minneapolis Institute of Arts, Gift of Mr. and Mrs. Richard P. Gale, Mound, Minnesota.

104 | *Happy Ending (Medetaki kashiko)*
 Okumura Masanobu, 1686–1764
 Edo Period, ca. 1715

Woodblock print, *sumizuri-e* (ink printed picture). H. 10 5/8", W. 14 13/16". Signature: *Fūryū Yamato eshi* (refined Japanese artist) Okumura Masanobu *zu*. Seal: Masanobu. The outline of the figure is made up of fragments of familiar phrases used in letter writing by women. They are: *Medetaki kashiko*

(happy ending), *Kaesu gaesu* (I implore repeatedly), *Sama* (Mr. and Mrs.), *Sonji* (?). Other texts are an ode: *Hiuchibako* (Flint fire box), *yaku ya asama no* (burns [being jealous]), *moji onna* (letter girl light-hearted), and above it: *Omoi mo omoi mo yume no nokorine* (Think and think of the remnant of a dream). EX. COLL: Chandler, Rouart. PUBL: Bibl. 19, p. 136, No. 55. Art Institute of Chicago, The Clarence Buckingham Collection.

105 | *The Actor Fujimura Handayu as a Woman*
Torii Kiyomasu, I, 1694?–1716?
Edo Period, ca. 1715

Woodblock print, *tan-e*; hand colored with tan (red lead) and mustard yellow. H. 22", W. 12 5/8". Signature: Torii Kiyomasu. Seal: Kiyomasu. Publisher: Motohama-chō, Iga-ya hammoto. On the kimono in cursive characters are phrases, probably fragments of a poem: *hana arashi* (flower hail), *kusa abura* (grass oil), *tsuyu no mura* (uneven dew), etc. The actor's role is that of Ōiso no Tora in the drama Bandō-Ichi Kotobuki Soga, performed at Nakamura-za in Shotoku, fifth year, 1715. PUBL: The same design in color in *Ukiyo-e taika shushei* (Tōkyō, 1931–32), Vol. 2, No. 5. Bibl. 19, p. 50, No. 6. Art Institute of Chicago, The Clarence Buckingham Collection.

106 | *Girl Holding a Small Lantern and Fan*
Ishikawa Toyonobu, 1711–1785
Edo Period, probably 1745

Woodblock print, *urushi-e*; hand colored in many hues. H. 28 1/2", W. 6 1/2". Signature: Tanjōdō Ishikawa Shūha Toyonobu zu. Seals: Ishikawa uji and Toyonobu. Publisher: seal of Urokogata-ya. PUBL: Bibl. 19, p. 210, No. 25. Art Institute of Chicago, The Clarence Buckingham Collection.

107 | *Feeding the Carp at Kameido*
Isoda Koryūsai, active 1764–1788
Edo Period, ca. 1771

Woodblock print, *nishiki-e*; printed in polychrome. H. 27 1/4", W. 4 3/4". Signature: Koryūsai ga. EX. COLL: Alexander G. Moslé. PUBL: *Catalogue of the Moslé Collection*, pl. CLXII, No. 1986. Frederick W. Gookin, *Japanese Colour-Prints, The Collection of Alexander G. Moslé*, No. 121, and p. 23. Art Institute of Chicago, The Clarence Buckingham Collection.

108 | *An Eagle on a Cliff Near a Kiri Tree*
Attributed to Kiyomasu, I
Edo Period, ca. 1716

Woodblock print, *tan-e*; hand colored in four hues. H. 22", W. 11 1/4". No signature; no publisher's mark.

EX. COLL: Doucet, Fuller. PUBL: Bibl. 19, p. 60, No. 18. *Estampes Japonaises Primitives . . .* Exposées au Musée des Arts Décoratifs en Fevrier 1909. Catalogue dressé par M. Vignier avec la collaboration de M. Inada, pl. 10, No. 38. Art Institute of Chicago, The Clarence Buckingham Collection.

109 | *The White Falcon*
Isoda Koryūsai
Edo Period

Woodblock print, *Ishizuri-e*; blind printed: damp paper pressed into incised lines, creating the *gaufrage* of the Chinese prints made from incised stone slabs, which it imitates; colored by hand. H. 35", W. 11 5/8". Signature: Koryūsai ga. EX. COLL: M. Alexis Rouart. PUBL: *Catalogue of the Rouart Sale*, 1922, frontispiece. Helen C. Gunsaulus, "Kachō by Koryūsai and Hokusai," *Bulletin of the Art Institute of Chicago*, April-May, 1941, p. 55. *Harunobu Koriusai Shunshō Estampes Japonaises . . .* Exposées au Musée Des Art Décoratifs en Janvier 1910. Catalogue dressé par M. Vignier avec la collaboration de M. Inada. Longuet (Paris), pl. XLVII, No. 441. Art Institute of Chicago, The Clarence Buckingham Collection.

110 | *Genji, the Kiri Chamber (Genji, Kiritsubo)*
Okumura Masanobu
Edo Period, ca. 1710

Woodblock print, *sumizuri-e* (ink printed picture). H. 10 3/4", W. 14 3/4". Seals: Okumura and Masanobu. No signature, no publisher's mark. No. 1 of the series *Ukiyoe Genji*, a set of 12, the last sheet of the series being signed: Ihon Gakō (Japanese artist), Okumura Shinnyō Masanobu. PUBL: Bibl. 19, p. 127, No. 28. Art Institute of Chicago, The Clarence Buckingham Collection.

111 | *The Maple Fête (Momiji no ga)*
Chōbunsai Eishi, 1756–1829
Edo Period, ca. 1792

Triptych, woodblock print, *nishiki-e*; printed in polychrome. H. 15 1/4", W. 29 3/4". Signature: Eishi ga. Publisher: Izumiya Ichibei. The triptych is from the series *Fūryū yatsushi Genji* (Up-to-date Tales of Genji). Musical instruments are drums, the large *tsuri-daiko* (hanging drum) used in the Bugaku orchestra, and the *kakko*, used to mark 'beats,' and a *shō*, like pan-pipes. Eishi or Hosoda Jibukyō Fujiwara no Tokikomi was a samurai. PUBL: Helen C. Gunsaulus "An Exhibition of Triptychs and Diptychs," *The Bulletin of the Art Institute of Chicago*, November, 1928, p. 107. Art Institute of Chicago, The Clarence Buckingham Collection.

112 | *Looking for Insects at Night*
Suzuki Harunobu, 1725–1770
Edo Period, ca. 1766

Woodblock print, *nishiki-e*, printed in polychrome. H. 11″, W. 8″. Signature: Harunobu ga. EX. COLL: Colburn. Art Institute of Chicago, The Clarence Buckingham Collection.

113 | *A Young Woman in a Summer Shower*
Suzuki Harunobu
Edo Period, 1765

Woodblock print, *nishiki-e* (brocade picture), printed in polychrome with embossing on kimono and obi. H. 11 1/4″, W. 8 5/8″. Signatures (lower right): Gakō (painter) Suzuki Harunobu ga Chōkō (carver) Endō Goryoku, Shōkō (printer) Yumoto Kōshi (Sachie). Seal and signature on left: Hakusei kō (conceiver of print). EX. COLL: Charles J. and Jared K. Morse. PUBL: *Japanese Prints: A Selection from the Charles J. Morse and Jared K. Morse Collection, Lent by Mrs. Jared K. Morse* (Wadsworth Atheneum; Hartford, 1951), pl. IX, No. 47. The Art Institute of Chicago, The Clarence Buckingham Collection.

114 | *Segawa Kikunojō, II, as the Courtesan Hitachi*
Ippitsusai Bunchō, 1725–1794
Edo Period, ca. 1771

Woodblock print, *nishiki-e*, printed in polychrome. H. 12″, W. 5 5/8″. Signature: Ippitsusai Bunchō ga. Seal: Mori Uji. Art Institute of Chicago, The Clarence Buckingham Collection.

115 | *The Ninth Month*, from the series *Twelve Months in the South* (*Minami jūni kō*)
Torii Kiyonaga, 1752–1815
Edo Period, ca. 1784

Woodblock print, *nishiki-e*, printed in polychrome. H. 15 1/2″, W. 10 1/4″. Signature: Kiyonaga ga. No publisher's or censor's marks. A night scene in the licensed quarters of Shinagawa looking out on Shinagawa Bay. EX. COLL: Ernest Fenollosa. Art Institute of Chicago, The Clarence Buckingham Collection.

116 | *A Lady and a Child at Night Catching Fireflies*
Eishōsai Chōki, active 1789–1795
Edo Period, ca. 1793

Woodblock print, *nishiki-e*, printed in polychrome, mica ground over black. H. 14 5/8″, W. 9 1/8″. Signature: Chōki ga. Publisher's mark: Tsutaya. EX. COLL: Raymond Koechlin, Louis V. Ledoux. PUBL: *Japanese Prints in the Louis V. Ledoux Collection Sharaku to Toyokuni, IV* (Princeton, 1950), No. 30.

Yeishi Chōki Hokusai Estampes Japonaises . . . Exposées au Musée des Arts Décoratifs en Janvier 1913. Catalogue dressé par MM. Vignier et Lebel avec la collaboration de M. Inada. Longuet, Paris. L. Aubert, *Maitres de l'Estampes Japonaises* (Paris, 1914), pl. 31. Art Institute of Chicago, The Clarence Buckingham Collection.

117 | *Uwaki*
Kitagawa Utamaro, 1753–1806
Edo Period, ca. 1794

Woodblock print, *nishiki-e*, printed in polychrome, pink mica background. H. 15″, W. 10″. At the left are three cartouches, the one at the left reads *Somi Utamaro ga* (drawn by Utamaro the Physiognomist) below is the censor's seal and the mark of the publisher Tsutaya Juzaburo. The right cartouche gives the title of the series: *Fujin sogaku jittai* (*Studies in Physiognomy: Ten Kinds of Women*). The cartouche in the center is blank in this print which is rarer than those with ideograms describing the woman. For the subject see *Ukiyo no kenyu* (*Journal of the Ukiyo Society*), August, 1926. See also J. Kurth, *Utamaro* (Leipzig, 1907), and Bibl. 30, text and pl. 48. The Cleveland Museum of Art, Bequest of Edward Loder Whittemore.

118 | *Portrait of the Actor Iwai Hanshirō, IV, as Sakurai*
Utagawa Toyokuni, I, 1769–1825
Edo Period, 1795

Woodblock print, *nishiki-e*, printed in polychrome. H. 15″, W. 9 3/4″. Signature: Toyokuni ga. Publisher: Izumiya. From the series *Yakusha butai no sugatae* (*Portraits of Actors in Stage Roles*). The eminent actor of women's roles is shown at night, dressed as a woman with his head and shoulders covered with a black hood. The part is probably that of Sakurai in the play *Matsu wa Misao onna kusunoki* played at Kawarazaki-za, 11th month of 1794. See L. V. Ledoux and H. G. Henderson, *Surviving Works of Sharaku* (New York, 1939), pl. 78, and description of pl. 75, for the role. Art Institute of Chicago, The Clarence Buckingham Collection.

119 | *The Actor Segawa Tomisaburō as Yadorigi*
Saitō Sharaku, active 1794–1795
Edo Period, 1794

Woodblock print, *nishiki-e*, printed in polychrome, mica background. H. 14 1/4″, W. 9 1/4″. Signature: Toshusai Sharaku ga. Publisher: Tsutaya. The role of Yadorigi, wife of Ogishi Kurando is in the play *Hansayame bunroku soga*, played at the Miyaki

Theater, Edo, from the 5th month of 1794. Art Institute of Chicago, The Clarence Buckingham Collection.

120 | *The Waterfall of Ono on the Kisokaidō*
 (Kisokaidō Ono no bakufu)
 Katsushika Hokusai, 1760–1849
 Edo Period, ca. 1827

Woodblock print, *nishiki-e*, printed in polychrome. H. 15″, W. 10″. Signature: Zen Hokusai Iitsu hitsu. Publisher: Eijudō. From the series *Sho-koku taki meguri (Visiting the Waterfalls in Various Provinces)*. EX. COLL: Ernest Fenollosa. Art Institute of Chicago, The Clarence Buckingham Collection.

121 | *Morning Mist at Mishima (Mishima asa kiri)*
 Ichiryūsai Hiroshige, 1797–1858
 Edo Period, ca. 1832

Woodblock print, *nishiki-e*, printed in polychrome. H. 9 1/2″, W. 14 1/2″. Signature: Hiroshige ga. Publisher: Takeuchi. From the series *Tōkaidō goju-san tsugi (The Fifty-three Post Towns of the Tōkaidō)*. Art Institute of Chicago, Gift of Frederick W. Gookin.

122 | *The Eight Section Bridge in Mikawa Province*
 in Olden Days
 (Mikawa no Yatsuhashi no kuzu)
 Katsushika Hokusai, 1760–1849
 Edo Period, ca. 1830

Woodblock print, *nishiki-e*, printed in four colors. H. 10″, W. 15″. Signature: Zen Hokusai Iitsu hitsu. Publisher: Eijudō. From the series *Sho-koku mei kyō kiran (Novel Views of Famous Bridges in Various Provinces)*. EX. COLL: M. Alexis Rouart. PUBL: *Catalogue of the Rouart Sale*, 1922, No. 366. Art Institute of Chicago, The Clarence Buckingham Collection.

123 | *Iris Flowers at Horikiri*
 (Horikiri no hana shobu)
 Ichiryūsai Hiroshige, 1797–1858
 Edo Period, dated 1857

Woodblock print, *nishiki-e*, printed in polychrome. H. 14 1/2″, W. 9 1/2″. From the series *Meishō Edo hyakkei (One Hundred Famous Views of Edo)*. EX. COLL: Frank Lloyd Wright. Art Institute of Chicago, The Clarence Buckingham Collection.

124 | *The Poet Li Po Admiring the Waterfall*
 of Lu-Shan
 Katsushika Hokusai, 1760–1849
 Edo Period, ca. 1830

Woodblock print, *nishiki-e*, printed in polychrome. H. 19 3/4″, W. 8 1/2″. Signature: Zen Hokusai Iitsu hitsu. Publisher: Moriya Jihei. From the series *Shika shoshin kyō (Imagery of the Poets*, or *Poems Imagined in Pictures)*. The last lines of Li Po's description of the waterfall are:

> The glowing sun's resplendent beams
> Create o'er Hsing-lu purple haze;
> And to the distant waterfall!
> Eternal river, upright hung
> Descending straight three thousand chang
> With silv'ry sheen, as if perchance
> The Milky Way were earthward bound
> From Heaven infinite and vast.
> tr. by Kojiro Tomita

PUBL: Frederick W. Gookin, "Color Prints by Katsushika Hokusai," *Bulletin of the Art Institute of Chicago*, February, 1930, p. 21. Art Institute of Chicago, The Clarence Buckingham Collection.

125 | Incense Burner with Cover,
 with flowers of autumn
 Momoyama Period

Lacquered wood. H. 2 1/2″, Dia. 3 1/2″. "Kodaiji" type, named after the Kyōto temple where this type was found. Howard C. Hollis, Cleveland.

126 | Charcoal Brazier *(Hibachi)*
 Momoyama Period

Lacquered wood. H. 8″, W. 11 3/4″, L. 15 1/2″. Design: crests and grasses. The crests are the *jū-roku yayé-kiku* (sixteen-petaled double chrysanthemum) which is the Emperor's crest and the *kiri* (Paulownia imperialis). In this case the form of the *kiri* is not the Emperor's, which has five blossoms on the central spray and three on the two lateral ones; the *kiri* represented here is the *go-shichi no kiri* with seven blossoms on the central spray and five on the outer ones. This crest was used by several families during the Edo period and Toyotomi Hideyoshi adopted it, too. Honolulu Academy of Arts, Gift of Mrs. Charles M. Cooke.

127, 127a | Writing Box *(suzuri bako)*,
 with cranes and reeds
 Attributed to Ogata Kōrin, 1658–1716,
 or possibly Honnami Kōetsu, 1558–1637
 Edo Period

Black lacquer on wood; design in gold paint, and inlaid lead and pewter. H. 3 3/16″, W. 8 1/2″, L. 9 1/8″. EX. COLL: T. Hara, Yokohama. PUBL: Bibl. 39, p. 98. Bibl. 5, p. 19, No. 61, and frontispiece. Bibl. 27, No. 139. Seattle Art Museum, Gift of the late Mrs. Donald E. Frederick.

128 | Writing Box, with boat among reeds
 Attributed to Honnami Kōetsu, 1558–1637
 Early Edo Period

Wood lacquered, with maki-e and lead inlay. H. 1 3/4", W. 8 7/8", L. 9 11/16". The boat is of lead, the reeds and waves are shown in gold *taka* (raised) *maki-e*, the flight of plovers are brushed in gold maki-e. A drawing of a similar motif is found among the paper decorations of the anthology *Sanjūrokunin Shū* of the Heian Period owned by the Nishi Honganji Temple in Kyoto. The choice of subject is but one of many instances of the rebirth in the work of Kōetsu and others of the courtly literary style of the earlier period. With the box are its inkstone, water pitcher, wrapping cloth, and outer box. PUBL: *Masterpieces from the Collection of the Tokyo National Museum* (Tokyo National Museum). *Illustrated Catalogue of the Exhibition of the Sōtatsu-Kōrin School* (Kyoto: Benrido). Bibl. 53, VII (Lacquer). Bibl. 64, V, p. 60, fig. 101. Tōkyō National Museum, Tōkyō (registered as Important Art Object).

129 | Writing Box, with cart
 Ritsuo, 1663–1747
 Edo Period

Wood with inlays of mother-of-pearl, silver, pewter, and gold lacquer. H. 1 1/2", W. 8 5/8", L. 9 1/4". PUBL: *Selections from the Avery Brundage Collection*, M. H. de Young Memorial Museum (San Francisco, 1960), No. 115, not illustrated. The Avery Brundage Collection, San Francisco.

130 | Nō Robe, with flowers
 of the four seasons and landscapes
 Momoyama Period

Cream-colored silk of *habutai* weave, like soft taffeta, lined with red silk. Tie-dye and embroidery. L. 65", W. (sleeve to sleeve) 52". The design shifts in color and motive on either side of the robe giving an asymmetrical arrangement called *katamigawari* (half body change). The robe is covered with diamond-shaped panels of broken outline called *matsukawa-bishi* (pine river diamond). On the right these are filled with solid embroidery, on the left with the flowers of the four seasons embroidered on a painted gold ground. The panels are separated by wide bands of trellis form, on the right with a gold ground, on the left with a soft, light red accomplished with sewed tie-dye. The gold bands continue the flower motives of the gold panels, the red ones are embroidered with swaying willows, their leaves touched with puffs of white snow. The designs of thirty-one of the dia-

mond-shaped panels in solid embroidery are all tiny landscapes each having to do with an episode from the *Isé Monogatari*. Most of the embroidery here is done with untwisted silk threads generally laid in long, soft stitches overlaid with web-like filaments crossing one another on the diagonal, called *kiriosa* and like our "split" stitch. EX. COLL: Hirase, Osaka. PUBL: Bibl. 20, pl. I, pp. 27–29. Helen C. Gunsaulus, "A Japanese Robe used in the Nō Drama," *Bulletin of the Art Institute of Chicago*, XXIII, No. 5, pp. 49–52. *Kobi-jutsu hin zuroku*, Memorial of Enthronement, 1916. Illustrated *Handbook* of Oriental Art, Art Institute of Chicago (1933), fig. 61, p. 49. Art Institute of Chicago, Gift of Mr. and Mrs. Charles Worcester.

131 | Nō Robe, with iris
 Edo Period, early 18th Century

Kara-ori (Chinese weave), a type of brocade invented by the Japanese weaver Kawaraya. L. 57 1/2". The design, like that of No. 130, is the asymmetrical "half body change." Over the twill ground which shades from terra cotta to blue, ivory, and aubergine, an allover basket pattern is brocaded in woven paper strips coated with gold foil (*kinran*). The many colored iris and incredibly graceful, life-like leaves of varying shades of green are "floated" in silk floss thread in patterns closely resembling embroidery. The robe is said to have been worn in performances of the Nō play *Kakitsubata* (described by L. Adams Beck in *Ghost Plays of Japan*). EX. COLL: Marquis Ikeda. PUBL: Bibl. 20, pl. V, pp. 43, 44, 45. Metropolitan Museum of Art *Catalogue of Japanese Costume Exhibition*, 1935, No. 19. Plate 7 of a two-volume book reproducing *100 Nō Robes*, edited by Iwao Kongo (Ōsaka, 1933). Mrs. Louis V. Ledoux, New York City.

132 | Nō Robe, with autumn flowers
 Edo Period, 18th Century

Silk brocade, *kara-ori* (Chinese weave), made particularly in Nishijin district, Kyōto, its place of origin, in the sixteenth century. L. 63 1/2", W. (sleeve to sleeve) 58". The design follows the "half body change" used so often in Nō robes, the checkered background having six stripes of *kinran* (mulberry-bark paper wrapped in gold foil), opposed to six stripes of green, violet, and white silk threads used alternately. The motifs are flowers of autumn: sprays of Chinese bellflower (*kikyo*), and bouquets of chrysanthemums and grasses in paper wrappings tied with silk cords; the colors give "an opulent effect of late sunshine in a garden in the fall," according to Helen

C. Gunsaulus. PUBL: Helen C. Gunsaulus, "Nō Costumes and Masks," *Bulletin of the Art Institute of Chicago*, XXX, No. 6, p. 81. Art Institute of Chicago, Gift of Nathalie Gookin in memory of Frederick W. Gookin.

133 | Furisode, *Kaidori* (outer kimono
of a ceremonial wedding costume), with
storks (or cranes) of the pine-grove of Chiyo
(Chiyono-matsubara senba tsuru)
Edo Period, mid-17th Century

Silk damask, tie-dyed and embroidered. L. 68", W. (sleeve to sleeve) 45 3/4". Starting with white silk damask, certain areas were reserved from the red dye by tie-dyeing in *kanoko* (spots of fawn), the finest type done on fine silver nails (seen in the bodies of some of the cranes and trunks of the trees), and *shibori* (to wring out), tieing large areas (as the snow on the trees). Certain of the cranes are embroidered in green, black, gold, and white. Cranes are symbols of long life, and pines of endurance, long life, and felicity. The furisode's (literally "to wave sleeve") long sleeves are worn only by unmarried ladies. PUBL: Bibl. 20, pl. IX, and text. *Kosode-Furisode*, published or privately printed by Nomura in Kyōto. Mrs. Louis V. Ledoux, New York City.

134 | Robe painted with *The Three Friends*
Style of Ogata Kōrin
Edo Period, 18th Century

Painting on silk. L. 62", W. 48 1/2". *The Three Friends* (pine, bamboo, and prunus) is a favorite motif in both China and Japan, signifying strength, resiliency or pliancy, and courage. The Brooklyn Museum.

135 | Water Jar, with peonies in panels
Ninsei, died after 1677
Edo Period

Glazed and enameled stoneware. H. 5 3/8". Formerly in the collection of the Empress Shōken, Consort of the Emperor Meiji. Flowers sprays in cusped panels bordered by allover diaper pattern in gold and color enclosing lozenges with four symmetrically disposed gold leaves. PUBL: Bibl. 78, V, pl. 31. Bibl. 47. Bibl. 94, XXIV, pl. 6. Tōkyō National Museum, Tōkyō.

136 | Tea Bowl, with prunus *(Yari-umé)*
Ogata Kenzan, 1663–1743
Edo Period

Glazed and enameled stoneware. H. 3 15/16", Dia. 4 1/50". *Yari umé* is a species of prunus, red in color and a symbol of longevity. PUBL: Bibl. 95, *Kenzan,*

VII, pl. 2 (color). Bibl. 78, VI, pl. 67, upper. *Tōyō kotoji (Early Oriental Ceramics*, IV [Tōkyō, 1955]), pl. 23. Bibl. 53, VI, pl. III. Bibl. 98, VII, pl. 3. Mosaku Sorimachi, Tōkyō.

137 | Raku Ware Tea Bowl
with crane on the outside, turtle inside
Kōrin-Kōetsu Style
Edo Period, 18th Century

Glazed earthenware. H. 3 3/4", Dia. 4". Kōrin-Kōetsu style Raku ware was produced by the potter Raku-Chōjirō (1515–1592) in Kyōto under the guidance of the tea master Sen-no-Rikyū. The name comes from a gold seal with the character raku on it which Chōjirō's son Jōkei was granted by Hideyoshi in memory of his father. The Royal Ontario Museum, Toronto.

138 | Arita Ware Porcelain Jar, with floral design
Edo Period, early 17th Century

Porcelain with decoration in colored enamels. H. 11 1/2", W. 9 3/4", Dia. at mouth 5". Arita porcelain is named for the region where, in the early seventeenth century, a Korean potter settling in Hizen Province discovered kaolin, set up kilns, and made the first porcelain in Japan. PUBL: Kamer Aga-Oglu, "Recent Ceramic Acquisitions Selected from Four American Museums," *Far Eastern Ceramic Bulletin*, December, 1959, No. 2, pl. 10. *The Art Institute of Chicago Quarterly*, February, 1960, p. 23. Art Institute of Chicago, Gift of Robert Allerton.

139 | Arita Ware Porcelain Plate,
with running tiger
Edo Period, 17th Century

Porcelain with decoration in colored enamels. H. 1 3/16", Dia. 8 5/16". Compare with Bibl. 102, II, pl. 164, for the same 'meshed' design. See also Bibl. 31, XXI (1945–46), pl. 9b. Mr. and Mrs. Severance A. Millikin Collection, Gates Mills, Ohio.

140 | Kakiemon Ware Plate,
with ladies pleasure-boating on a lotus pond
Edo Period, second half of 17th Century

Porcelain with decoration in colored enamels. H. 2 1/2", Dia. 12 1/8". Kakiemon ware is named for the potter Sakaida Kakiemon who, in the first half of the seventeenth century at Arita, was traditionally the first to succeed in using overglaze color decoration. The family and others made this type of porcelain *(nishiki-de* or brocade style). An almost exact duplicate of this design is to be found in Kobayashi Taichiro, *Kakiemon oyobi Imari zusetsu (Illustrated*

Text of Kakiemon and Imari [Kyoto, 1944], color plate II; and another in *Kutani, Nabeshima, Kakiemon meihinshū (An Album of Old Ceramics of Kutani, Nabeshima and Kakiemon)*, pl. 97. Mr. and Mrs. Severance A. Millikin Collection, Gates Mills, Ohio.

141 | Kakiemon Ware Plate,
 with tiger, bamboo, and flowering tree
 Edo Period, second half of 17th Century
Porcelain with decoration in colored enamels. Dia. 9 3/4". Compare with Bibl. 102, pl. 122, where the motif of a tiger wrapped around a bamboo is on the right of a plate rather than on the left as here. PUBL: Bibl. 28, No. 152. Bibl. 5, No. 54, no illustration. Seattle Art Museum, Eugene Fuller Memorial Collection.

142 | Kakiemon Ware Bottle,
 with sprays of blossoms and floral motif
 Edo Period, late 17th Century
Porcelain with decoration in gold and colored enamels. H. 8 3/8", W. at base 3 1/2". Compare with Bibl. 59, Fig. 243, p. 101, which illustrates a bottle of the same shape and similar design. Mr. and Mrs. Severance A. Millikin Collection, Gates Mills, Ohio.

143 | Kakiemon Ware Sake Bottle,
 with fox and trailing, blossoming vine
 Edo Period, early 18th Century
Porcelain with decoration in colored enamels. H. 7 3/4", W. at base 2 7/8" × 2 15/16", at top 3 1/4" × 3 1/4". Compare with Bibl. 78, IV, Fig. 149, p. 230, which illustrates a water pot of the same ware, shape, and design. Mr. and Mrs. Severance A. Millikin Collection, Gates Mills, Ohio.

144 | Kakiemon Ware Bowl, with *The Three Friends: pine, prunus, and bamboo*
 Edo Period, late 17th Century
Porcelain with decoration in colored enamels, floral border on the rim, phoenixes inside. H. 3 7/8", Dia. 7 5/8". PUBL: Bibl. 28, No. 153. Bibl. 5, No. 52, no illustration. Seattle Art Museum, Eugene Fuller Memorial Collection.

145 | Kakiemon Ware Bowl, with blossoms,
 berries, branches, and textile motif
 Edo Period, early 18th Century
Porcelain with decoration in colored enamels. H. 2 1/2", Dia. 7 7/16". One of a pair. Compare with Bibl. 78, IV, pl. 118, illustrating a bowl of the same ware and decorative forms. The Cleveland Museum of Art, Gift Mr. and Mrs. Severance A. Millikin.

146 | Kakiemon Ware Bowl,
 with eight-petaled rim, dragons, and clouds
 Edo Period, late 17th Century
Porcelain with decoration in colored enamels. H. 3 1/4", Dia. 8 1/8". Dragon inside center; inner walls have clouds and dragons in relief. Mr. and Mrs. Severance A. Millikin Collection, Gates Mills, Ohio.

147 | Kakiemon Ware Covered Bowl,
 with chrysanthemums floating in a stream
 and chidori flying above
 Edo Period, early 18th Century
Porcelain with decoration in colored enamels and with molded design of waves on exterior. Similar to bowl in Bibl. 59, No. 78. The Cleveland Museum of Art, James Parmelee Fund.

148 | Imari Ware Vase,
 with Dutchmen and foreign vessel
 Edo Period, late 17th Century
Porcelain with decoration in colored enamels and underglaze blue, double gourd shape. H. 22". Imari is named for the Kyūshū export port of Imari. Figs. 257 and 258 in Bibl. 59, p. 106, indicate that identical designs for boats and groups of foreigners were used more than once on porcelains of various shapes. The Cleveland Museum of Art, Gift of Ralph King.

149 | Imari Ware Rice Container
 Early Edo Period
Porcelain with decoration in colored enamels. H. 4 1/2", Dia. at mouth, 7". Compare with *Ko-Imari (Old Imari* [Tokyo, 1958]), pl. 46, illustrating a plate with a border around its inner rim similar to the floral motif on the overhanging collar of the rice container. *Kakiemon, Imari and Nabeshima*, exhibition catalogue, The Japan Ceramic Society (Tōkyō, 1959), No. 55, illustrates a deep bowl with the same net-like pattern that is used on the rim of the rice container. Mr. and Mrs. Severance A. Millikin Collection, Gates Mills, Ohio.

150 | Imari Ware Plate, with chrysanthemums
 Edo Period, 18th Century
Porcelain with over-all decoration in colored enamels and underglaze blue. H. 1 1/4", Dia. 8 1/4". PUBL: Bibl. 102, I, pl. 95. Mr. and Mrs. Severance A. Millikin Collection, Gates Mills, Ohio.

151 | Nabeshima Ware Plate, with textile design
 Edo Period, late 17th Century
Porcelain with over-all decoration in colored enamels and underglaze blue. H. 1 1/2", Dia. 6". Nabeshima

ware was made at the kiln established by the Lord of Nabeshima in 1722. PUBL: Okochi Masatoshi, *Kakiemon to Iro-Nabeshima* (Tōkyō, 1933), second edition, p. 207, fig. 103. Bibl. 78, IV, fig. 189 on p. 250, 2nd on the left column of the page. *Kakiemon, Imari and Nabeshima*, exhibition catalogue, The Japan Ceramic Society (Tōkyō, 1959), fig. 84 (labeled, Dish with Persian Design). Mr. and Mrs. Severance A. Millikin Collection, Gates Mills, Ohio.

152 | Nabeshima Ware Plate, with lotus and leaves
in *ju-i*-head shaped cartouches
Edo Period, late 17th Century
Porcelain with decoration in colored enamels and underglaze blue. H. 2 1/8″, Dia. 8 1/8″. PUBL: *Exhibition of Old Japanese Ceramics and Chinese Fine Arts* (Ōsaka: 1934), II, No. 256. Mr. and Mrs. Severance A. Millikin Collection, Gates Mills, Ohio.

153 | Nabeshima Ware Plate,
with blossoming branch of camellia
Edo Period, late 17th Century
Porcelain with decoration in colored enamels and underglaze blue. H. 2 3/8″, Dia. 8″ (at base 4 1/4″). PUBL: Okochi Masatoshi, *Kakiemon to Iro-Nabeshima* (Tōkyō, 1933), second edition, p. 163, fig. 63. Mr. and Mrs. Severance A. Millikin Collection, Gates Mills, Ohio.

154 | Nabeshima Ware Plate, with cockscomb
Edo Period, early 18th Century
Porcelain with decoration in colored enamels and underglaze blue. Dia. 5 7/8″. Similar to *Kutani, Nabeshima, Kakiemon meihinshu* (*Album of Old Ceramics of Japan* [Tōkyō]), pl. 69. PUBL: Bibl. 28, No. 159. Bibl. 5, No. 58, no illustration. Seattle Art Museum, Eugene Fuller Memorial Collection.

155 | Kutani Ware Plate, with leaf in reserve
Momoyama or early Edo Period,
first half of 17th Century
Glazed porcelain. H. 1 3/8″, Dia. 5 3/4″ (base 3 3/16″). Kutani ware is named for the famous kiln founded by Lord Toshiharu of the Daishoji Clan in Kaga Province (now Ishikawa Prefecture); opened between 1640 and 1650, probably abolished at the end of the seventeenth century, restored again after the interval of a century. The Cleveland Museum of Art, Gift of Mrs. A. Dean Perry.

156 | Kutani Ware Plate, with phoenix
Edo Period, mid-17th Century
Porcelain with decoration in colored enamels. Subject: Phoenix giving a cry in the morning sun. H.

2 7/16″, Dia. 13 3/8″. PUBL: Bibl. 78, VI, pl. 9 (color). Bibl. 59, pl. 8. *Ko-Imari* (*Old Imari* [Tokyo, 1959]), No. 10, p. 260. *Nihon no toji*, pl. 8. Shizuo Yamagami, Ibaragi-ken, Japan.

157 | Kutani Ware Plate, with landscape design
Edo Period, second half of 17th Century
Porcelain with decoration in colored enamels and underglaze blue. H. 2 3/4″, Dia. 12 5/8″. *Tosetsu*, No. 20, November, 1954, Figs. 21 and 22 illustrate a plate similar to the Seattle piece, the medallion border has a different design. PUBL: Bibl. 28, No. 161. Bibl. 5, No. 55, no illustration. Seattle Art Museum, Eugene Fuller Memorial Collection.

158 | Kutani Ware Plate, with bird and flower
Edo Period, second half of 17th Century
Porcelain with decoration in colored enamels. H. 2 1/2″, Dia. 11 3/4″. The Cleveland Museum of Art.

159 | Kutani Ware Plate,
with quail on a rock, and peonies
Early Edo Period, late 17th Century
Porcelain with decoration in colored enamels. Dia. 8 1/8″. PUBL: Bibl. 28, No. 162. Seattle Art Museum, Eugene Fuller Memorial Collection.

160 | Kutani Ware Plate, with over-all scroll
and branch of large leaves
Edo Period, late 17th Century
Porcelain with decoration in colored enamels. H. 2 1/2″, Dia. 13 1/8″. Mr. and Mrs. Severance A. Millikin Collection, Gates Mills, Ohio.

161 | Kutani Ware Plate, with branches of large
green leaves laid on allover imbrication
Edo Period, late 17th Century
Porcelain with decoration in colored enamels. H. 3 3/16″, Dia. 14 3/4″. The Cleveland Museum of Art, Purchase from the J. H. Wade Fund.

162 | Kutani Ware Square Plate, with floral spray
Edo Period, late 17th or early 18th Century
Porcelain with decoration in colored enamels. 6 3/4″ square. PUBL: Bibl. 28, No. 163. Bibl. 5, No. 56. Seattle Art Museum, Eugene Fuller Memorial Collection.

163 | Kakiemon Ware Bowl,
with flowers and rocks outside, lion inside
Edo Period, early 18th Century
Porcelain with decoration in colored enamels and underglaze blue. H. 5 1/4″, Dia. 10″. Mr. and Mrs. Severance A. Millikin Collection, Gates Mills, Ohio.

164 | Imari Ware Court Lady Dish
 Edo Period, 18th Century

Porcelain with decoration in colored enamels and underglaze blue. W. 7 1/4", L. 11 1/2". The lady wears the *junihitoye* (twelve single robes) of court dress. Howard C. Hollis, Cleveland.

165 | Nabeshima Ware Plate, with willow
 Edo Period, early 18th Century

Porcelain with blue underglaze decoration. H. 3", Dia. 12". Howard C. Hollis, Cleveland.

166 | Kutani Ware Plate, with fan design
 Edo Period, late 17th Century

Porcelain with decoration in colored enamels. Dia. 8 5/16". Bibl. 78, VI, pl. 85 illustrates a similar fan motif on a deep green ground. Mr. and Mrs. Severance A. Millikin Collection, Gates Mills, Ohio.

167 | Sword Guard *(Tsuba)*, with plover *(chidori)*
 Edo Period

Metal, probably *sentoki*, an alloy of tin, copper, lead and zinc. Dia. 3 1/2". Unsigned. Modified *mokkō* form, that is, resembling the *aoi* (asarum) leaf shaped gourd, with raised rim. *Chidori* and waves chiseled in relief, background textured. The *seppa dai* (oval around the blade opening) is notably raised from the ground. The Cleveland Museum of Art, Gift of D. Z. Norton.

168 | Sword Guard, with wheel motif
 Edo Period

Iron with gold inlays. Dia. 3 1/8". Unsigned. Wheel design perforated, rim with floral motives in flat inlay. The Cleveland Museum of Art, Gift of D. Z. Norton.

169 | Sword Guard, with geese and pond
 Edo Period

Iron. Dia. 2 1/2". Unsigned. Perforated design. The Cleveland Museum of Art, Gift of D. Z. Norton.

170 | Sword Guard, with pine and cloud
 Masakata, Itō School
 Edo Period, early 19th Century

Iron. Dia. 2 3/4". Signed "Masakata residing in Musashi Province." Design perforated as was characteristic of the Itō School. See Helen C. Gunsaulus, *Japanese Sword-Mounts in the Collections of Field Museum* (Chicago, 1923), p. 67, section VII, The Umetada Family, The Itō School. The Cleveland Museum of Art, Gift of D. Z. Norton.

171 | Sword Guard, with bridge and pine tree
 Kakubusai Masazane
 Edo Period

Shakudo: alloy of copper and gold. Dia. 2 3/4" × 2 7/8". Signed "Kakubusai Masazane" with a *parafe* or written seal. Design perforated, chiseled in relief, and embellished with high inlay, and flat inlay. Rounded rim. The Cleveland Museum of Art, Gift of D. Z. Norton.

172 | Sword Guard, with dragon and waves
 Issan, Canton School
 Edo Period, early 19th Century

Iron. Dia. 2 7/8". Signed "Issan residing at Nagasaki." Design perforated and chiseled in the round; knobbed rim. The Cleveland Museum of Art, Gift of D. Z. Norton.

173 | Sword Guard, with waves
 Edo Period

Iron. Dia. 3". Unsigned. Openings for *kogai* and *kozuka* (small skewer and knife) filled with a white metal, probably *shakudo*. Design perforated and chiseled in relief. The Cleveland Museum of Art, Gift of D. Z. Norton.

174 | Sword Guard, with iris
 Edo Period

Iron. Dia. 3 1/8". Unsigned. Design perforated and chiseled in relief, and flecked with gold. Rounded rim. The Cleveland Museum of Art, Gift of D. Z. Norton.

175 | Sword Guard, with plum and cherry blossoms
 Edo Period

Iron. Dia. 3 1/4". Unsigned. Design perforated, with surface forged to look like the grain of wood *(mokumé-ji)*. Cherry is the flower of chivalry, plum the symbol of courage. See Captain F. Brinkley, *Japan, Its History, Arts, and Literature*, VII (Boston and Tokyo, 1902), p. 245, for a description of the technique of *mokumé-ji*. The Cleveland Museum of Art Gift of D. Z. Norton.

176 | Sword Guard, with fans
 Edo Period

Iron. Dia. 3". Unsigned. Fans, symmetrically disposed, are perforated. The Cleveland Museum of Art Gift of D. Z. Norton.

A selected bibliography

1 Akiyama, Aisaburo. *Japanese Painting*. Unpublished book. Skira, New York City.

2 Anesaki, Masaharu. *Art, Life, and Nature in Japan*. Boston: Marshall Jones, 1933.

3 ———. *Buddhist Art in its Relation to Buddhist Ideals with Special Reference to Buddhism in Japan*. Boston and New York: Houghton Mifflin Co., 1915.

4 *Archives of the Chinese Art Society of America*. New York: Chinese Art Society of America Inc., 1960.

5 *The Art of Japan in the Edo Period*. Nelson Gallery of Art and Atkins Museum, Kansas City, and City Art Museum, St. Louis, 1958.

6 Beaujard, A. *Les Notes de Chevet de Sei Shōnagon*. Paris, 1934.

7 Benedict, Ruth F. *The Chrysanthemum and the Sword*. Boston: Houghton, 1946.

8 *Bijutsu kenkyū (Journal of Art Studies)*. Tōkyō: The Institute of Art Research, 1932.

9 Binyon, Laurence, Sexton, J. J. O'Brien. *Japanese Colour Prints*. London: Benn, 1923.

10 Bonneau, Georges. *Le Monument Poétique de Heian: Le Kokinshū (Annales du Musée Guimet [Bibliotheque d'Etudes] Vols. 45, 46, 47.)* Paris: Librairie Orientaliste Paul Geuthner, 1933–36.

11 Buhot, Jean. *Histoire des Arts du Japon*. Paris: Van Oest, 1949.

12 *Bukkyo bijutsu nyūmon (Introduction to Japanese Buddhist Arts)*. Nara: National Museum, 1959.

13 Commission for Protection of Cultural Properties, Tōkyō. *Report on the Exhibition of Japanese Painting and Sculpture . . .* (Held in the United States in 1953.) Tōkyō, 1954.

14 Fischer, Otto. *Die Kunst Indiens, Chinas und Japans*. Berlin: Propyläen-Verlag, 1928.

15 Gray, Basil. *Japanese Screen Painting*. London: Faber and Faber, 1955.

16 Grilli, Elise. *Golden Screen Paintings of Japan*. New York: Crown Publishers, n. d.

17 Grousset, René. *The Civilizations of the East*. Vol. IV of 4 vols. New York: Alfred A. Knopf, 1934.

18 ———. *Histoire de l'Extreme Orient (Annales du Musée Guimet [Bibliotheque d'Etudes] Vols. 39, 40)*. Paris: Librairie Orientaliste Paul Geuthner, 1929.

19 Gunsaulus, Helen C. *The Clarence Buckingham Collection of Japanese Prints: The Primitives*. Chicago: The Art Institute of Chicago, 1955.

20 ———. *Japanese Textiles*. Privately printed for The Japan Society of New York, 1941.

21 *Handbook*. Seattle: Seattle Art Museum, 1951.

22 Harada, Jiro. *English Catalog of Treasures in the Shōsōin*. Tokyo: Imperial Household Museum, 1932.

23 ———. *The Gardens of Japan*. London: The Studio Ltd., 1928.

24 ———. *A Glimpse of Japanese Ideals*. Tōkyō: Kokusai bunka shinkokai, 1937.

25 *Heian jidai no bijutsu (Art of the Heian Period)*. Kyōto: Benridō, 1958.

26 *Hōsai banka daihōkan (An Outline of Exotic Art in Japan)* catalogue of Ikenaga Collection. 2 vols. Ōsaka: Sōgensha, 1933.

27 *Japanese Art in America.* Claremont Graduate School, Scripps College, Scripps College Art Galleries. Claremont, California, 1960.

28 *Japanese Art in the Seattle Art Museum.* Seattle Art Museum, 1960.

29 *Japanese Paintings and Prints from the Collection of Mr. and Mrs. Richard P. Gale.* The Minneapolis Institute of Arts, 1961.

30 *Japanese Prints of the Primitive Period in the Collection of Louis V. Ledoux.* New York: E. Weyhe, 1942.

31 Jenyns, Soame. "The Wares of Kutani," *Transactions of the Oriental Ceramics Society,* XXI (1945–1946), 18–52.

32 *Kamakura no bijutsu (Fine Arts of Kamakura).* Tōkyō: Asahi Shimbunsha, 1958.

33 Keene, Donald (ed.). *Anthology of Japanese Literature.* New York: Grove Press, 1955.

34 Kenji, Toda. "Japanese Screen Paintings of the Ninth and Tenth Centuries," *Ars Orientalis,* III (1959), 151–166.

35 *Kokka* (Monthly Journal of Oriental Art). Tōkyō: The Kokka Co., 1889–.

36 *Kōrin-ha gashu (Masterpieces Selected from the Kōrin School).* 5 vols. Tōkyō: Shimbi Shoin, 1903–1906.

37 *Kōrin Hyakuzu (One Hundred Pictures of Kōrin).* Kyōtō, 1815. (See note 36.)

38 Koyama, Fujio (ed.). *Tōyō ko-tōji (Early Oriental Ceramics).* Tōkyō: Bijutsu Shuppansha, 1954–1957.

39 Lee, Sherman E. "Japanese Art at Seattle," *Oriental Art,* Winter 1949–50, pp. 89–98.

40 Machida, Kōichi, *et al. Tōyō bijutsu-shi yōsetsu (Outline History of Oriental Art).* 2 vols. Tōkyō: Yoshikawa Kōbunkan, 1958.

41 Maeda, Taiji. *Japanese Decorative Design.* Tōkyō: Japan Travel Bureau, 1957.

42 *Masterpieces of Asian Art in American Collections.* New York City: The Asia Society, Inc., 1960.

43 Matsushita, Takaaki. *Japan, Ancient Buddhist Paintings.* New York: The New York Graphic Society, 1959.

44 Miller, Roy Andrew. *Japanese Ceramics.* After the Japanese text by Seichi Okuda, Fujio Koyama, and Seizo Hayashita. Tōkyō: Tōto Shuppan Co., Ltd., 1960.

45 Minamoto, Hōshu. *An Illustrated History of Japanese Art.* Translated by Harold G. Henderson. Kyōto: K. Hoshino, 1939.

46 Minamoto, Toyomune. *Kitano Tenjin engi.* Vol. VIII of *Nippon emakimono zenshū* series (*Japanese Scroll Paintings*). Tōkyō: Kadokawa Shoten, 1958.

47 Mitsuoka, Tadanari. *Ceramic of Art Japan.* Tōkyō: Japan Travel Bureau, 1954.

48 Moriya, Kenji. *Die Japanische Malerei.* Wiesbaden: F. A. Brockhaus, 1953.

49 Murasaki, Lady. *The Tale of Genji.* Translated by Arthur Waley. 6 vols. London: G. Allen and Unwin, 1926–1933.

50 *Museum* (Monthly Publication of the Tōkyō National Museum). Tōkyō, 1951–.

51 Nabeshima House Factory Research Committee. *Nabeshima Colored Porcelains.* Kyōto: Heian-dō, 1954.

52 *National Treasures of Japan for the Year 1951* Tōkyō: The Cultural Properties Commission of Japan, 1951.

53 *Nihon bijutsu taikei (Compendium of Japanese Arts).* 11 vols. Tōkyō: Kōdansha, 1959–.

54 *Nihon-ga taisei (Comprehensive Collection of Japanese Paintings).* 55 vols. Tōkyō: Tōhō Shoin, 1931–.

55 *Nihon no koten: kaigahen (Japanese Classic Art: Painting Series).* 6 vols. Tōkyō: Bijutsu Shuppansha, 1955–1959.

56 *Nippon seika (Art Treasures of Japan).* 5 vols. Nara, 1908–1911.

57 Nishimura, Tei. *Namban Art; Christian Art in Japan.* Tōkyō: Kōdansha, 1958.

58 Noma, Seiroku. *Artistry in Ink.* New York: Crown Publishers, 1957.

59 Okuda, Seiichi; Koyama, Fujio, and Hayaskiya, Seizo. *Japanese Ceramics*. Tōkyō: Tōto Bunka Co., 1954.

60 Old Imari Research Committee (ed.). *Old Imari*. Tōkyō: Saga: Kinkadō, 1959.

61 Omori, Annie Shepley, and Kochi Doi (trans.). *Diaries of Court Ladies of Old Japan*. Boston and New York: Houghton Mifflin Co., 1920.

62 *One Hundred Masterpieces from the Collection of the Tōkyō National Museum*. Tōkyō: Tōkyō National Museum, 1959.

63 Oshima, Yoshinaga. *Shōsōin gomotsu zuroku (Catalogue of the Imperial Treasures in the Shōsōin)*. Tōkyō: Imperial Household Museum, 1929.

64 *Pageant of Japanese Art, The*. 6 vols. Tōkyō: Tōto Bunka Co., 1952.

65 Paine, Robert Treat. *Japanese Screen Paintings*. Boston: Museum of Fine Arts, 1935.

66 ———. *Ten Japanese Paintings in the Museum of Fine Arts, Boston*. Privately printed for The Japan Society of New York, 1939.

67 ——— and Soper, Alexander. *The Art and Architecture of Japan*. Baltimore: Penguin Books, 1955.

68 Randall, Doanda. *Kōrin*. New York: Crown Publishers, Inc., 1959.

69 Saikaku, Ihara. *Nippon eitai-gura or Daifuku shin-chōjakyō (The Japanese Family Storehouse or the Millionaire's Gospel Modernized)*. Translated by G. W. Sargent. England: Cambridge University Press, 1959.

70 Saito, Ryukyu. *Japanese Ink-Painting*. Rutland: C. E. Tuttle Co., 1959.

71 Sansom, George Bailey. *A History of Japan to 1334*. Stanford: University Press, 1958.

72 ———. *Japan, a Short Cultural History*. New York: D. Appleton-Century Co., 1931.

73 Seckel, Dietrich. *Emakimono*. New York: Pantheon Books, 1959.

74 Seidlitz, Woldemar von. *A History of Japanese Colour Prints*. Philadelphia: J. B. Lippincott Co., 1920.

75 *Seizanshō seishō (Illustrated Catalogue of the Nezu Collection)*. 10 vols. Tōkyō: Kaichiro Nezu, 1939–1943.

76 *Sekai bijutsu zenshū (World Art Series)*. Tōkyō: Heibonsha Ltd., n. d.

77 *Sekai bunka-shi takei (Cultural History of the World)*. 26 vols. Tōkyō: Kadokawa Shoten, 1958.

78 *Sekai tōji zenshū (Catalogue of World's Ceramics)*. 16 vols. Tōkyō: Zauko Press & Kawade Shobō, 1955–56.

79 Sera, Yosuke (ed.). *Ko-Imari somezuki zufu (Old Imari, Blue and White Porcelain)*. Kyōto: Heiandō, 1959.

80 Shirahata, Yoshi. *Saigyo Monogatari emaki; Taima Mandara engi: Nippon emakimono zenshū (Japanese Scroll Paintings)*. 12 vols. Vol. XI of the series. Tōkyō: Kadokawa Shoten, 1958.

81 *Shodō meihin zuroku (Catalogue of Calligraphic Masterpieces)*. Tōkyō National Museum, n. d.

82 *Shōsōin gomotsu (Treasures of the Shōsōin Repository)*. 3 vols. Tōkyō: Asahi shimbunsha, 1960–62.

83 Soper, Alexander C. *The Evolution of Buddhist Architecture in Japan*. Princeton, N. J.: Princeton University Press, 1942.

84 ———. "The Rise of Yamato-e," *Art Bulletin*, XXIV (December, 1942), 351–379.

85 Suzuki, Kei. *Shōki emakimono no fuzokushi-teki kenkyū (Study of the Primitive Scroll Paintings Viewed from the History of Manners and Customs)*. Tōkyō, 1960.

86 Swann, Peter C. *An Introduction to the Arts of Japan*. Oxford: Bruno Cassirer, 1958.

87 Tajima, Shiichi (ed.). *Tōyō bijutsu taikan (Masterpieces Selected from the Fine Arts of the Far East)*. 18 vols. Tōkyō: Shimbi Shoin, 1909–1919.

88 Taki, Seiichi. *Three Essays on Oriental Painting*. London: B. Quaritch, 1910.

89 Tanaka, Ichimatsu (ed.). *The Art of Kōrin*. Tōkyō: Nihon Keizai Shimbun, 1959.

90 ———. *Genji monogatari emaki: Nippon emakimono zenshū (Japanese Scroll Paintings)*. Vol. I. Tōkyō: Kadokawa Shoten, 1958.

91 Tazawa, Yutaka (ed.). *A Pictorial History of Japanese Art*. Tōkyō, 1952.

92 Toda, Kenji. *Japanese Scroll Painting*. Chicago: The University of Chicago Press, 1935.

93 *Tōji and Its Cultural Treasures*. Tōkyō: Asahi Shimbun-sha, 1958.

94 *Tōki Zenshū (Ceramic Series)*. 24 vols. Tōkyō: Heibonsha Ltd., 1957–1960.

95 Tomita, Kojiro. "A Japanese Lacquer Box of the Fourteenth Century," *Bulletin of The Museum of Fine Arts* (Boston), XXIX (April, 1931), 23–26.

96 Tsuneyo, Fujita, et al. (eds.). *Nippon bijutsu zenshi (History of Japanese Art)*. 2 vols. Tōkyō: Bijutsu Shuppan-sha, 1959.

97 Tsudzumi, Tsuniyoshi. *Die Kunst Japans*. Leipzig: Insel Verlag, 1929.

98 *Ukiyo-e [Genre pictures or pictures of the floating world, complete survey]*. 12 vols. Tōkyō: Tōhō Shoin, 1931.

99 Vos, Frits. *A Study of the Isé Monogatari*. 2 vols. The Hague: Mouton & Co., 1957.

100 Warner, Langdon. *The Craft of the Japanese Sculptor*. New York: McFarlane, Warde, McFarlane, and Japan Society of New York, 1936.

101 ———. *The Enduring Art of Japan*. Cambrigde: Harvard University Press, 1952.

102 Yamane, Yuzu. *Nihon iroe kotoshu (Japanese Colored Porcelain)*. Kyōto: Kyōto-Shoin, 1953.

103 *Yamato Bunka (Quarterly Journal of Eastern Arts)*. Osaka: Yamato Bunka-ken, 1951–.

104 Yashiro, Yukio (ed.). *Art Treasures of Japan*. 2 vols. Tōkyō: Kokusai bunka shinkokai, 1960.

105 ———. *2,000 Years of Japanese Art*. Edited by Peter C. Swann. New York: Harry N. Abrams Inc., 1958.

106 Yoshino, Tomio. *Japanese Lacquer Ware*. Tōkyō: Japan Travel Bureau, 1959.

Index of artists

Lenders to the exhibition

Art Institute of Chicago
Georges de Batz, New York City
Brooklyn Museum of Art
Avery Brundage, Chicago
John M. Crawford, Jr., New York City
Fogg Art Museum, Harvard University, Cambridge
Mr. and Mrs. Richard E. Fuller, Seattle
Mr. and Mrs. Richard P. Gale, Mound, Minnesota
Caral G. Greenberg, New York City
Osborne Hauge, Falls Church, Virginia
Victor Hauge, Washington, D. C.
Howard C. Hollis, Cleveland
Honolulu Academy of Art
Peter W. Jostin, New York City
Lillian M. Kern, Cleveland
Mathias Komor, New York City
Mrs. Louis V. Ledoux, New York City
Mr. and Mrs. Aschwin Lippe, New York City
Junkichi Mayuyama, Tokyo
Mr. and Mrs. Severance A. Millikin, Gates Mills, Ohio
Museum of Fine Arts, Boston
Nelson-Atkins Art Gallery, Kansas City
New York Public Library, New York City
Royal Ontario Museum, Toronto
Seattle Art Museum
Inosuke Setsu, Tokyo
Mosaku Sorimachi, Tokyo
Stephen Spector, New York City
Tokyo National Museum
Shizuo Yamagami, Ibaragi-ken, Japan

Icon Editions